The Official Nik Software

Image Enhancement Guide

The Photographer's Resource for Professional Workflow Techniques

Joshua D. Bradley

WILEY

Wiley Publishing, Inc.

The Official Nik Software

Image Enhancement Guide

The Official Nik™ Software Image Enhancement Guide

Published by
Wiley Publishing, Inc.
111 River Street
Hoboken, N.J. 07030
www.wiley.com

Published by Wiley Publishing, Inc., Indianapolis, Indiana
Published simultaneously in Canada

Library of Congress Control Number: 2008933764

ISBN: 978-04-702-8763-7

Manufactured in the United States of America

10 9 8 7 6 5 4 3 2 1

For general information on our other products and services or to obtain technical support, please contact our Customer Care Department within the U.S. at (800) 762-2974, outside the U.S. at (317) 572-3993 or fax (317) 572-4002.

Wiley also publishes its books in a variety of electronic formats. Some content that appears in print may not be available in electronic books.

Colophon: This book was produced using the New Caledonia typeface for the body copy, Formata and Myriad for the headlines, and News Gothic for the caption text.

Dedication

To the girls in my life, Dawn and Raven.
Your love and faith in me is what keeps me moving forward

To Moose.
I could not have made it this far this fast
without your guidance and patience

Credits

Acquisitions Editor
Stephanie McComb

Editorial Manager
Robyn B. Siesky

**Vice President &
Executive Group Publisher**
Richard Swadley

Vice President and Publisher
Barry Pruett

Business Manager
Amy Knies

Marketing Manager
Sandy Smith

Project and Layout Editor
Carol Person, The Zango Group

Book Design and Production
Galen Gruman, The Zango Group

Cover Design
Michael Trent

Photography
Joshua D. Bradley

Technical Editor
Josh Haftel, Nik Software

**Copy Editing, Proofreading, and
Indexing**
The Zango Group

About the Author

Joshua D. Bradley has always been interested in photography — even at a young age, using disposable cameras his grandmother would give him. He started to take the art more seriously, as a hobby in his twenties, when he picked up a Canon Elan 7. Since receiving his biology degree at California State University at Bakersfield, Josh's interest in photography has focused on threatened and endangered species in California, as well as spectacular landscapes of the state. He then upgraded to the digital medium, which afforded him greater diversity in photography. The photographs he produced then offered him the opportunity to meet his mentor and now friend, Moose Peterson, by joining Moose's Master Light Program.

From there, Josh was asked to be Moose's assistant, and things have taken off. Josh is one of the teachers for the Digital Landscape Workshop Series events and is a co-instructor at Wildlife Photographer's Base Camp. Josh's photography has taken him all over the United States exploring the beautiful landscapes and vistas as well as the wildlife that call it home.

Josh resides in California with his wife and daughter and continues to progress in his photography with the abundant opportunities of photographing endangered wildlife in his backyard.

CONTENTS

PART II Finishing with Color Efex Pro 3.0 47

PART IV: Multiple Filters, Multiple Programs 119

INTRO

Hey there! Chances are that if you're reading this introduction, you either own or are thinking of owning some of the great products from Nik Software. When I first started trying to write everything there was about the plug-ins, I realized that this book could end up being the size of an encyclopedia! I don't know about you, but reading an encyclopedia is really boring, so I wrote this book a different way: as a series of hands-on lessons for the kinds of effects a photographer is likely to use on real images.

This book provides insight into each of the Nik plug-ins, from installation all the way through creating some amazing images. I share with you my workflow with some tips and tricks that I have learned about the process that will take you from the point of capture all the way to the final print. With some creative flair here and there.

So what makes these plug-ins so great? They offer so much creative control, from how to cut down on noise in your image using Dfine 2.0, to using Silver Efex Pro to make some of the most amazing black-and-white images faster than you can imagine.

These plug-ins make your life easier because you don't have to make all those tiny adjustments in multiple layers in Photoshop; instead, you get the same desired effect in one mouse click using Color Efex Pro 3.0 or a simple adjustment of a slider in Viveza. The power of each plug-in is astounding, and when you combine them into your workflow the power goes up exponentially.

So why is it so important to save time behind the computer? The simple answer: money! If you're a photographer, you're not making money by sitting behind a computer all day. You make money when you're out shooting. That is why the plug-ins that Nik creates are so important. You capture your image, download it to your computer, run it through the Nik plug-ins, and you are back out the door with camera in your hand. Not too many programs let you accomplish this and none, in my opinion, do it better than the plug-ins Nik has created.

If there were to be a disclaimer in this book, it is this: These plug-ins save you time only if you know what you want to do with your image. It's critical that you have in mind the story that you want the image to tell and what tools you will need to make that story happen. And having that knowledge has to happen when you get ready to click the shutter: When you take a photo, you're thinking "Okay, this is going to be a great black-and-white, and I can use Silver Efex Pro to get the image to where I want it," or "This image is going to look great once I apply the Tone Contrast filter in Color Efex Pro 3.0."

By having a plan at the point of capture, you automatically save time behind the computer by not playing around with various filters and settings. You know what you want to do with the image and you get back out the door.

But playing around is not a bad thing. When you have time, it is always great to play. I came up with some great techniques and new ways to tweak filters by playing. After all, it's hard to know what you can do with the software until you have done it yourself through experimentation (or checked out the lessons in this book!). While money may be your driving force, in most cases taking time to play can pay off in the long run as well.

I encourage you to play with the Nik plug-ins with your own images, but to help you along, this book also includes a CD with the "before" images for each lesson so you can both follow along the lessons and try other techniques to compare the results. Each lesson in this book also shows you a before and after image to give you an idea of what the lesson is going to achieve. Being a visual person, I like to see what something can do, and not just try to read though a set of instructions to see what happens.

The organization of the book itself is built around my workflow. After touring the Nik plug-ins in Part 1, you dive into my workflow, which follows the flow of Dfine, Viveza, Color Efex Pro 3.0 or Silver Efex Pro, Dfine again (for final noise reduction), Viveza again (for touch-up), and finally Sharpener Pro 2.0. Parts II through VI follow this workflow.

I use this workflow most of the time. But not always: Sometimes I may not need to hop into Viveza or do a final noise reduction on touch-ups. It all depends on the image, and how it looks when I'm finished.

Many of these lessons are based on the Nik Software's premise of "photography first." I always try to keep that motto in mind when I'm out shooting. One thing that I don't want you to do is take bad images and try to make them into fantastic images using these programs. A bad shot is a bad shot, and no amount of anything will fix that. So remember to take your time behind the camera to make a great image and then come home and finish it to make it amazing.

Another key thing I want you to take away from this book is that fact that nothing is written in stone. What I show you regarding to my workflow might not be suitable for you — but it

is a starting point. Just as it is with everything in photography, it is all about personal preference. I might absolutely love the look of an image but you might think it is oversaturated. That's okay: Nothing written within these pages is set in stone, and it shouldn't be. So take this book and build from what I show you to make it your own.

I hope you enjoy the lessons and that they spark a new creativity in your photography,

Enjoy!

CONVENTIONS

This is a book about digital photography techniques, which means you're doing the special effects on a computer — a Windows PC or a Macintosh — using the Nik Software plug-ins running inside Adobe Photoshop. And that means there are menu commands, mouse actions, and other computer controls involved. To make sure you know what I mean when I describe operating the Nik plug-ins, what follows are the conventions I use in the text for these actions.

Mouse Conventions

Here's what I mean when I talk about using the mouse:

- Click: Most Mac mice have only one button, but some have two or more; all PC mice have at least two buttons. If you have a multibutton mouse, quickly press and release the leftmost mouse button once when I say to click the mouse. (If your mouse has only one button — you guessed it — just press and release the button you have.)

- Double-click: When I say to double-click, quickly press and release the leftmost mouse button twice (if your mouse has only one button, just press and release twice the button you have). On some multibutton mice, one of the buttons can function as a double-click (you click it once, the mouse clicks twice); if your mouse has this feature, use it — it saves strain on your hand.

- Right-click: A Windows feature since Windows 95, right-clicking means clicking the right-hand mouse button. On a Mac's one-button mouse, hold the Control key when clicking the mouse button to achieve the right-click effect. On multibutton Mac mice, Mac OS X automatically assigns the right-hand button to Control+click.

- Drag: Dragging is used for moving and sizing items in a document. To drag an item,

position the mouse pointer on it. Press and hold down the mouse button, and then slide the mouse across a flat surface to drag the item. Release the mouse button to drop the dragged item in its new location.

The commands that you select by using the program menus appear in this book in normal typeface. When you choose some menu commands, a related pull-down menu or a pop-up menu appears. If I describe a situation in which you need to select one menu and then choose a command from a secondary menu or list pane, I use an arrow symbol. For example, "Choose Edit ▶ Paste" means that you should choose the Paste command from the Edit menu.

Keyboard Conventions

In those rare cases where I get into nitty-gritty computer commands, I provide both the Windows and Macintosh shortcuts throughout, with the Windows shortcut first. In most cases, the Windows and Mac shortcuts are the same, except for the names of the keys, as follows:

- The Windows Ctrl key is the most-used shortcut key. Its Mac equivalent is the Command key, which is indicated on keyboards and program menus (and thus in this book) by the symbol ⌘.

- Shift is the same on the Mac and Windows. In many Mac program menus, Shift is displayed by the symbol ⇧.

- The Option key on the Mac is usually the same as the Alt key in Windows. In many Mac program menus — including iTunes — you'll see the symbol ⌥ used.

- The Control key on the Mac has no Windows equivalent (it is *not* the same as the Windows Ctrl key). Many Mac programs indicate it with the symbol ⌃ in their menus.

- The Tab key is used both to move within fields in panels and dialog boxes and to insert the tab character in text. iTunes and many other Mac programs indicate it in menus with the symbol ⇥.

- The Enter key (Windows) or Return key (Mac) is used to apply a dialog box's settings and close the dialog box (equivalent to clicking OK or Done), as well as to insert a hard paragraph return in text. In many Mac programs, it is indicated in menus by the symbol ↩. Note that there is another key labeled Enter on most keyboards, in the numeric keypad. This keypad Enter usually works like the regular Return or Enter.

- The Delete key (Mac) and Backspace key (Windows) deletes text, one character at a time, to the left of the text-insertion point. On the Mac, programs like iTunes use the symbol ⌫ to indicate Delete. Windows also has a separate Delete key that deletes text, one character at a time, to the right of the text-insertion point. The Mac's Clear key, although in the same position on the keyboard, does not delete text.

If you're supposed to press several keys at the same time, I indicate that by placing plus signs (+) between them. Thus, Shift+⌘+A means press and hold the Shift and ⌘ keys, then press A. After you've pressed the A key, let go of all three keys. (You don't need to hold down the last letter in the sequence.)

I also use the plus sign (+) to join keys to mouse movements. For example, Alt+drag means to hold the Alt key while dragging the mouse in Windows, and Option+drag means to hold the Option key while dragging the mouse on the Mac.

PART I

How to Use the Nik Tools

The Lessons

Everyone reads the manuals that come with the software, right? Not always, of course. So, I'm going to give you a run down of the install process and the user interface of each of the Nik Software programs covered in this book's lessons. In most cases when you install a plug-in, such as the Nik plug-ins, they are embedded inside the application (in this case, Photoshop). But when you upgrade, re-install, or tweak Photoshop, you will need to re-install all your plug-ins as well.

So here's a simple solution. First, when you install the plug-in, don't blindly click OK and let the computer take over! You need to tell the computer where you want to save your plug-ins. Then, when you upgrade Photoshop, the plug-ins are in their own little folder sitting exactly where you put them on your hard drive. And the new Photoshop won't have removed them.

In the rest of this part, I describe the plug-ins in the order that I use them in my workflow. Because Color Efex Pro 3.0 and Silver Efex Pro are generally used separately, your workflow might be different.

LESSON 1:
INSTALLING THE PLUG-INS

First, go to your main hard drive and create a new folder named "Plug-ins" (or a name you'll remember) and you're ready to install your plug-ins.

Double-click the program icon and you're off and running. After you accept all the agreements, you will arrive at the Color Efex Pro 3.0 Complete Setup dialog box. Click the Browse button to open the Browse for Folder window, as shown in Figure 1-1. Select your plug-in folder, click OK, and you're taken back to the installation window where you click the Next button.

Open Photoshop and choose Photoshop ▶ Preferences ▶ Plug-ins (on the Mac) or Edit ▶ Preferences ▶ Plug-ins (in Windows) to open the Preferences dialog box (see Figure 1-2). Turn on Additional Plug-Ins Folder and locate your plug-in folder and click OK. Back in the Preferences dialog box, click OK. The final step is to close Photoshop and restart it. After restarting Photoshop, your plug-ins will be listed in the Filter menu.

When installing software, make sure you have all your product keys. Usually I store them in an obscure text file that is not easily recognized by prying eyes. I also keep a copy of the keys on a thumb drive, and I e-mail myself a copy of the keys so that no matter where I am I have the keys in case I need to re-install the plug-ins.

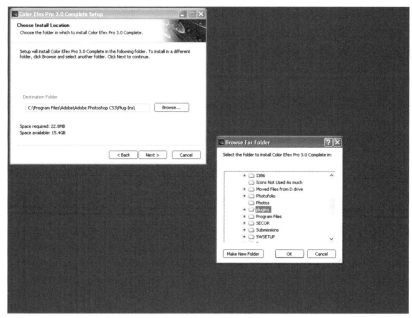

Figure 1-1

Selecting the new plug-ins folder.

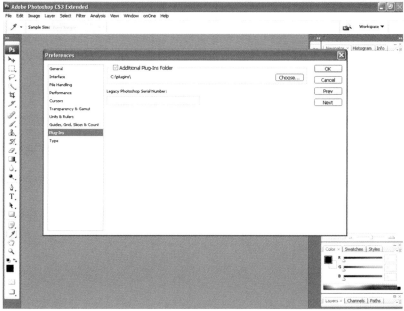

Figure 1-2

Locating the newly created plug-in folder.

LESSON 2:
USING DFINE 2.0

Figure 1-3 shows the Dfine 2.0 window that you access by choosing Filter ▶ Dfine 2.0. Starting at the top left, the View tools provide a Single Image view, a Vertical Split view, and Horizontal Split view. The Horizontal Split and Vertical Split views let you see how noise reduction will affect the image. In most cases, I use the Single Image view and use the Loupe mode to see the effect on my image.

The middle option is Preview, which is active only in Single Image view. You can see the noise reduction results by toggling Preview on or off.

Next are the Preview modes, as shown in Figure 1-4. Preview modes let you see the effects of the noise reduction on individual elements of your image. You can examine each color channel (RGB) or look at the Luminance or Chrominance masks created during the noise-reduction process. However, you can preview Luminance and Chrominance only in Single Image view (more on that in a few paragraphs).

Using the Color Range Noise Reduction method or the Control Point method, you can view Contrast and Color Noise masks. When you view an image in either the Contrast Noise mask or the Color Noise mask modes, the white areas receive the most noise reduction, gray areas receive an intermediate amount of reduction, and the black areas do not receive any reduction in noise (see Figure 1-5).

Next are the Select, Zoom, Pan, and the Background Color Selector tools.

The Select tool lets you interact with the measurement rectangles (as well as control points, but more on that later) that appear, as Figure 1-6 shows. Press the A key to access the Select tool. To switch to it while using one of the other tools, just hold down ⌘ or Ctrl (when you release the key, you switch back).

The Zoom tool does exactly what it says: It zooms. You have three levels of zoom: Fit to Window, 100 percent, and 300 percent. The shortcut key is the Z key. Just as in Photoshop, press ⌘+= or Ctrl+= to zoom in, press ⌘+– or Ctrl+– to zoom out, and press ⌘+0 or Ctrl+0 to go back to Fit in Window.

The Pan tool (the shortcut key is H) lets you reposition the image when you are zoomed in at 100 percent or 300 percent. And just as in Photoshop, holding down the space bar automatically switches to the Pan tool.

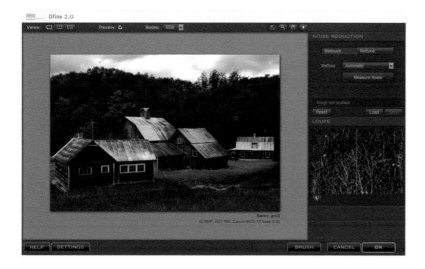

Figure 1-3
I generally use Dfine's Single Image view.

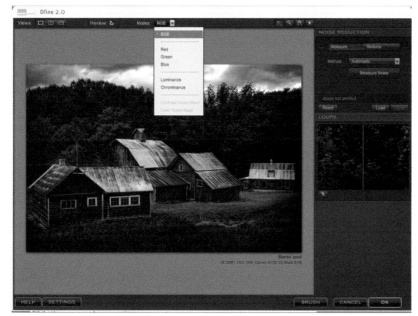

Figure 1-4
Use Preview modes to see how noise reduction will affect your image.

That little light bulb next to the Pan tool is the Background Color Selector. Trust me: Set it to Medium Gray and just leave it. I'll show you how to do that it in the settings section, or if you're dying to find out right now, jump ahead, but come back to this spot.

Next on the tour of the Dfine 2.0 window is the Noise Reduction Engine. The layout is simple. You can use a Measure button or a pop-up menu to select which measuring method you want to use. You can choose either Automatic or Manual mode (see Figure 1-7). I usually use Automatic. It saves time and does a great job finding the noise in an image.

The button below the Method pop-up menu is the Measure Noise button. Depending on which method you choose, you will see different options. Automatic gives you a Measure Noise button. In Manual mode, you will see the Measure Noise button, as well as a Add Measurement Rectangle button that lets you select the areas you want to measure — I find that the auto process usually does it better and faster (see Figure 1-8). Choose Manual mode ▶ Manual Reading if Automatic doesn't find an area to profile.

Note that Automatic won't find an area to profile when the image is comprised of high detail and there is no smooth, texture-less area to read. If this happens, use the Manual mode to draw a box that Manual Reading can use to read noise, and then hit Measure Noise; it will create a profile based on that information. You can also use the Manual mode to draw additional measurement boxes if you think that the Automatic mode missed a different type of noise.

After you've measured the noise, you have three options to reduce the noise detected. The Reduce button in the Noise Reduction Engine has another Method selection pop-up menu where you can choose Whole Image, Color Ranges, and Control Points (see Figure 1-9). Whole Image does just what it implies and will affect the entire image. So any adjustment you make to the Contrast and Color Noise will affect the whole image. In some case this is great, but it isn't the best tool if you want to reduce noise in only one section of the image. The Color Range and Control Point methods are much better, and I'll show you why in the "Fighting Noise" part of the book.

Up next is the Loupe. In the Fit to Window mode, it acts as, well, a loupe showing a close-up image of a selected area as well as a side-by-side comparison of the before and after noise reduction. Consequently, if you zoom in to 100 percent or 300 percent, the Loupe turns into the Navigator. You will see a thumbnail of your image and a red box showing where you are in your image (see Figure 1-10). To lock the Loupe in place, Control+click or right-click it.

Along the bottom of Dfine's window is the Brush button, which brings up the Selective tool in Photoshop, and the Settings button, which brings up the Settings dialog box (see Figure 1-11). As you can see from my configuration, I like things simple. I set my Default Zoom and Preview Mode to Use Last Setting, and I use Medium Gray for my Default Appear-

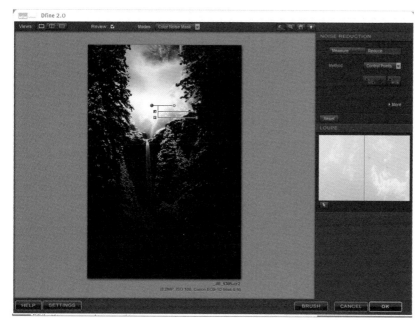

Figure 1-5

With Color Noise mask in Preview mode, you can see exactly what your control point is affecting.

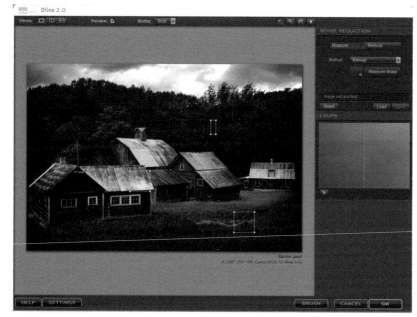

Figure 1-6

You can create measuring rectangles on your image to look for noise.

ance. I use medium gray because it is the best background view for my images. Because I don't use Auto Profile, I set it to Do Nothing and the final option, After clicking OK, I have set to Apply Filter to a Separate Layer. By creating the new layer with the effect, I can easily change it if I don't like how it looks.

You may think I skipped over some buttons in the Noise Reduction Engine — and you're right, I did. I skipped Reset (which clears the profiling done either by the computer or you), Load, and Save. Remember when I said this book was about speed? Well, it is, and I just don't use these buttons. Actually, these buttons are for you die-hard noise fighters who think the computer isn't that smart and you want to build your own Dfine profiles. I think the program does an amazing job auto-profiling the images. I'd rather be out shooting than creating profiles, wouldn't you?

There's a lot to absorb in such a simple window, but from here on the learning curve goes down, and for good reason: The folks at Nik made each program's window almost the same. And, now that I've described how most of the buttons function, I'll focus on the filters and settings for each program and fire through them.

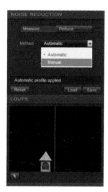

Figure 1-7
You can measure noise Automatically or Manually.

Figure 1-8
By clicking the Add Measurement Rectangle button, you can create areas you want Dfine to examine for noise.

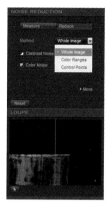

Figure 1-9
You have three options to reduce noise in your image: Whole Image, Color Ranges, or Control Points.

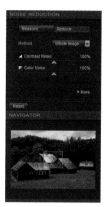

Figure 1-10
When you are zoomed in at 100 percent or 300 percent, use the Navigator window to show where you are on the main image.

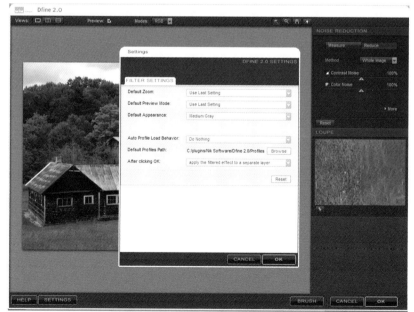

Figure 1-11
The Settings dialog box lets you select how you would like Dfine's filters to perform.

LESSON 3:
USING VIVEZA

The next step in the workflow is Viveza. Without injecting too much of my opinion: This plug-in rocks! Until Viveza, Canon shooters (of whom I am one) had not been able to use control points on .cr2 (Canon Raw Format) images. Canon shooters who have seen a demonstration of Nikon's Capture NX 2 have asked how they too can use U Point technology? Here's your answer, folks: Viveza gives you the same U Point technology control as Capture NX 2, but you don't have to be a Nikon shooter to enjoy it.

Figure 1-12 shows the layout of the Viveza plug-in. Viveza's window is the same as Dfine's, with the exception of the display modes. Viveza, Color Efex Pro, and Silver Efex all offer Single Image, Split Image, and Side-by-Side preview modes.

Now we skip to the really cool part of this plug-in. Pick a point on your image and click the Add Control Point button on the spot you want to enhance (see Figure 1-13). The black dot is your control point with four sliders. The first is the Size slider, which lets you select the area you want to affect. Above the Brightness slider, the Contrast slider, and the Saturation slider is a small triangle. Clicking the triangle opens a host of other sliders: the Red, Blue, and Green color channel sliders, the Hue slider, and one of my favorite sliders, Warmth.

As you may notice in Figure 1-14, when I created my control point, a line appeared in the Control Point List. This list gives you a breakdown of the control points on the image. Each control point line has five basic parts. The check box at the far left of Control Point Details lets you turn the control point on or off. Next is a small color bar, which shows the color you sampled when you set the point. The Control Point Number helps you remember the points. The Size column works by showing you the Size slider value (25 percent in Figure 1-14). And finally, use the Show Selection column check box to show the area your slider is affecting. Figure 1-14 shows the image when the Show Selection column is checked. The white section is the affected area of the control point.

Below the Control Point List is the Details pane. The view you have selected, BCS or All, determines which sliders and values you'll see. At the bottom left of the Details pane are the Color Swatch and eyedropper tools. Selecting the Color Swatch tool opens the color picker, where you can determine the color created by the selected control point. Selecting the eyedropper tool lets you change to a color found inside the image.

The Rendering Method pop-up menu has three options: Basic, Normal, and Advanced. I explain Normal and Advanced later in the book. I don't actually have a need for Basic in my workflow, so I don't use it. However, you should try it out to see if it works with your workflow.

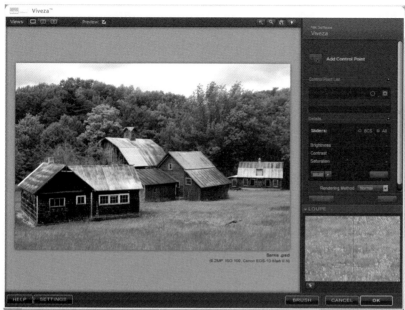

Figure 1-12
Viveza's Control Point List Detail pane.

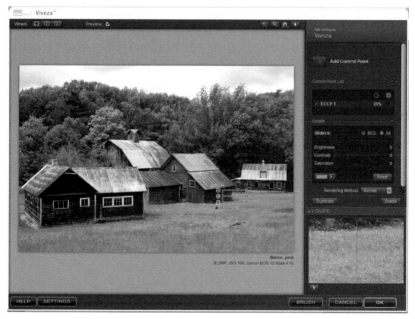

Figure 1-13
You can see your point in the Control Point List, and the details of your point in the Details pane.

Next are the Duplicate and Delete buttons. When you have a control point selected, clicking Duplicate creates a new control point with the exact same settings. Or, you can select the control point you want to duplicate and press ⌘+D or Ctrl+D. You can also duplicate a control point by pressing Opt or Alt and dragging the control point you want to duplicate. Pressing the Delete button says bye-bye to the selected control point.

The Loupe tool works just like it does in Dfine.

There are a couple of important buttons on the bottom of the window.

The Brush button, works in the same way as the Dfine's brush, except instead of brushing away noise you brush on an effect.

Selecting the Settings button displays the Settings dialog box as shown in Figure 1-15. I have Use Last Setting selected for Default Zoom and Preview Mode, and I have my Default Appearance set to Medium Gray. I have my Control Point Size set to 25 percent so that it doesn't automatically take over the whole image, and I have my Default Control Point sliders set to BCS. I use the BCS setting because it eliminates the clutter, and if I want to see the full list, all I have to do is click the little triangle.

Finally, I have After Click OK set to Apply the Filtered Effect to a Separate Layer. So once you click the OK button, the filter is applied to a new layer — and you're finished.

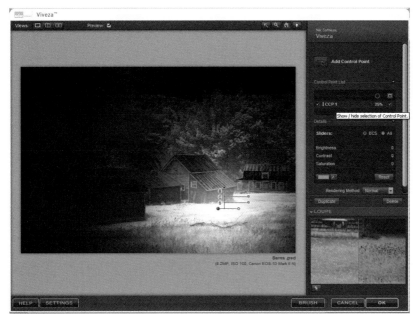

Figure 1-14
Checking the Show Selection box displays the area affected by the control point.

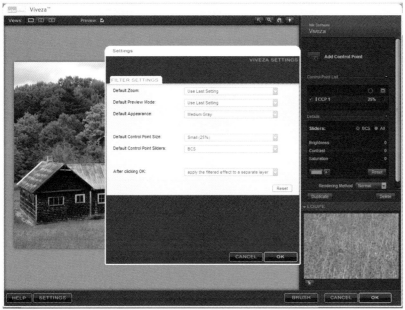

Figure 1-15
Use the Settings dialog box to set your preferences in Viveza.

LESSON 4:
USING COLOR EFEX PRO 3.0

In my opinion, this plug-in is a "wow!"

The Color Efex Pro 3.0 interface is straightforward (see Figure 1-16). The top of the window is the same as Viveza's with the exception of the Filter Display and Preview modes. From the Filter Display mode, you can toggle the Filter List on and off to give you more room for your image. I always leave the Preview mode set to Original Image.

Skipping over the Select, Zoom, and Pan tools, you come to the Filters Controls. Selecting a filter from the Filter List determines which controls are available in the Filter Controls. For instance, in Figure 1-16, I selected the Infrared Film filter, so I get those controls, and since this is one of my favorite filters I talk about it in a later chapter. Below the main controls for your selected filter are the Protect Shadows/Highlights sliders which allow you to prevent losing details in the brightest and darkest areas of your image. And, just below the Shadow/Highlights sliders are the control points.

The control points work differently in Color Efex Pro. Control points in Color Efex Pro 3.0 let you selectively apply the current filter without using a selection or mask. They use U Point technology to determine the object or area automatically, letting you either add or remove the filter's effect anywhere in the image. Depending on how you adjust its Opacity slider, the – control point takes away from the effect on the image. In Figure 1-17, using the Paper Toner filter, I dropped a – control point on the sky to take away the effect of the Paper Toner settings. The + control point has the opposite effect. I generally use the – control point more than the + control point.

Clicking the control point's title, you can expand your options to reveal a few more goodies such as the Apply to Entire Image slider where you can specify how much of the current effect you want to apply to the whole image.

Control Points Details gives information on each control point in you image. Below the Details area are the Reset and Delete buttons. You use the Reset button to return the image back to its original state. The Delete button removes specific control points (see Figure 1-18).

When you have filter settings you use frequently, you can save a lot of time by using the Quick Save slots. After saving your settings, you simply click the slot and your settings are applied automatically. Remember that speed I was talking about?

Next is the Navigator Loupe tool. I don't use the Loupe regularly, so in my workflow, I have it tucked away until I need it.

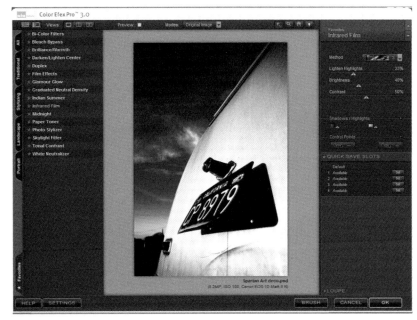

Figure 1-16

The overall layout of Color Efex Pro 3.0 and just some of the many filters you can choose.

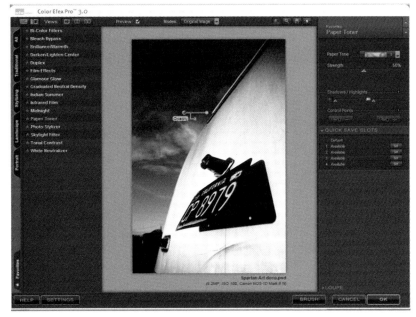

Figure 1-17

Dropping a negative control point takes away the filter's effect from the image.

Once again on the bottom right is the Brush button, which lets you bring up the Selective tool and paint on your effect. Use the Settings button to access the Settings dialog box (see Figure 1-19). This dialog box looks slightly different because it has two tabs. The Filter Settings tab has Default Zoom, Preview, Appearance, and After Clicking OK.

Using the Filter List pane, you can select which Filter Categories you want to appear in the Filter List (see Figure 1-19). Each Tab Category has different filters for different styles, and you can select which filters work best for your style of photography. I usually leave it on default settings. In most cases I use my Favorites and the All tabs. If you want to know how to set your Favorites, either click the star next to the filter name or Control+click or right-click the filter name. To remove a filter, just click the star next to the filter name.

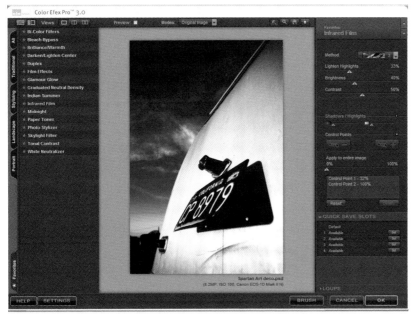

Figure 1-18

The area in the upper-right corner is the Filter Control pane where you can adjust the effects of the filter.

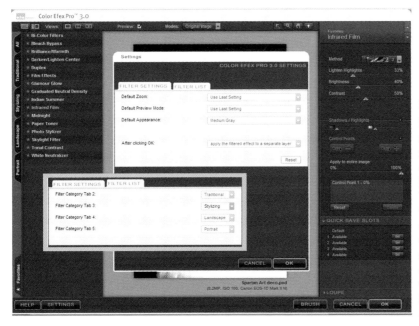

Figure 1-19

Use the Settings dialog box to set your preferences for Color Efex Pro 3.0. The inset shows the Filters List dialog box where you can choose which categories you want in your Favorites tab.

LESSON 5:
USING SILVER EFEX PRO

Silver Efex Pro is the newest member of the Nik product line. But in my opinion, Silver Efex Pro is already the end-all-be-all of black-and-white conversion plug-ins. The versatility built into this plug-in is outstanding.

Let's go through the window layout to get an idea of everything packed into this plug-in. The top of the window is fairly standard (see Figure 1-20). The Filter Display mode in Silver Efex Pro lets you toggle between displaying the Style Browser and the Image Preview or just the Image Preview.

Next are the Select, Zoom, and Pan tools, and on the right side are the Silver Efex Pro Filter Controls. At the top of the window are the main sliders: Brightness, Contrast, and Structure. Brightness and Contrast you know about, but the Structure slider is similar to the Midtone and Shadow sliders from the Tonal Contrast filter in Color Efex Pro — but on black-and-white steroids. The Structure slider lets you control the local contrast, so you can increase or decrease the visibility of fine details and structures. It is amazing what you can accomplish as you'll see in Part V.

Below those sliders is the Add Control Point button. In Silver Efex Pro, when you drop a control point on your image, you have three control sliders: Brightness, Contrast, and Structure. The Protect Shadows/Highlights sliders protect details in the brightest and darkest parts of the image.

The Control Points Details pane has an on/off toggle, the name of the control point, percent of area selected, and the Show Selection column (see Figure 1-21).

At the bottom of the Details pane are Duplicate and Delete buttons. You can duplicate a point by the same methods I talked about in the Viveza section of this part.

Next is the Color Filter set (see Figure 1-22). Remember when we had to use colored filters to achieve a particular look in our black-and-white photography? Well now there is a digital version, and what's even better is that you can simulate stacking of the same filter to make it look like you had two filters with you out in the field without the loss in stops of light. Pretty cool!! You can choose Red, Orange, Yellow, Green, or Blue filters.

Once you select the filter you want to add, click the Details bar below the filter to see the filter's Hue adjustment as well as a Strength slider (here's where you can make it appear as if you stacked two filters doubling the intensity of the effect).

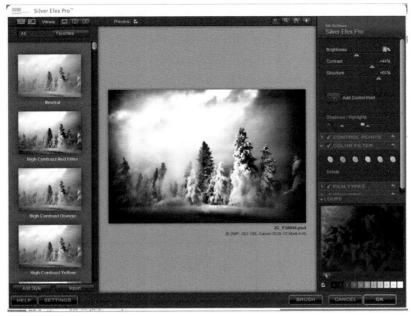

Figure 1-20
The Silver Efex
Pro interface.

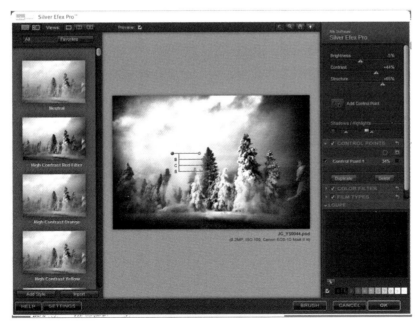

Figure 1-21
Each control
point you add
appears in the
Control Point
Details pane.

Now for probably every black-and-white shooter's dream: the Film Types pane (see Figure 1-23). You can choose from a list of presets for the film type you want, then choose the Grain amounts and the Sensitivity of the film to an array of colors. The Tone Curve pane in Film Types lets you fine-tune the tonal range of your image.

In the Stylizing Details pane, you have control over toning your image through Presets (see Figure 1-24). Vignette lets you re-create vignetting of your lens on to the image. Burning Edges obviously lets you burn the edges. You have full control of the intensity of the burn on each side, as well as its size and blending.

I told you this plug-in was packed, and we're not finished yet. Just below the Stylizing Details pane are the Import/Export buttons. If you have a style that you would like to share, you can export those settings into a .sep file and your friends can import it into Silver Efex Pro. I think sharing settings is a great way to learn. After all, that is how we grow as photographers.

Next is the Loupe. It works just as it always does but there's a little something extra called the Zone System Map (see Figure 1-25). The Zone Map lets you view the tonal relationships in your image, and affects those relationships using either the control points or other enhancement sliders.

Like the other plug-ins, the Brush button and the Settings button are located at the bottom on the window (see Figure 1-26). You click the Setting button to get the Settings menu where you can choose Default Zoom, Preview Mode, and Appearance. You also have the After Clicking OK option, that lets you decide if the effect you just created will be applied to a new layer or to your current layer.

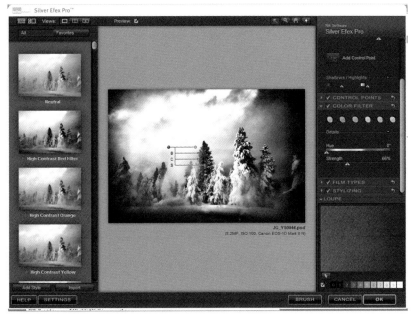

Figure 1-22

Using a digital version of the glass filters gives you even greater control over the final image.

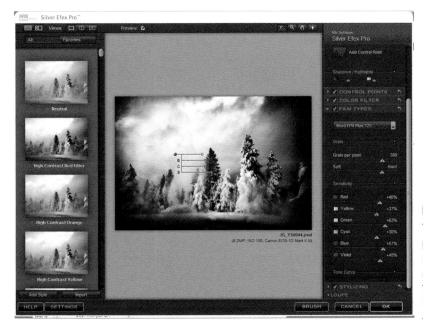

Figure 1-23

The Film Types pane lets you select from an array of types of film and customize the effect.

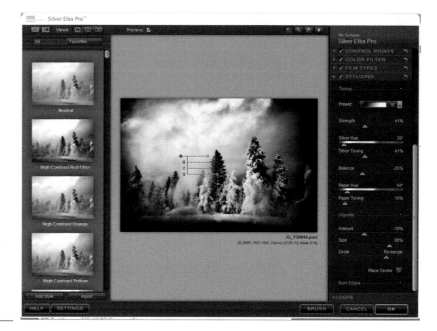

Figure 1-24

The Stylizing Details pane gives you creative control over Toning, Vignette, and Burn Edges.

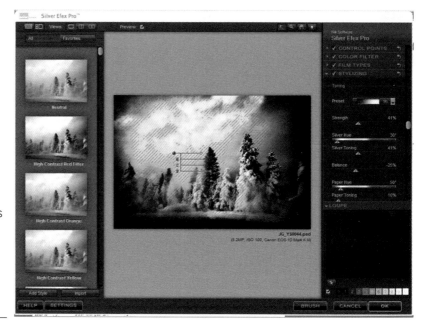

Figure 1-25

The Zone System Map shows you different ranges in the gray scale and where they reside in your image.

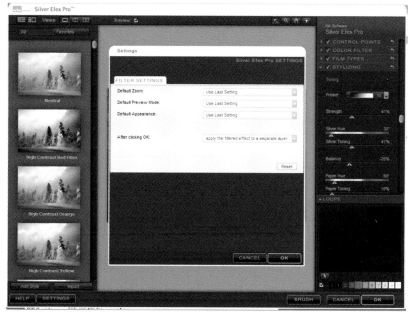

Figure 1-26

The Settings dialog box lets you dictate the look and actions of Silver Efex Pro.

LESSON 6:
USING SHARPENER PRO 2.0

Sharpening your image is the final stop in our workflow. Choosing Filter ▶ Nik Sharpener Pro from Photoshop's Filter menu gives you a list of preset filters ranging from Display to Raw Presharpening (see Figure 1-27). When you first dive into the sharpening process it can be a little daunting, but I'll go through the various layouts and controls so that when it is time to do that final touch on your image, you'll be ready and prepared.

Raw Presharpening

Sometimes even when your camera image is right, the low-pass filter will soften the image. Nik developed the Raw Pre-Sharpener to help get that sharpness back. The layout for the Presharpener is simple and straight forward (see Figure 1-28).

At the top of the window is the Multiple Preview button, which gives you the choice of viewing the whole image, a side-by-side view, or a over/under view. To its right is the Pre-view on/off toggle. Next is the Zoom Ratios tool. By clicking on the + or – button, you zoom in or out on your image. If you mouse over the image, a Move tool will appear so that you can move your image inside the preview window.

On the bottom of the window is the Strength slider, where you can input what percentage strength you want the filter to sharpen. The Save and Load options do exactly what they imply: You can save sets of sliders that you like to use, and load a preset to use on another image. The Cancel and OK buttons play or cancel the effect.

In the small window are the Single Click presets. These presets are used as a form of batch processing. Once you have determined a preset that you like, you can save it as a single-click preset. If you have complicated sharpening techniques that you like to use, setting it up once and saving it as a single-click preset will save you a ton of time.

That wraps up the Raw Pre-Sharpener window. Now let's see what else this program can do.

The Inkjets

The Inkjet presets are all I ever use — and even then it is just the Epson preset. But Nik has developed sharpening filters for all the big players — Canon, HP, Epson, and Lexar — plus a generic filter for the other inkjet printers. All the inkjet filters have the same layout, so I'll go through the layout and you'll be set for all things sharpened. Figure 1-29 shows the Epson preset. This layout is identical for the other inkjet preset.

Above the preview window is the Multiple Preview Mode button, which provides the same preview options as Presharpening. To the right is an eyeball button called Analysis Modes. The Analysis Modes button lets you choose between No Overlay mode (the default mode)

Figure 1-27

Choose Filter ▶ Nik Sharpener Pro for a list of preset options for your sharpening needs.

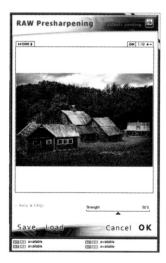

Figure 1-28

You effect the amount of sharpening to your image by adjusting the Strength slider.

Figure 1-29

The interface for the various Inkjet presets is uniform, so using the filter for different printers is a cakewalk.

or one of two unique overlay modes. The two different overlay modes show a visual representation of the sharpening that will be applied to the image.

The first mode displays the interaction between the sharpening and the original image colors and detail. The sharpening effect is represented by red stripes showing the varying levels of opacity. Areas that have stronger red stripes will be sharpened more than areas with transparent red stripes (See Figure 1-30).

The second mode displays only what was sharpened. Sharpening is represented in a range of white to red. The darker the red, the more sharpening that will be applied to the image (see Figure 1-31). This mode works best when using the Advance tab, which I'll talk about in a minute.

Next to the Analysis mode are the Preview on/off toggle and the Zoom tool, which operate the same as I described for the Presharpener.

Now the backbone of this window, the tabs. The Inkjets presets has two tabs. Use the Basic tab to set the five filters for the sharpening effect you want (see Figure 1-32). Use the Width and Height sliders to set the size of the image when you open Sharpener Pro.

Next is the Viewing Distance slider. In my workflow I leave this set to Auto. There are all kinds of recommended distance for viewing photographic works, but the most agreed-upon is the square of the distance of the diagonal (the top left to the bottom right corner) of your print. However, if you like to take control of the distance you have five options: Up to 2', 2' to 5', 4' to 8', 6' to 10', and +10'.

Below the Viewing Distance slider is the Paper Type slider. You can fine-tune the sharpening even further by selecting the type of paper you are printing on. In many cases you will need to go to the paper manufacturer's Web site for this info. This is a vital step in getting a properly sharpened print, since this slider bases the amount of sharpening on the way the paper alters the amount of visible detail.

The Printer Resolution slider lets you sharpen based on the resolution your printer uses. Check your printer specifications to find its optimal printing resolution. If you can't find a setting on your printer, you can move the slider around to find what works best for your printer.

The Advanced tab provides additional controls to set the amount of sharpening to the entire image (see Figure 1-33). You have five sliders that can control the amount of sharpening across a different color range. You can select which color range you want to affect using the eyedropper and selecting the color you want to affect. You can further control the amount of sharpening by moving the slider between 0 percent and 125 percent. If you choose a color and move the slider to 0 percent, the color will not be sharpened.

Figure 1-30
When in the first overlay mode of the Analysis mode, the areas that will be sharpened are represented by red lines of different opacities, each representing the sharpening strength.

Figure 1-31
When in the second overlay mode of the Analysis mode, the red shaded areas represent the areas that will be sharpened; areas in white will not be sharpened.

Figure 1-32
The Basic tab sliders include Size, Viewing Distance, Paper Type, and Printer Resolution.

Conversely, if you pick a color and move the slider past 0 percent, you will sharpen your selected color range by that percentage. One thing to keep in mind, if you don't select a color and leave, the entire image will be affected.

Now let's move to the layouts for continuous-tone printing. The filter sets that share this type of layout are the Photographic & Dye Sub, Fuji Pictography, and the Lab Photographic filter presets. The presets are similar to the Inkjet presets: Image Height and Image Width, Viewing Distance, and Printer Resolution. Missing, however, is the paper type slider (see Figure 1-34).

The Halftone filter preset has an identical layout to the Inkjet preset except that its Printer Resolution slider is displayed in lpi (lines per inch) instead of dpi.

Finally, the Display preset is used for projectors or for posting to the Internet. It has a Strength slider just like Raw Pre-Sharpener, and that is it.

With the exception of Raw Pre-Sharpener, all the layouts for Sharpener Pro include Use Autoscan. This option ensures that the Autoscan process, which analyzes and adapts the sharpening process to achieve optimal image sharpness, is turned on. Clicking the Show More button brings up image details and the single-click user defined presets. Next to the Show More button is the Settings button, where you can set Sharpener to your liking (see Figure 1-35). Next are the Save and Load buttons and finally the Cancel and OK buttons for applying, or not, the sharpening effect.

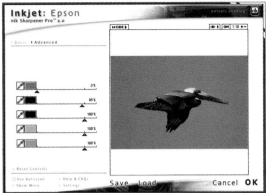

Figure 1-33

By selecting a color range and adjusting the slider, you can affect the amount of sharpness.

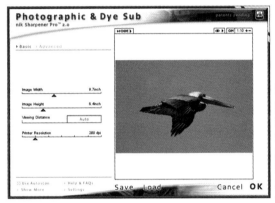

Figure 1-34

For continuous-tone printing, the layout of the presets is similar to the Inkjet presets.

Figure 1-35

You can alter the settings for Sharpener Pro to suit your needs and style of printing.

LESSON 7:
GETTING THE HARDWARE NEEDED

I've talked about all the plug-ins, but not the hardware that you need to use them. Everyone has a preference; some are die-hard Mac users, while others prefer Windows. This fight will go one forever, and Nik's plug-ins work equally well on both platforms, so choose your favorite without worry.

I use a Wacom 12wx Cintiq tablet. It's fast, and all those shortcut keystrokes can be programmed into the tablet so instead of hitting two or three keys, I just click a button on my tablet. It is all about speed, and tablets make things go faster, in my opinion.

Another vital item is memory, both in the forms of RAM and hard drive space. When you open Photoshop, it will take about 1GB of RAM. If you have only 1GB in your computer, you're sunk. About 4GB should handle all your image-editing needs. You'll also need the fastest RAM you can get.

Because I travel so much, my laptop has dual 200GB hard drives. I also take a LaCie 120GB hard drive to back up all my images when I'm on location. There are many types of portable hard drives available, so you'll need to find the one that works for you. Because I travel so much, I wanted one that could take a beating.

At home I have about 6TB of storage on external hard drives. Three house all my images, and the other three are backups. Because memory is getting cheap these days, it's easy to find large-capacity hard drives for under $500.

I have a great filing system for all my images, but that is another book. Do what works best for you so you can find what you want quickly. If a client is on a tight deadline and you can't find an image because you forgot where you put it and you can't deliver, do you think that client will ever call back ? Just some stuff to think about.

PART II

Silencing Noise and Fine-Tuning

The Lessons

All right, you made it through Part I. Now it's time to get down to business. Both Dfine 2.0 and Viveza are incredibly powerful and extremely easy to use, and sometimes these programs are all you need to finish an image. That's because both deal with the issue of image noise, which is the top challenge you'll have with your images.

Images generally have two types of noise. Chrominance noise hides in the neutral colors such as in clouds and looks like little red, green, and blue pixels (aka Christmas lights). The other type of noise is Contrast (aka Luminance). Contrast noise looks like dark and light speckles found in areas like the sky.

Dfine is one of the most user-friendly programs and 90 percent of the time selecting Dfine's Measure Noise is all you need to do and presto the algorithm runs and your image is finished.

Most of the time I use the Whole Image method on images with a vast amount of noise in one color. I took the shot on the next page of some dead trees and a geyser at Yellowstone National Park. Here is how the Whole Image method works with this image.

LESSON 1:
REDUCING AN ENTIRE IMAGE'S NOISE

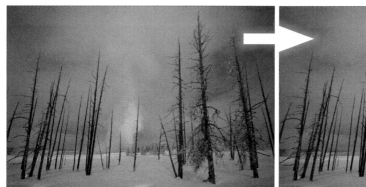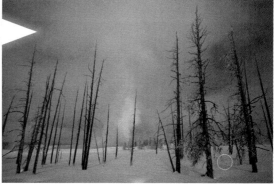

Step 1: Click it and forget it

Using the Whole Image method is basically a matter of clicking Measure Noise and Dfine gives you a layout of the noise in the image. I've zoomed 100 percent to be able to isolate the area where I want to remove the noise (see Figure 2-1). I clicked the Measure Noise button, and agreed with what Dfine considers to be the problem areas. So I headed back up to the top of the Noise Reduction Engine and went to Reduce ◆ Method ◆ Whole Image to bring up the sliders that allow me to finish the noise reduction.

Step 2: Sliding away the noise

Because I selected the Whole Image noise reduction method, I have the ability to adjust the Contrast and Color sliders to suit my needs on the amount of noise I want to remove (see Figure 2-2). For this image, the default settings are all I needed, so I just clicked OK. In this case using the Whole Image reduction method to reduce noise was fine for my tastes. Pretty simple and fast.

I used the Contrast slider to balance noise reduction and detail retention. The higher the value I put on the Contrast slider the more contrast noise reduction is applied. If the image detail became too soft, I could either move the slider to the left or go back to Step 1 and re-profile the image. A higher value on the Color slider works the same way except instead of structure detail being lost, I'd have lost color in my image.

Figure 2-1
Looking at this close-up of the image, I could see the noise in the steam from the geyser.

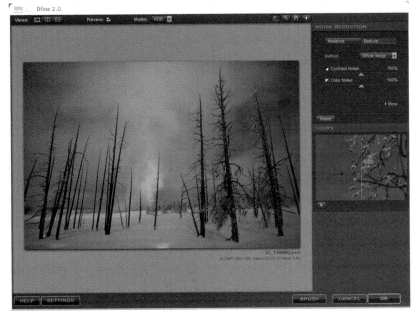

Figure 2-2
I adjusted the noise using the Contrast and Color sliders.

LESSON 2: FIGHTING NOISE WITH COLOR SELECTIONS

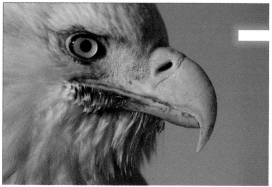

For more complicated noise reduction in Dfine, I used Color Ranges. I took this shot of a bald eagle in Homer, Alaska. It is one of my favorites and one you will see throughout the book.

Step 1: Fighting noise but not losing detail

I always start with the Whole Image method. As you can see in Figure 2-3, the image has lost a slight amount of detail in the feathers on the eagle's head. I'm picky, so I opened the Noise Reduction Engine and chose Reduce ▶ Method ▶ Color Ranges to bring up the Color Ranges selection.

Step 2: Isolating your colors

Choosing Color Ranges opens a selection of color swatches and eyedroppers to sample my image (see Figure 2-4). I knew the noise was in the sky on the right, so I used an eyedropper in the first color set and selected the blue sky. I grabbed the second eyedropper and selected an area of sky with a different shade of blue. I isolated the feathers to avoid them being affected by the noise reduction.

I used the additional eyedroppers in areas where I wanted to keep detail. I used the same method as I used when I selected the sky. But instead of leaving Chrominance and Contrast at 100 percent, I moved each slider down to 0 percent so that the detail on the eagle was not lost. I sampled everything I wanted left untouched (feathers, beak, etc.), clicked OK — and I was finished.

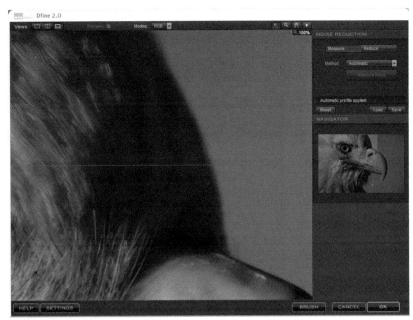

Figure 2-3
Using the Pre-
view mode,
I could examine
the before and
after effects of
the Whole Image
noise reduction.

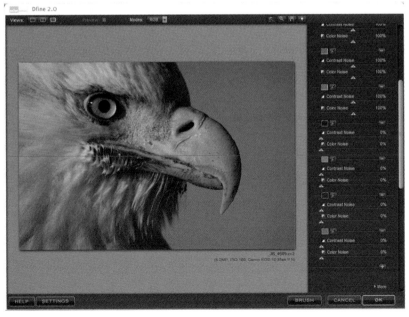

Figure 2-4
By using Color
Ranges, I could
control noise
based on my
color choices.

LESSON 3: PRECISE NOISE REDUCTION WITH CONTROL POINTS

Control points in Dfine are amazing little points that give you precise control of your image using U Point technology. They are by far the fastest way to get rid of noise in a complicated image.

Step 1: Picking your noise the precise way

When I clicked Measure Noise, Dfine isolated my problem areas. I added control points where I wanted to eliminate noise and set the sliders to 100 percent (see Figure 2-5). Because I wanted to reduce noise in another area, I held down the Option or Alt key, and placed the control point where I want to reduce the noise.

Step 2: Precision noise-reduction prevention

I could also prevent noise reduction in my image by duplicating the same procedure as in Step 1, but adjusting the Contrast and Color sliders to 0 percent (see Figure 2-6). I could duplicate this process as many times as I needed. To finish, I clicked OK.

One little tidbit that's important to remember: When you finish an image using Color Range or Control Points and open a new image in Dfine, you need to switch the method back to Whole Image so that, when you select Measure Noise, you will see the effect of the noise reduction.

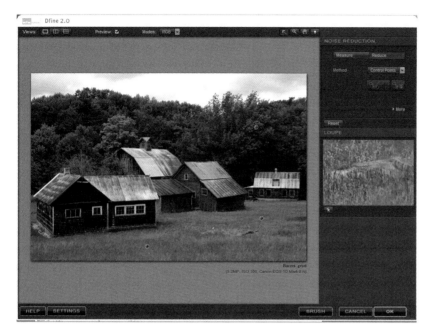

Figure 2-5
I set the control points to reduce or prevent noise.

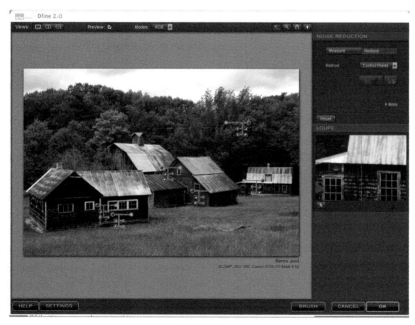

Figure 2-6
I adjusted the Contrast and Color sliders to 0 percent.

LESSON 4:
FINISHING AN IMAGE IN 20 SECONDS

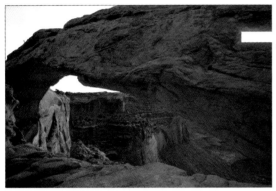 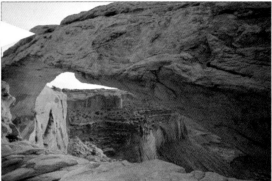

I took this fairly bland image of Mesa Arch in Moab, Utah. If you look closely, you'll see it has issues. First, the sky is pretty bland and has no character. Second, the rocks look flat because the sun is still rising and they have a slight color cast. So get your stopwatch ready.

Step 1: Saving skies that are blown out

The sky needs to be a better shade of blue. I opened Viveza and clicked Add a Control Point and dropped it in the upper-left corner of the sky. I increased the Size slider to cover the upper portion of the sky, dropped the Brightness to –27 percent, and changed the Blue channel to +27 percent. To make the sky in the arch look similar to the upper portion, I duplicated the point in the upper sky, moved it inside the arch, and decreased the Size slider (see Figure 2-8).

Step 2: Using control points to warm an image

Now it's time to deal with the rocks. First, I dropped a control point on the top arch. I increased the Size slider to cover the whole image, and increased the Brightness by 25 percent, the Contrast by 23 percent, and the Warmth to 100 percent. The red rock now has more definition and looks as if sunlight is reflecting onto the rocks.

To give the other rocks the sunshine effect, I duplicated the control point on the arch twice by pressing ⌘+D or Ctrl+D two times. I dropped the first duplicated point on the rocks in the lower left, increased the Brightness to 50 percent and bumped up the Saturation to 19 percent. I dropped the second point under the arch on the left. I changed the Size slider to encompass only that portion of the arch and adjusted the Brightness to 25 percent, the Contrast and Saturation to 15 percent, and the Red channel to 11 percent to give the appearance of the sun hitting the arch (see Figure 2-9). See: Done in 20 seconds.

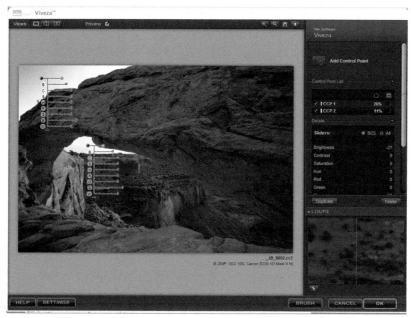

Figure 2-7
Viveza provides amazing flexibility through the use of control points.

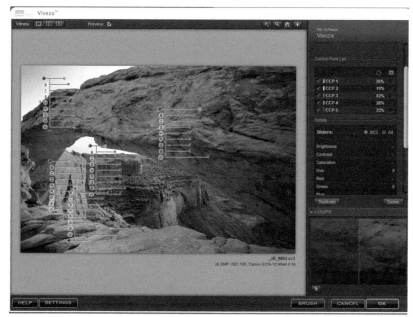

Figure 2-8
I created artificial sunlight to bring definition to a subject.

LESSON 5: QUICKLY ELIMINATE UNWANTED COLOR CAST

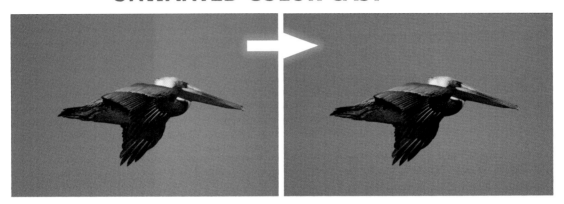

There are multiple ways to remove color cast. You can use a powerful filter inside Color Efex Pro 3.0 or use Photoshop's super curves developed by Taz Tally. Viveza is quick and easy, and it lets me get rid of unwanted color casts while keeping the color casts I want. But I need to mention that this will only work for calibrated monitors. If you view this image on a non-calibrated monitor, it might not look right.

Step 1: Instant color cast removal with a single control point

As you can see, the Florida brown pelican looks good, but the color cast in the sky behind him is horrible. So I want to fix that. (Fair warning: This is going to be really fast.) I opened Viveza and clicked Add a Control Point. I placed the control point just below the pelican's breast (see Figure 2-9). I then increased the Size slider to cover the whole image, and adjusted the Blue channel slider to 36 percent. You should use whatever setting you need to eliminate the color cast in your image. I then clicked OK (Figure 2-10 shows the result). That's it, done! I hope you didn't blink.

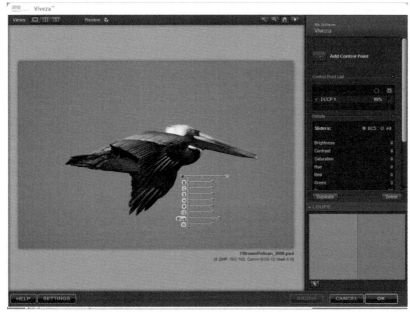

Figure 2-9
By increasing the Size slider, I could adjust the entire image.

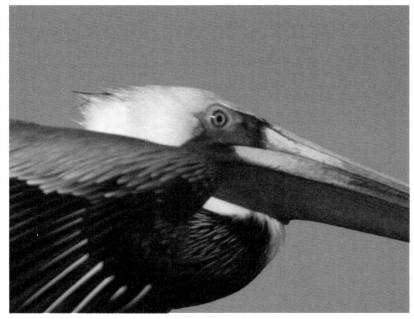

Figure 2-10
I eliminated color cast by adjusting a single control point, as this "after" close-up shows.

LESSON 6: GETTING AN IMAGE READY FOR THE NEXT STEP

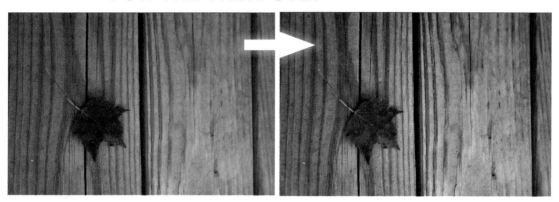

I'm going to show you the preparation I make before transferring an image to Color Efex or Silver Efex. I'll finish this image in the Color Efex Pro and Silver Efex Pro chapters, and yes, this is a slightly sneaky ploy to get you to read the rest of the book. I took the image of a leaf on a bridge in Bar Harbor, Maine.

Step 1: Making the subject stand out

The leaf is fairly flat and has no character. The wood is uniformly lit and has no real character either. So I wanted to fix both. I knew I wanted to use Viveza to enliven the leaf, and put some punch in the wood grain.

I first created a control point on the leaf. I dropped a control point in the center of the leaf and adjusted the Size Selection slider so that it was barely past the edges. From there I increased the Brightness slider to 18 percent, the Contrast slider to 40 percent, and the Saturation slider to 8 percent and breathed new life into that dying leaf (see Figure 2-11).

Step 2: Adding definition with the contrast slider

The leaf was set, but the wood on the bridge needs some help. To get character back into the wood, I dropped a control point on the wood grain, increased the Size slider to cover the whole image, and cranked up the Contrast to 63 percent. That does it. Figure 2-12 shows the location of both points, and the effect so far. You'll see the finished image a little later.

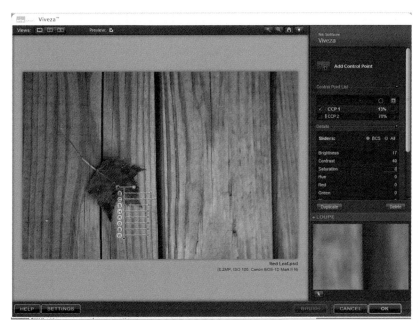

Figure 2-11

A few quick slides inside Viveza let me make the image come to life.

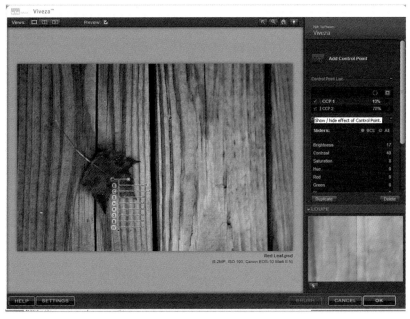

Figure 2-12

By adding a control point and playing with the sliders, I could make the image pop

PART III

Finishing with Color Efex Pro 3.0

One of the great things about Nik Software is its motto: Photography First. This maxim rings true throughout this book. At the point of capture, taking the photograph is the first and foremost creative act in this entire process.

All the Color Efex Pro filters are tools you can use to finish your vision. After all, a camera is not perfect; its film or sensors give you only what it sees. Cameras can't filter out color casts, or see subtle details in good beams coming through the clouds in the sky. It is up to you to finish the creative vision you see at the point of capture. There are many things you can do to project your creative vision, and by far Color Efex Pro 3.0 epitomizes the creative process.

This part focuses on using individual filters and how to apply them during your creative process. I hope you will be inspired by these lessons and expand on my ideas.

No, I'm not going to describe every filter in Color Efex Pro, but you are going to see the majority of them applied in some fashion, so let's dive into their power.

The Lessons

LESSON 1: USING BI-COLORED FILTERS FOR REALISM

Maybe this has happened to you. I went to the Grand Prismatic hot spring in Yellowstone National Park expecting to see the colorful bacteria shown in many photographs. But when I arrived, the colorful bacteria was gone. Unfortunately, I went in the winter when the bacteria were dormant. So, what did I do I about this? I brought to this image what my mind and heart knew should be there.

I took this shot of the Grand Prismatic, and as you can see there is pretty much zero color. However, I knew what the hot spring looked like during the summer months when the bacteria create a brilliant display of colored rings, so I decided to recreate it with Color Efex Pro.

Step 1: Finding which bi-color filter works best

So to add realism to the image, I opened Color Efex Pro 3.0 by going to Filter ▶ Nik Software ▶ Color Efex Pro 3.0. I selected Bi-Color Filters from the filter list, and looked at the default effect (see Figure 3-1). Because I know what the Grand Prismatic looks like in the summer months, I knew that I wanted something that went from orange to a bluish color. I started going through the Color Sets in the top-right corner of the window to see my options. The Nik guys loaded this filter with 20 different bi-color filter presets and even broke them into different categories to help users find the filter that works best. When I saw the cool-to-warm series of color sets, I started there. After all, orange to blue is warm to cool.

Step 2: Creating a realistic effect of bacteria growth

Okay, I know it is a weird name for a step, but hey it's what I actually did. So because I knew I was going to check out the cool to warm presets, I rolled the mouse over each

Figure 3-1

Looking at the default effect of a filter provided a good idea of what to do next.

Figure 3-2

Using the Cool to Warm filter preset #2, I created a realistic look of bacteria growing in the spring.

preset to view the effect it had on my image. When I got to preset #2, I found what I had envisioned: that great rich orange to blue that I had wanted. But it needed some fine-tuning to make it look realistic.

Step 3: Dialing in the image to achieve realistic depth

The "before" image looks fairly flat and two-dimensional. And that doesn't work well if you're trying to create a sense of depth in an image.

When I added the Bi-Color filter, I started to get a sense of depth as you can see in Figure 3-2, but it still didn't provide that final little bit of depth that would make this image pop. So to achieve this artificial depth, I tweaked the sliders on the preset. Because I want the water in an image to depict depth, I fell back on something I had learned in the past: As water gets deeper, it gets darker. So, I adjusted the sliders to achieve that desired effect (see Figure 3-3).

Step 4: Adjusting the sliders to achieve the final look

To get the final effect, I adjusted the sliders as follows: Opacity at 76 percent, Blend at 41 percent, and Vertical Shift at 46 percent. I left the rotation at 180 degrees. These settings are fairly straightforward. Increasing the Opacity gave the image more vibrance and made the colors pop just like during the summer months. By decreasing the Blend slider, I got the transition I needed to add depth to the water. The Vertical Shift slider let me just kiss the top of the image with a darker blue giving the viewer the sense that the water falls off the edge of the print.

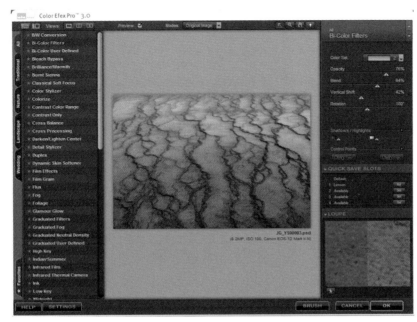

Figure 3-3

Using color to give a sense of depth is a great way to lead the eye through the image.

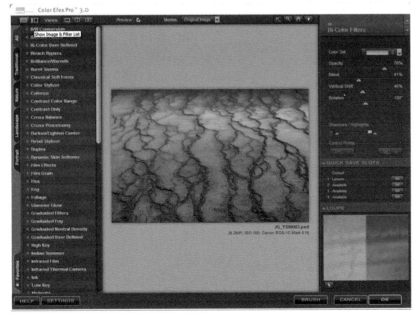

Figure 3-4

A few quick adjustments to the sliders let me achieve a sense of depth, completing the effect.

LESSON 2: CREATING DRAMATIC SUNRISES AND SUNSETS

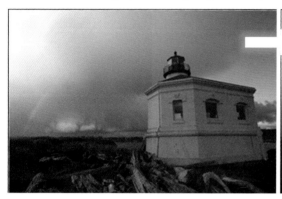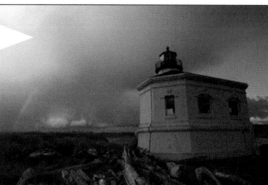

Every once in a while you will come across a scene with clouds in the sky and a nice land-scape in silhouette, but the colors are just not there. That classic brilliant sunset you've seen in other images isn't there. Well, I have a way to get those colors even if the sky won't deliver them.

This shot was taken in Oregon at the Coquille River Lighthouse. I had just finished shoot-ing birds in flight when I saw this old barn in the distance. I shot this toward the end of the day, and even though the light was nice, the photo could use a little extra push. To achieve this effect, I used the Bi-Color User Defined filter because I needed certain colors to achieve the look I wanted. So here's how to make a great sky.

Step 1: Knowing your skies and how to create them

Before you use the Bi-Color filter, check to see what colors already exist in your image and then choose your colors. This image had a slight warmth coming from the sun, and the sky in the background had just a hint of blue. I fired up Color Efex Pro, opened Bi-Color User Defined, and selected shades of orange and blue (see Figure 3-5). The effect actually looked pretty good but it was not what I envisioned for this image. The image needed a few more touches before I could call it finished.

Step 2: Control your effect by looking at the light

Now that I had my colors, I needed the color to flow correctly. Because the warmer parts of the image were to the left and the cooler to the right, I slid the Rotation slider to 266 degrees so the effect went from top-left to bottom-right. This rotation coincided with the way the light was falling in the background and gave the light a more realistic flow.

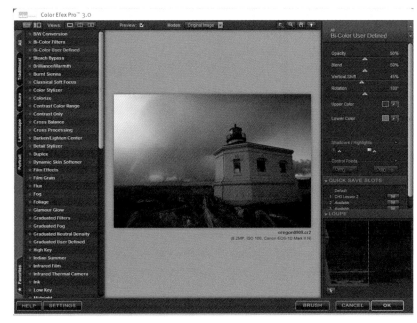

Figure 3-5

Examining the image helped me pick a filter color for a realistic effect.

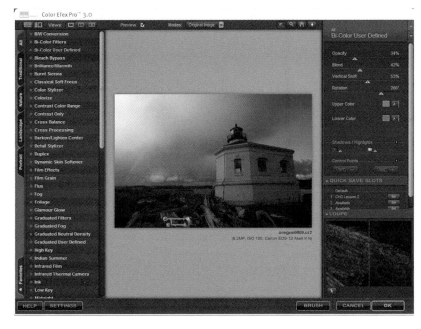

Figure 3-6

Adjusting the sliders let me mimic Light Fall-off and dial in my effect.

Next, I adjusted the Vertical Shift slider to 53 percent to put the midpoint of the effect around the last bit of clouds on the right. I lowered the Blend slider to 42 percent so there would be a good blend of the two colors throughout the image. And finally, I lowered the Opacity to 34 percent to lessen the effect slightly (see Figure 3-6).

Step 3: Fine-tuning the effect with control points

I got the effect I wanted, but the foreground — including the lighthouse — was bugging me. Because I did a global effect, everything in the image was affected. So I went to the handy negative control points.

As you can see in Figure 3-7, I dropped three points in the image, two points in the foreground, one on the lighthouse, and one in the upper-right portion of the sky. I dropped these points to take away some of the effect. If you look closely at the image, you will see that the wood and grass in the front are the same colors as the effect. This is fine except that actual sunlight doesn't work that way. Yes, there will be a color cast from the sky, but it's not uniform.

To give the foreground a more realistic look, I took the three control points and brought the effect up by 50 percent. This change applied the effect, but not as drastically as in the sky.

Step 4: Dropping the sky

I dropped the last negative control point in the sky to bring down the blues. It looked neat, but somehow a neon blue sky seemed a little fake. So I got a more natural feel by dropping the point and then only allowing 50 percent of the effect through. Figure 3-8 shows the effect the negative control points had on the image.

I know the title of this lesson said "sunrises and sunsets," while I've shown you just a sunset. But the method in this lesson works for both.

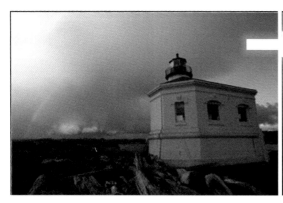 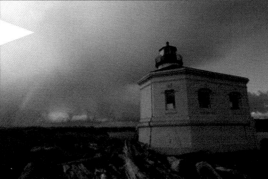

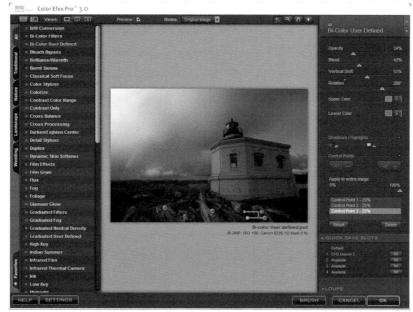

Figure 3-7
I fine-tuned the effect using negative control points.

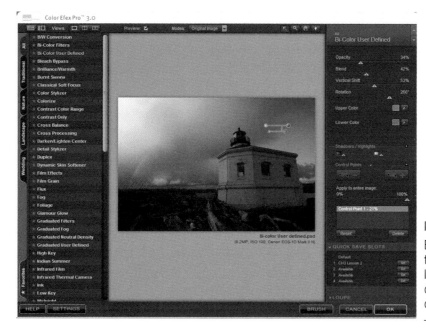

Figure 3-8
By adjusting the Opacity, I could increase or decrease the overall effect.

at 50 percent. The image is almost finished, but when I applied the bleach effect, I lost the detail in my light, so I'll take care of that in the next step.

Step 3: Using negative control points to mask the effect

When I applied the effect globally it diminish the light in the process. To gain my light back, I simply grabbed a negative control point and dropped it on the light adjusting the size slider to encompass just the bulb. This masks the Bleach Bypass effect letting the light come back unaffected. I added another negative control point to the area with the red glow to bring that back as well. However, with this control point, I pushed the Opacity slider to 25 percent to bring back some of the effect, so that the image had continuity (see Figure 3-11). Ordinarily I would be finished but I still don't quite like the way my two negative control point are effecting their surroundings so I clicked Brush to exit out of Color Efex Pro and access the Nik Selective tool.

Step 4: Preserving detail with the Nik selective tool

With the Nik Selective tool open I clicked the Fill button. I want to see the effect on the image and only paint away the effect on the light. When doing precise work like this, I like using my Wacom Cintiq 12wx with the pen tool so I can draw on the image and know exactly what I'm affecting. I made sure the foreground color was set to black, I tapped the B key to bring up my brush, set its Opacity to 50 percent, and begin to paint away the Bleach Bypass effect. Figure 3-12 shows the image with the masking completed by the painting with the Nik Selective tool.

Pretty quick and simple, right? You probably noticed the red light. Well, it's an effect I describe in the next chapter. Just a heads up. There's one other filter I used to finish the image, and I'll let you know which one in a few lessons, don't worry.

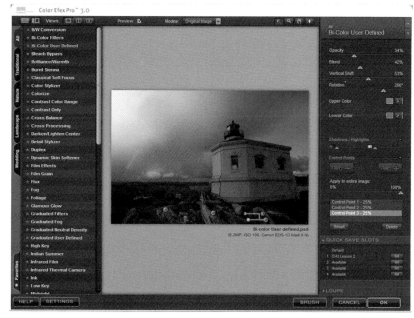

Figure 3-7
I fine-tuned the effect using negative control points.

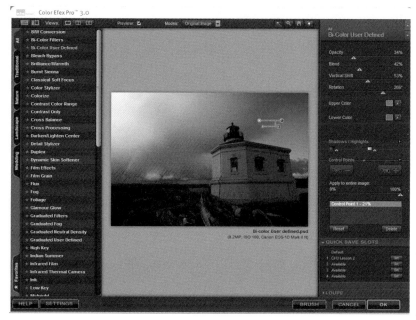

Figure 3-8
By adjusting the Opacity, I could increase or decrease the overall effect.

LESSON 3: MAKING IT OLD WITH BLEACH BYPASS

This is another of my favorite filters that I use for many things. I've included a few solutions for making images look older in this chapter and a few more in the next as well. The Bleach Bypass filter in Color Efex Pro actually mimics a process that was used in the wet darkroom, and it is really fun to use.

For this image, I want to give the boat more character by making it look older and more bleached out. The process is fairly straight forward and didn't take much time, but the effect makes the image pop.

Step 1: Making a subject appear older

As you can see from the before image, there is not much to this boat. I was mostly interested in the light fixture. Unfortunately the boat really doesn't help tell the story of the photograph. The boat is nondescript and needs something extra to help it along. So I went to Bleach Bypass for help. By going to Filter ▶ Nik Software ▶ Color Efex Pro 3.0 and choosing Bleach Bypass, I brought up the filter (see Figure 3-9). The default settings are perfect for the look I wanted to achieve, but me being me, I had to add my own spin.

Step 2: Bleaching to finish

Okay, the image was almost finished just by opening the Bleach Bypass filter, but there are a few more things I want to do before I call the image finished. To make the final adjustments, I brought the Brightness slider down to –40 percent to make all the cracks in the boat even darker which adds more character. Then I dropped the Saturation slider to 20 percent. This accentuates the bleach effect making the hull of the boat whiter, and added to the effect I wanted. I left the Global slider at 15 percent and the Local Contrast slider

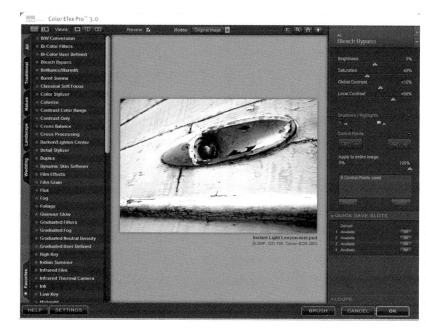

Figure 3-9

Using Bleach Bypass, I could create a sense of old very quickly in an image.

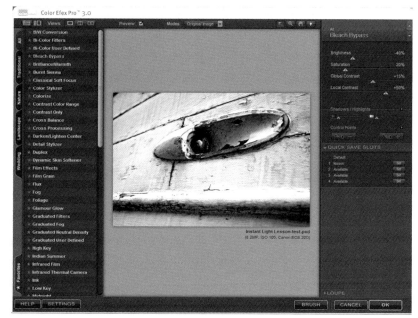

Figure 3-10

By adjusting just the Brightness and Saturation sliders, I could greatly increase the effect of the bleaching on the image.

at 50 percent. The image is almost finished, but when I applied the bleach effect, I lost the detail in my light, so I'll take care of that in the next step.

Step 3: Using negative control points to mask the effect

When I applied the effect globally it diminish the light in the process. To gain my light back, I simply grabbed a negative control point and dropped it on the light adjusting the size slider to encompass just the bulb. This masks the Bleach Bypass effect letting the light come back unaffected. I added another negative control point to the area with the red glow to bring that back as well. However, with this control point, I pushed the Opacity slider to 25 percent to bring back some of the effect, so that the image had continuity (see Figure 3-11). Ordinarily I would be finished but I still don't quite like the way my two negative control point are effecting their surroundings so I clicked Brush to exit out of Color Efex Pro and access the Nik Selective tool.

Step 4: Preserving detail with the Nik selective tool

With the Nik Selective tool open I clicked the Fill button. I want to see the effect on the image and only paint away the effect on the light. When doing precise work like this, I like using my Wacom Cintiq 12wx with the pen tool so I can draw on the image and know exactly what I'm affecting. I made sure the foreground color was set to black, I tapped the B key to bring up my brush, set its Opacity to 50 percent, and begin to paint away the Bleach Bypass effect. Figure 3-12 shows the image with the masking completed by the painting with the Nik Selective tool.

Pretty quick and simple, right? You probably noticed the red light. Well, it's an effect I describe in the next chapter. Just a heads up. There's one other filter I used to finish the image, and I'll let you know which one in a few lessons, don't worry.

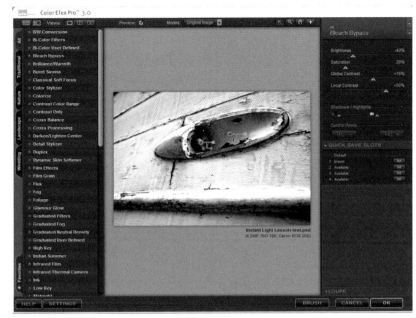

Figure 3-11

By using the negative control point, I masked the Bleach Bypass effect and restored the light back to its original state.

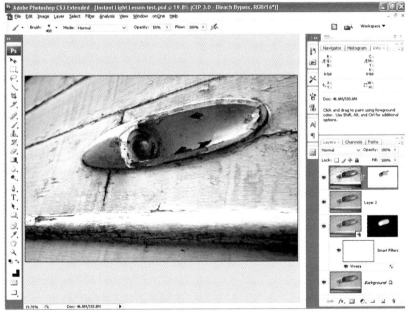

Figure 3-12

By using the Selective tool, I painted away the effect preserving the light and its glow.

LESSON 4:
EDGY LOOK WITH BLEACH BYPASS

Every once in a while I get asked to photograph people. And yes, I photograph people, too. When I photograph people, especially people in rock bands, I get a lot of inspiration to create my own style of effect from different album covers from the past and the present. It is amazing what you can drawn upon in this world for inspiration, so always keep your eyes open.

I took this shot of my good friend Erica, who wanted some shots for a cover. (You'll see more of her later in the book.) She wanted to have an edgy look for some of the shots, and I knew exactly what I needed to do, and that was to use the Bleach Bypass filter in Color Efex Pro. When using this filter to obtain the effect in the "after" image above, make sure you have nice lighting on your subject, because the bright areas are going to become brighter and the dark areas are going to become darker.

Step 1: Bleached for effect
When I first approached this image, I had a certain effect in mind. That look takes time to develop, but once you have it down you can use a quick save slot to apply it easily over and over again in the future — you may never have to fidget with the slider again.

So I kicked things off by going to Filter ▶ Nik Software ▶ Color Efex Pro 3.0 and choosing Bleach Bypass (see Figure 3-13). The default setting looks okay, but the Contrast is making her skin rough. To fix that, my first step is to drop both the Global and Local Contrast sliders to 0 percent. This change starts me in the right direction, but now it is time to fine-tune.

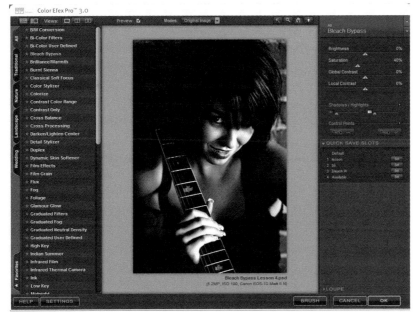

Figure 3-13

A good way to start off when working on portraits is to set the Contrast sliders to 0 percent.

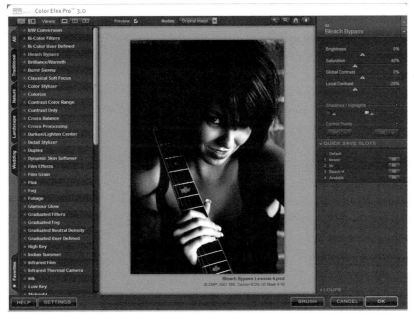

Figure 3-14

Bringing down the Local Contrast slider into the – range smoothed out the skin in this effect.

Step 2: Local contrast and skin smoothing

I noticed that the Local Contrast slider seemed to have the most effect over Erica's skin, so that is where I started. With the slider set at 0 percent, her skin was still fairly rough — not what I wanted for this image. So I took the Local Contrast slider down until the skin had a nice softness. I ended up bringing the slider down to –20 percent. This setting gave her skin that softness I was looking for, but enough grit to still keep the look I was trying to achieve (see Figure 3-14).

Step 3: Global contrast and bringing down the lights

Okay, I have the skin tone set, but I needed to bring a little more darkness to some of the other areas in the image. I headed to the Global Contrast slider. By bringing the slider back to the positive range, I started to bring down the image in the darker regions. I did this to bring more focus to the lighter areas of the image. I took the slider up to 40 percent, which gave me the look I'm going for. Too much more would have made the image too dark. Depending on your image the settings will vary, so make sure you play with the settings a little to get the effect you want (see Figure 3-15).

Step 4: Color pumping by tweaking the saturation slider

Almost finished. But I had left the Saturation slider at the default 40 percent during the entire process. I did this because of the global adjustment I had been making. The Global Contrast slider can lighten and darken the image and throw off the Saturation if you change it at the beginning of the process, so that is why I always leave the Saturation adjustment until one of the last steps. To finish off the image, I brought the Saturation slider up to 50 percent, and that is all she wrote (see Figure 3-16).

By the way, if you want to take your image to a gray-scale inside the Bleach Bypass filter, you can drop the Saturation down to 0 percent, which it makes for a cool effect.

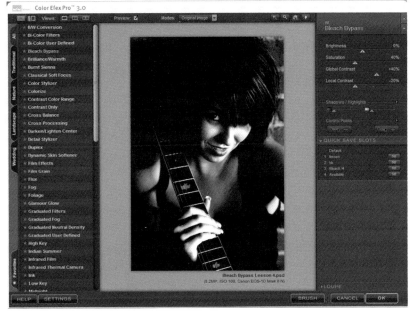

Figure 3-15

Using Global Contrast let me increase or decrease the mood of the image by making it lighter or darker.

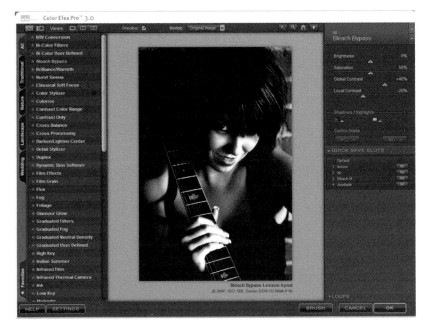

Figure 3-16

By pumping up Saturation, I gave the image a whole new look.

LESSON 5: USING THE B/W FILTER

You're probably wondering why I'm talking about the black-and-white filter in the Color Efex Pro chapter when I have a whole chapter on the new Silver Efex Pro. Well, because it's a filter in Color Efex Pro, and while Silver Efex Pro is the new kid on the block and is a drop-dead amazing tool, learning about the original is a good thing. I'll walk you through one of my favorite ways to convert a digital image from color to black-and-white. It is going to involve some tweaking of dials, and not every image will lend itself to this exact method. However, you can adapt my method to suit your needs.

Step 1: Deciding which black-and-white method is the right one

Okay, here is a shot of a lighthouse in Massachusetts. It is a good-looking lighthouse in color, but I wanted to convert it to black-and-white to see how it will look that way.

First, I selected Filter ▶ Nik Software ▶ Color Efex Pro 3.0. From the Color Efex Pro window, I chose B/W Conversion. When the window first opens in B/W conversion, the default method is B/W conversion. I have used this method in the past and it works, but I prefer the Dynamic Contrast method because it brings an extra punch to the image. Figure 3-17 shows you the Dynamic Contrast default setting. As you can see, the image was really dark, but I fixed that with just a few movements of the slider.

Step 2: Using the sliders to create a black-and-white image

Now I needed to start pulling the image back from the darkness. I left the Color and Strength sliders at their default settings. My first step involved the Brightness slider, and I cranked it up to 90 percent to be able to see the entire image. Then I lowered the Contrast Enhancer slider to 10 percent because at a higher level I would lose the far ends of my highlights and shadows and I wouldn't see any detail. Figure 3-18 shows you what the

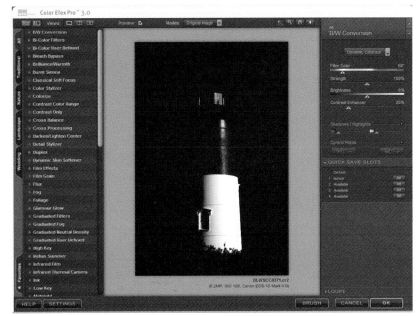

Figure 3-17

The B/W Conversion filter in the Dynamic Contrast method gave me a dark image at first, but it will end up great.

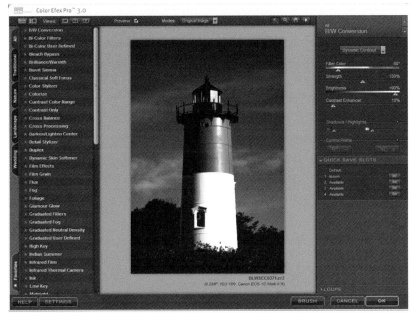

Figure 3-18

By increasing the Brightness slider and decreasing the Contrast Enhance slider, I brought my image back from being completely unviewable.

image looked like at this point in the conversion process. When you look at this image, you can see that I still had some loss in the shadows and highlights. With these adjustments done, I was ready for the next step in the process.

Step 3: Saving the shadows and highlights in an image

I had some detail loss in the far ends of my tonal range. I wanted those back, so I went to the Shadow/Highlight sliders. This step is quick and dirty but it was essential to get the detail back. I worked with the Shadows slider first; putting the slider at 40 percent recovered the shadows. I next used the Highlight slider to recover some of the blown-out details. I ended up moving the slider all the way to 100 percent (see Figure 3-19). From there I clicked OK, and I was finished with the image — maybe.

Step 4: Doubling up for effect

At this point I could call the image good and click Save, but one thing still bothered me: the sky. I wanted it to be darker. I had a few ways to accomplish this. One neat thing about having layers in Photoshop is that you can create a layer like I just did with the B/W filter, go back to Color Efex Pro, and basically double the effect you just created. I use this process every once in a while and it pays off.

So with the black-and-white layer I just created, I went back to Color Efex Pro to the B/W Conversion filter. Because I had just used Color Efex Pro, it remembered all the settings I had, so the effect was doubled.

Remember: I wanted the sky to be darker, so I moved the Filter Color all the way to the far left, and decreased the Brightness slider to 65 percent. Sure, the sky became dark to where I wanted it to be, but everything else became dark as well. Not so good, so I grabbed a negative control point and dropped it in the upper portion of the lighthouse, decreasing the Size slider so that the selection is just inside the lines of the lighthouse. I then did the same thing for the lower portion of the lighthouse. Figure 3-20 shows the result.

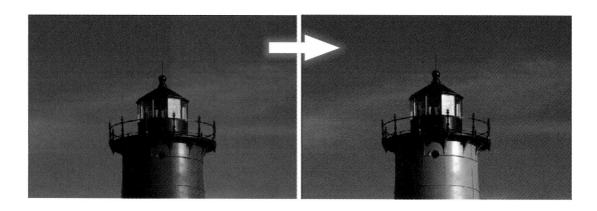

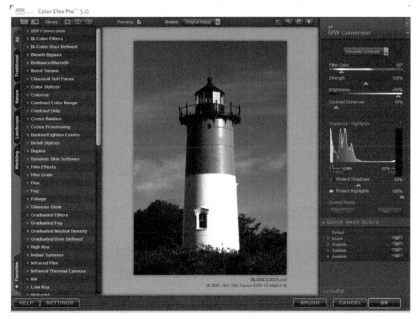

Figure 3-19

By adjusting the Shadow/ Highlight sliders, I recovered some of my lost detail in the image.

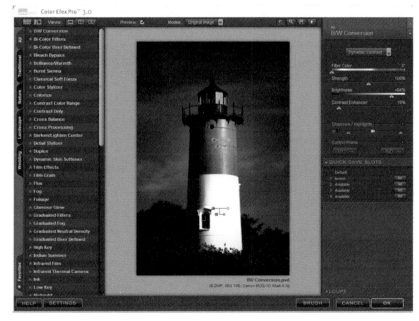

Figure 3-20

By using negative control points, I could dictate how I wanted the final image to look.

LESSON 6:
SPOT COLOR AND PORTRAITS

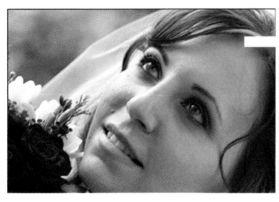 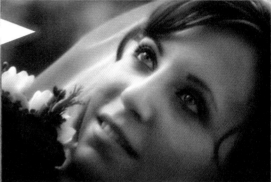

Spot color is a popular look in portraits and landscape photography. Color Efex Pro 3.0's B/W Conversion is so fast that the conversion can be done in less than 10 seconds if you're quick. This effect is fast because of the two handy 0 percent and 100 percent Control Point buttons that I call the negative and positive control points.

Step 1: Creating the desired black-and-white conversion

I'm using a portrait of my friend Sam. In Color Efex Pro 3.0, I selected the B/W Conversion filter. I chose the Tonal Enhancer from the pop-up palette (below the Brightness slider) and picked Method 2. I moved the Filter Color to 130 degrees in the green range. (That's because I find that the green color range makes good skin tones in black-and-white conversion.) I lowered the Strength slider to 85 percent to darken the image a bit and set Brightness to 0 percent (see Figure 3-21).

Step 2: Spot color in three clicks with control points

You can't just drop a negative control point on the spot where you want the color to come through and be done. That's mostly because the control point will try to blend into the rest of the image, and you end up with color where you don't want it.

Here's how to fix that: First, I clicked the negative control point button and went to the flowers where I want to have color. I adjusted the Size slider to be slightly smaller than the total flower area to compensate for the blending that will occur between the control point and the rest of the image. After dropping the negative control point, I clicked the positive control point and dropped it near the outer edge of the negative control point's size selection area to contain the color bleed. Figure 3-22 shows where the points were positioned.

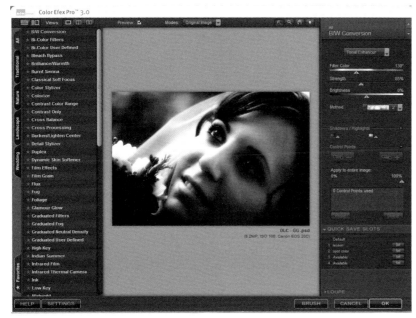

Figure 3-21
I set the B/W
Conversion for
spot color.

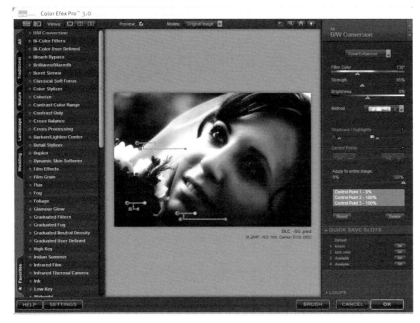

Figure 3-22
By using nega-
tive and positive
control points,
I could create
a spot color
rapidly.

LESSON 7:
SPOT COLOR AND LANDSCAPES

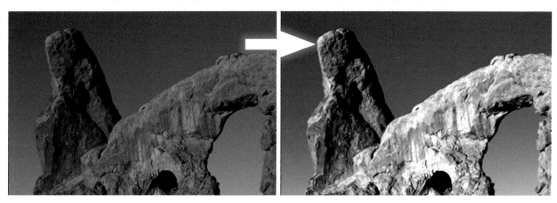

Adding spot color to a landscape is similar to adding color to a portrait, but depending on the image you may need to add more or less positive control points to get the desired effect.

This shot was taken at Arches National Park in Utah. It's a great color shot, but I wanted to have some fun with it. I was inspired by my good friend and mentor Moose Peterson. He does black-and-white with color, and I enjoy how it looks.

Step 1: Creating the desired black-and-white conversion
I chose Filter ▶ Nik Software ▶ Color Efex Pro 3.0. When the window opened, I chose the B/W Conversion filter, and stayed with the B/W conversion option. I moved the Filter Color to the yellow range (60 degrees to be exact). I increased the Strength slider to 200 percent to lighten the rock face just a bit. After I adjusted the Strength slider, I made sure the Brightness slider was set to 38 percent (see Figure 3-23).

Step 2: Spot color in four clicks with control points
First, I wanted to create my spot color and then isolate it with other control points. I grabbed a negative control point and dropped it in the middle of the sky. I don't like the complete blue sky coming through, so I brought the Opacity slider back to 35 percent. I then dropped three positive control points on the rock face to counteract the blue sky. I left all these sliders at 100 percent opacity. Figure 3-24 shows the control point orientation. The overall effect is finished, and that does it for spot color and landscapes.

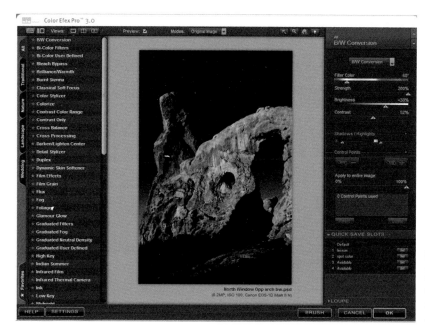

Figure 3-23
I set the B/W conversion for spot color.

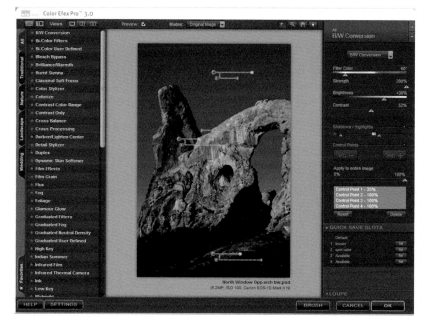

Figure 3-24
By using negative and positive control points, I could rapidly create a spot color.

LESSON 8:
ANTIQUING WITH COLOR STYLIZER

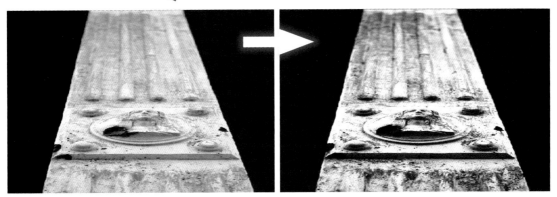

Sometimes I want an antique feel to some of the photos I take. I can achieve different looks with Paper Toner, Duplex, or Old Photo filters. But when I want that "antique" look, I use Color Stylizer because I can pick the color and control the Contrast and Saturation.

I took this shot in Holly Springs, Mississippi, at a grocery store that had been around since 1890ish. I don't know why it had an Egyptian pharaoh's head on the pillars, but it did, so I photographed it. The light was flat, and there's not much detail in the shot, plus the pillar was a funky shade of white that didn't look good. So here's how I made it look antique.

Step 1: Picking an antique color
The Color Stylizer has only a few options. It has a color picker for choosing color, an eye-dropper for picking a color from the image, and Contrast and Saturation sliders. When I make an antique photo, I first pick the color I think works best. The color changes depending on the subject, so experiment when you work on your image. Personally, when I have a subject that is all white, I choose a dark brown color from the Color Picker. If you want an exact number, on this image I used #211606 (see Figure 3-25).

Step 2: Antiquing with the contrast and saturation sliders
The last part of process when I antique an image is to first punch up the Contrast slider. Doing this adds what I can best describe as "wear and tear" on the subject. For this image, I took the Contrast slider up to 68 percent to give the pillar a worn feel. Once I had the Contrast where I wanted it, I moved to the Saturation slider. This slider made a very subtle change to the image, and I do mean subtle. In most cases I leave it at 35 percent and call it good (see Figure 3-26). Here, I was happy with how it looked, so I clicked OK.

Figure 3-25

By using the Color Picker in Color Stylizer, I chose the color to apply to my image

Figure 3-26

The Contrast slider added the aged effect to the subject while the Saturation slider added subtle changes to the color for that finished look.

LESSON 9:
FOCUS WITH DARKEN/LIGHTEN CENTER

Have you ever noticed that sometimes your eye is drawn to a certain spot in an image? Do you notice that in most cases it's the lightest spot in the image? Many times I like to steer the viewer's eye to the subject. Whether you do this in camera at point of capture or in postproduction, doing so is important because you want tell the viewer to "look here."

I use this filter almost everyday in my postproduction work because it is easy to use, and incredibly effective. It is basically a controllable vignette filter that lets me control the light and dark regions of the image, steering the eye to the brightest point. I can almost guarantee that if you didn't use this filter before, you will now. Remember the Bleach Bypass lesson earlier in this part? Well this is the filter I used to focus on the light on the boat hull.

Step 1: Drawing the eye to the light
I chose Filter ▶ Nik Software ▶ Color Efex Pro 3.0. The Darken/Lighten Center filter is equipped with either a round or oblong light, three sliders (Center Luminosity, Border Luminosity, and Center Size), and a Place Center button. As always, I set the Border Luminosity down –100 percent to see the edges. I then clicked the Place Center button and dropped that point in the center of the small tree (see Figure 3-27). With the center point set, I moved the Border Luminosity back to –88 percent to ease off the darkened edges.

Step 2: Focusing the light with the Center Size slider
By adjusting the Center Size slider, I could tighten or expand the focus of the light. Because I wanted to steer the viewer to the small tree, I increased the Size slider to 70 percent to lighten the area around the tree, but keep the outer edges of the background darkened (see Figure 3-28). I clicked OK and was finished.

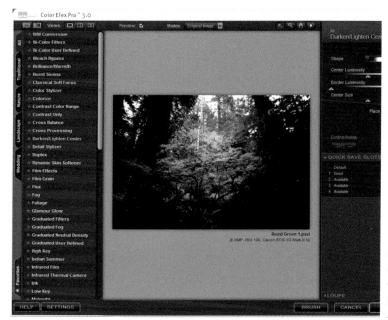

Figure 3-27

By darkening Border Luminosity to –100 percent, it was easier to place the center of the effect with the Place Center button.

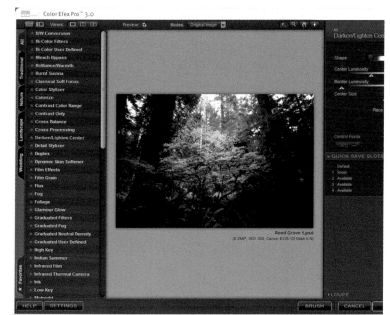

Figure 3-28

By adjusting the Center Size slider, I could determine how much of the area around the center point is lightened or darkened.

LESSON 10:
THE ARTIFICIAL SNOOT

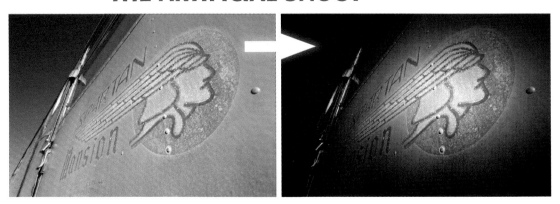

So what in the world is a snoot? Well, it looks like a tube that extends off the flash that is used as a light shaping tool to create a tighter beam of light. It has many applications, one being to focus the light coming from the flash onto a spot in your image. In most cases, that spot is being blasted with the funneled light. I usually carry a snoot in my camera bag, and it is a great tool to use.

Not too long ago I was up in a "ghost town" in Cisco, Utah with the Digital Landscape Workshop Series having a blast. I found this old trailer with a great but fading logo, that I photographed every which way I could. I wanted to hit it with a flash while underexposing the background (a trick I learned from Joe McNally) to darken the background but make the logo stand out. I wanted to put my snoot on the flash, but I forgot to pack it. So I came up with a method of creating an artificial snoot inside Color Efex Pro using the Darken/Lighten Center filter. Let me show you what I did.

Step 1: The recipe for the snoot
This step is slightly different from other steps because I'm going to show you how I created a Quick Save so you never have to remember the sliders settings needed for an artificial snoot. First, I chose Filter ▶ Nik Software ▶ Color Efex Pro 3.0 and then chose Darken/Lighten Center. I set the sliders as follows: Shape to Oblong, Center Luminosity to 40 percent, Border Luminosity to –100 percent, and Center Size to 0 percent.

After I set the filter controls, the next step was to save them in a Quick Save slot and label it Snoot. Now whenever I need the Snoot settings, it's as easy as clicking Quick Save (see Figure 3-29).

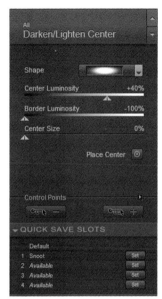

Figure 3-29
I used the filter settings shown here to create an artificial snoot.

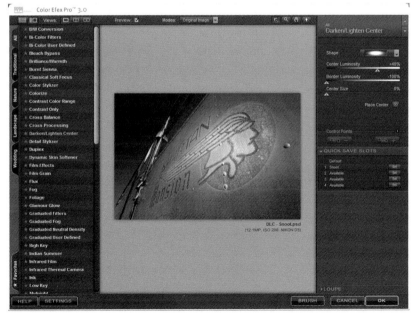

Figure 3-30
I established a center point to start the effect.

Step 2: Finding your center with the Place Center button

As noted in Step 1, I put the Border Luminosity slider down to –100 percent. I used this setting because I could then see exactly the area the filter is affecting in the image. Once I knew where the border edges were, I clicked the Place Center button. I then moused over my image, and the cursor turned into cross-hairs. I put the cross-hairs over the area I wanted to be the center of the effect (in this case the helmet), and clicked the mouse to set the point. Figure 3-30 shows the effect with the center point placed. This was the first step of the snoot process, and from here it got a lot easier.

Step 3: The second run, another Darken/Lighten Center operation

If you have played with the Color Efex Pro filters at all, you know that if you apply a filter to a layer, and then go back into Color Efex Pro to the same filter, you'll see the layer amplified with the same filter. Basically you'll get double the effect. This is how I approached the process to further isolate my subject. Applying the filter the first time wasn't enough to achieve that almost-spotlight effect that a snoot provides, and that's why I went back in to Color Efex Pro (see Figure 3-31).

Step 4: Fine-tuning your lighting with the Center Size slider

Now this is where it gets really easy. The effect is almost right, but it seemed too heavy-handed, so I decided to fine-tune the light and get a more realistic light falloff. To make the light appear to fall off more naturally, I grabbed the Center Size slider and increased it to 35 percent. The reason this worked so well is because the Center Luminosity was still set at 40 percent — that setting never changed. But I had the center at 0 percent, and by opening the center, it lightened the inner core of the effect and gave me the more natural light that I wanted (see Figure 3-32). I clicked OK to finish the effect. The result: I got a nice snoot-like appearance without even having a snoot.

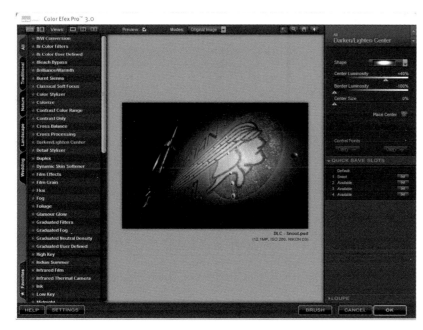

Figure 3-31
By going back into Color Efex Pro, I doubled the effect of the Darken/Lighten Center filter.

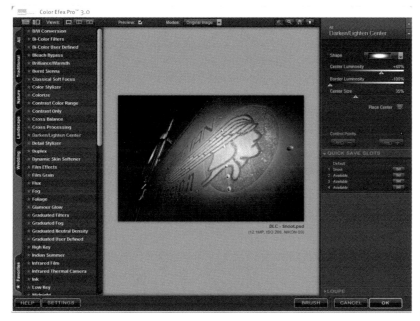

Figure 3-32
Increasing the Center Size slider to 35 percent let me softened the effect, thereby creating a more natural light falloff.

LESSON 11:
DUPLEX AND PORTRAITS

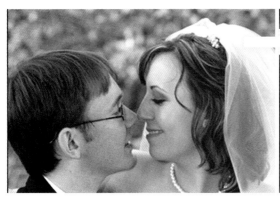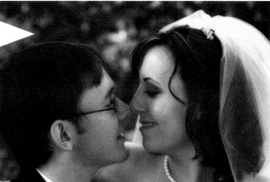

The Duplex filter has some neat uses. By itself, it is great for making duotone images or creating an old-time feel, much like the Color Stylizer filter. With this filter, I have the flexibility to use it on portraits or use it on still life to make some interesting images.

When I got ready to use the Duplex filter for this image, I started with the default settings because the default has a great effect right from the get-go.

This shot was taken at my friends Sam and Nick's wedding. I took the shot when they were having a cute moment after the ceremony. As you can see, the original image was fairly cool in color and kind of flat, so I decided to drop it into Color Efex Pro to see what I could do to make this image really pop.

Step 1: Defaulting in duplex
To get the ball rolling, I chose Filter ▶ Nik Software ▶ Color Efex Pro 3.0 and then chose the Duplex filter. As you can see in Figure 3-33, the default settings improved the image by giving it a nice sepia tone. One thing nice about the Duplex filter is that you have control over the color tone applied as well as the Strength, Diffusion, Saturation, and Contrast of the effect.

When I use this filter on portraits, I usually stay in the warmer color range. From there it is just a matter of adjusting the slider to suit the scene. When I play around with the color picker or any of the other sliders, I can always quickly get back to the default settings by clicking the Default option found in the Quick Save slots pane.

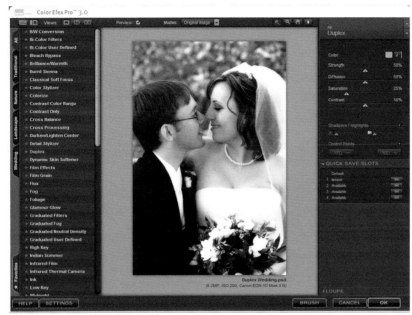

Figure 3-33
Seeing how the default filter will affect your image is a good guide to use for finishing your image.

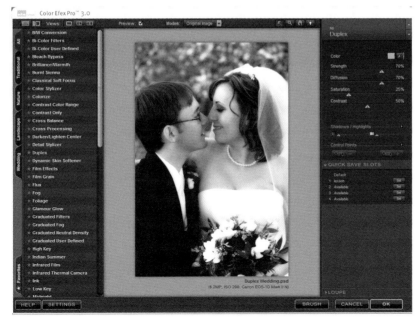

Figure 3-34
I used the Diffusion slider to add some strength and softness to the color.

Step 2: Setting a mood by setting the sliders

When you are finishing an image, really look at it. Ask yourself: What story does it tell? What do you feel when you look at it? My first impression when I sat down to work on this image was that it was a warm and tender moment between the wonderful couple. So I decided to increase the Strength slider to 70 percent, which increased the warmth of the color tone. Next, I thought that it needed some softness, so I changed the Diffusion slider to 70 percent (see Figure 3-34).

A quick note on the Diffusion slider. I find that moving the Diffusion slider beyond 70 percent makes the image appear muddy, so keep that in mind when you're working on images.

Okay, that is it for the mood side of finishing the image. Now it is time to look at some more technical stuff.

Step 3: Getting a great duotone effect with Saturation and Contrast sliders

To finish this image, there were still a few things I wanted to do.

First, I wanted to get a little more color back into the image. The default is set at 25 percent, so I brought it up to 30 percent. That added a bit more color but not so much that I lost the nice effect.

Next, I wanted to punch up the image a bit to get a little more detail, so I took the Contrast slider up to 70 percent (see Figure 3-35). The image was almost finished.

Step 4: Saving the shadows with the Shadow Protection slider

I liked the image at this point, but because I punched up the image with the Contrast slider, I'd lost detail in Nick's jacket. To recover some of the detail, I went to the Shadow Protection slider and brought it up to 10 percent. It was just enough to get back details without affecting other shadowed areas in the image (see Figure 3-36). As a final detail, I added a Darken/Lighten Center filter to finish the image.

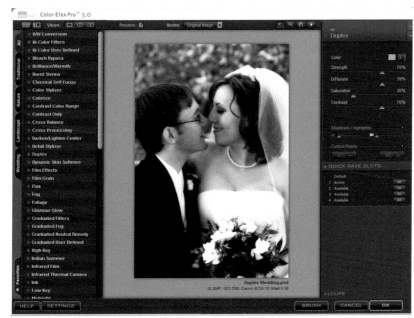

Figure 3-35

By bumping up the Saturation and Contrast sliders, I recovered some color and brought in more detail.

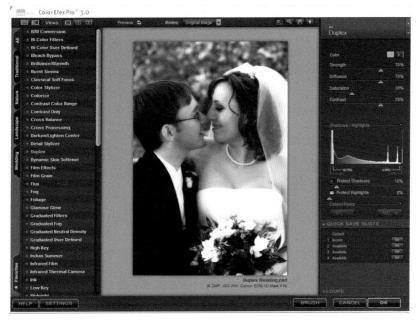

Figure 3-36

The image had lost detail in the shadows, so I used the Shadow Protection slider to bring it back.

LESSON 12: THE GRADUATED NEUTRAL DENSITY FILTER

The Graduated Neutral Density filter can be found in my camera bag except when I forget to pack it for a trip. The great thing about the Graduated ND filter is that you can use it to compress the amount of light in a scene. This filter is important because a camera can only see five stops of light. Anything beyond 5.1 is blown out, and you lose the info.

When you have an image that is getting close to that 5.1 number but you don't have a filter with you, sometimes you can use the Graduated ND in Color Efex Pro 3.0 to bring it back. This shot has a fairly plain sky, and I'll show you how I used the Graduated ND to bring back the sky. I took this shot in Bass Harbor, Maine, off the Coast Guard Head Light. A head light is basically a stationary red light.

Step 1: Starting from the top

I opened the Graduated ND by choosing Filter ▶ Nik Software ▶ Color Efex Pro 3.0 and then choosing the Graduated ND filter. The first thing I did was to decrease the Upper Tonality slider to –100 percent. This let me see the ND effect on the top of the image (see Figure 3-37). The effect of the ND was really strong, so the rotation needed to be adjusted to better reflect the way the light fell. So that was my next step.

Step 2: Adjusting the rotation and vertical shift

The Graduate ND filter has a Rotation and Vertical Shift slider that lets you orient the ND filter. This is the equivalent of having an ND filter on the front of the camera and sliding it up and down or rotating it clockwise or counter-clockwise.

Because I went to work on the sky first, I adjusted the Rotation slider to place the darkest part of the Upper Tonality to the upper-left corner and moved the Rotation slider to 150

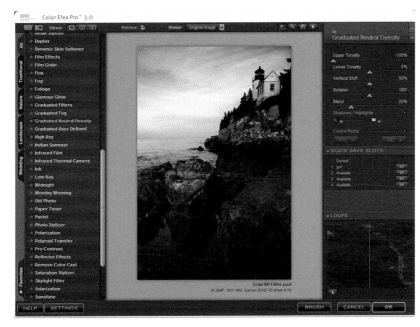

Figure 3-37

By decreasing the Upper Tonality slider to −100 percent, I can see the effect of the ND filter and start adjusting the filter to finish the image.

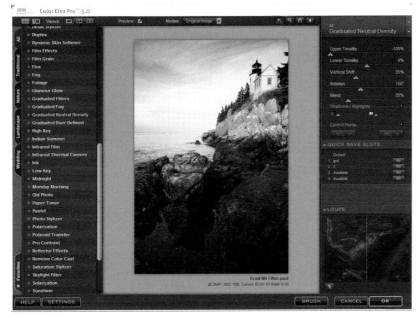

Figure 3-38

The Vertical Shift and Rotation sliders give you control of the ND's placement on the image.

degrees. Once I had the rotation set, I needed to adjust the Vertical Shift slider so that the ND effect was mostly covering the sky. I wanted the effect to start tapering off along the edge between the sky and the rock cliffs. Taking the slider to 35 percent did this, and set me up for the next step (see Figure 3-38).

Step 3: Blending, soft or hard edge

The Blending slider inside Graduated ND lets you control the transition of the effect. You can choose a Hard or Soft edge just like with a real ND filter. The closer to 0 percent, the harder the edge, while at 100 percent you have a completely soft edge. A hard edge on this image is not what I was looking for, so I took the Blending slider up to 60 percent to get a nice transition from the sky onto the rocks. By doing this I also picked up some extra color in the cliffs and the light hitting the head light (see Figure 3-39).

Step 4: Bottoms up, the Lower Tonality slider

So, the last step to finish the image was to bring down the rocks in the foreground. I didn't want to make them too dark, so I brought down the Lower Tonality slider to –10 percent. This finished the rocks, and helped draw the eye to the head light. Now I wanted to bring up a little detail just in the shadow areas, so I changed the Shadow Protection slider to 10 percent (see Figure 3-40). And that was all he wrote.

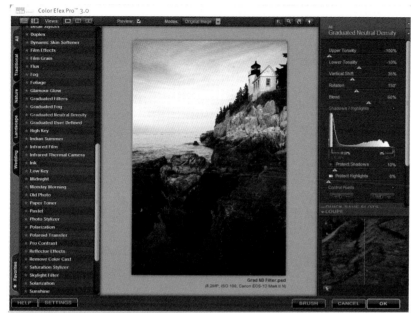

Figure 3-39

Adjusting the Blending slider lets you apply a hard or soft edge to your image.

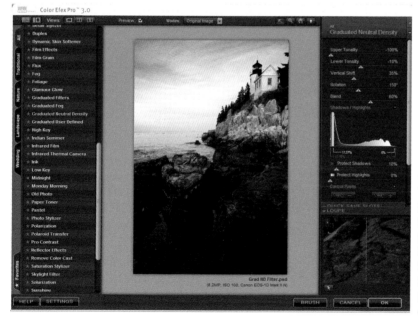

Figure 3-40

Using the Lower Tonality slider to bring down the foreground and adjusting the Shadow Protection darkens the area but preserves detail.

LESSON 13: BLACK-AND-WHITE INFRARED, METHOD 1

The Infrared Film effect is a favorite of mine, and it comes with some great options. For black-and-white infrared, I usually stick with Method 1 or 2 from the black-and-white options. I find that for landscapes, Method 1 works nicely.

This shot is from Nevada City, Montana. It is a great place and I could probably stay there for two or three days and still not photograph everything I wanted. This shot was taken about midday as a storm was blowing through the mountains behind the town. I'll walk you through the process I used for converting this image to infrared black-and-white.

Step 1: Getting the right method
I first fired up the Infrared Film filter by choosing Filter ▶ Nik Software ▶ Color Efex Pro 3.0 to get the default settings for the Infrared filter. The default gave me a really dark image to start with, but I fixed that in the next step. I made sure I selected Method 1, which gave me the great black-and-white infrared (see Figure 3-41). The reason this method was so important was because it determined how I needed to adjust the slider to get the desired effect.

Step 2: Bring on the light with the brightness slider
The first thing that I needed to do with this image was to bring back the brightness. I always try to check the sky when I'm getting ready to brighten an infrared image. I really liked the way the IR Film filter made the sky really dark and the clouds look amazing. So when I got ready to adjust the brightness, I made sure that I didn't make it so bright that I lost the sky and the effect it created.

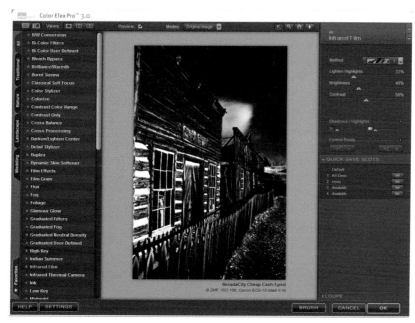

Figure 3-41

Inside the Infrared film filter are multiple methods to choose from: four black-and-white and five color.

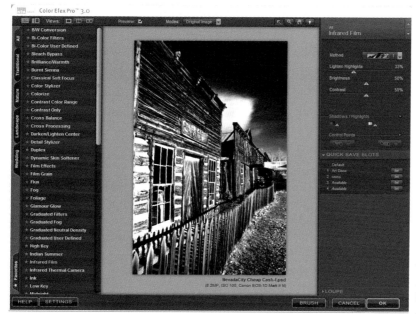

Figure 3-42

By adjusting the Brightness slider first, I could then determine how the rest of the sliders should be adjusted.

For this image, I brought the Brightness up to 50 percent. This setting brought the buildings back from the darkness, but it didn't affect the sky (see Figure 3-42).

Step 3: Using Contrast and Lighten Highlights

You can pick up some detail with the Contrast slider. I changed the Contrast slider to 65 percent to bring up some of the wood structure and darken the sky a little bit more. Then I headed to the Lighten Highlights slider and brought it up to 50 percent. This setting lightened the clouds but also brightened the timber chinking (see Figure 3-43). I needed to fix that in the final step.

Step 4: Toning down the highlights with the Protection slider

The last step was a fairly quick one, but one that was necessary. When I brought up the clouds with the Lighten Highlights slider, I also washed out the chinking in the lower-left corner. To get that back, I used the Protect Highlights slider. Because the chinking was the brightest part of the image, when I brought up the slider it was the first detail to be affected. In this case, I moved up the Protect Highlights slider to 50 percent. This brought down the blown highlights but didn't affect the clouds (see Figure 3-44). And with that, I had finished a black-and-white infrared image.

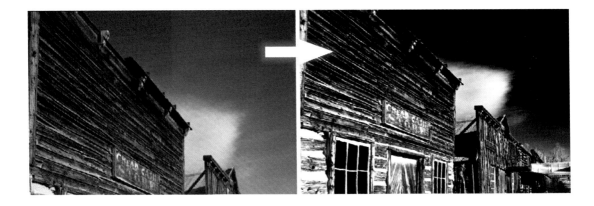

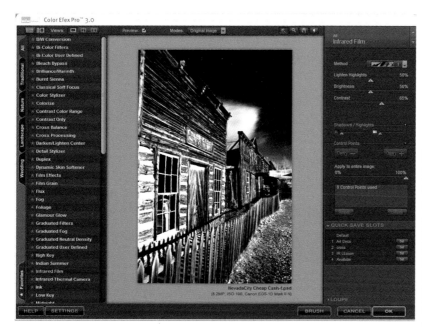

Figure 3-43

Increasing the Contrast slider darkened the skies, and increasing the Lighten Highlights slider brightened anything that had a highlight in it.

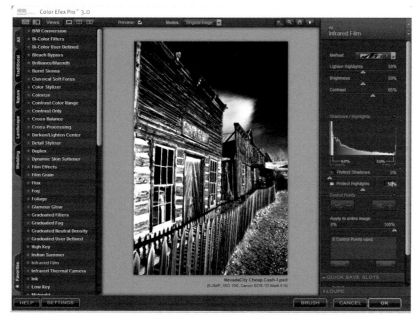

Figure 3-44

By adjusting the Shadow/Highlight sliders, I recovered some of my lost detail in the image.

LESSON 14: BLACK-AND-WHITE INFRARED, METHOD 2

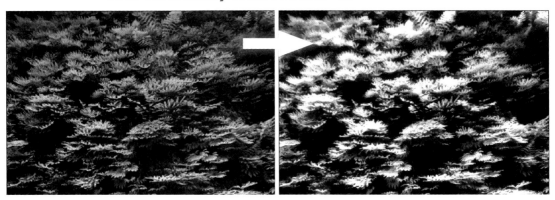

Remember earlier in the book when I suggested that you should take some extra time to play with the plug-ins and just have some fun? Well using Method 2 in the Infrared Film filter is one of the filters you should play with. Often, when I have extra time, and sometimes when I don't, I play around with the filters to see what they will do to an image, and this time around I found something fun.

Using Method 2 in the Infrared filter gives an image a slight glow that creates an interesting effect. I have used this filter on all kinds of shots, and each time I enjoy seeing the results. When using this effect, it is a matter of personal taste and creative license; there are no set rules.

This shot was taken in the redwoods in northern California. The canyon walls were covered with ferns and it was a blast to photograph.

Step 1: Dialing up the glow in infrared
When you first launch the Infrared filter, it appears with the default settings, which can make the image dark and muted. The glow is also very slight. To begin to dial up the effect and get the glow back, I first brought up the Brightness slider to 50 percent. Increasing the Brightness slider — besides doing the obvious of making the image brighter — also increased the amount of glow in the image (see Figure 3-45).

Step 2: Laying off the highlights
One of the sliders in the filter control pane is the Lighten Highlights filter. It does exactly what its name implies, and it can give a fine amount of control of the highlights in the image. For this image, I noticed that once I had the Brightness slider where I needed it,

Figure 3-45
By increasing the Brightness slider, the glow effect was also increased.

Figure 3-46
By using the Lighten High-lights slider, I gained control of the highlights in the image.

the highlights where a bit too bright, so I took the Lighten Highlights slider and moved it down to 0 percent. Figure 3-46 shows how the image had begun to look close to the final desired effect.

Step 3: Contrast slider and the final glow
As I got close to finishing the image, I went to the Contrast slider and began to slowly increase the slider. I finally set it at 80 percent because it brought up more of the glow and added more detail around the edges (see Figure 3-47).

Step 4: Pulling back the shadows
Here's something you have seen before, but it is a great way to recover some of the areas that might have been lost in the process of finishing your image. By increasing the Contrast slider, I had lost some of the leaves in the shadows that were closer to the canyon walls. So I went to the trusty Shadow Protection slider and increased it to 50 percent. The Shadow Protection brought back some of the leaves I had lost and added more depth to the image (see Figure 3-48).

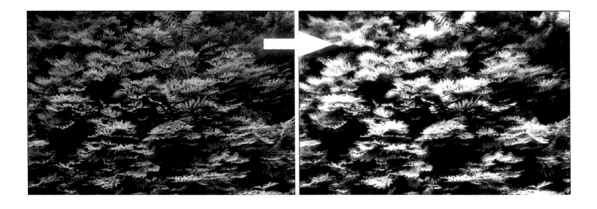

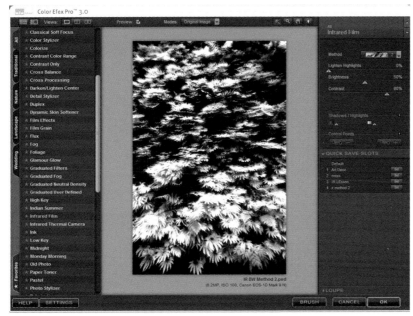

Figure 3-47

Increasing the Contrast added more detail to the leaves' edges, and as an added bonus, gave the image a little more glow.

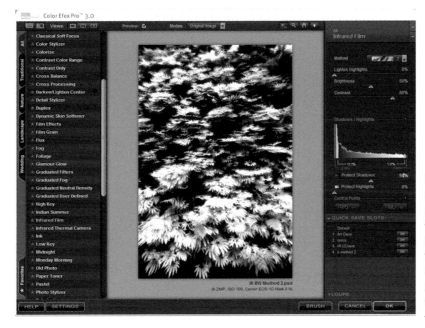

Figure 3-48

By adjusting the Shadow Protection slider, I got back detail in the shadows, and the image gained a sense of depth.

LESSON 15: ART DECO AND COLOR METHOD IN INFRARED

Okay, I have a confession. Until recently I really hadn't looked at Color Efex Pro 3.0's color methods inside the Infrared filter, but when I started playing around one day, I discovered what this filter could do and made a mental note to try it on an image. I highly suggest you try it out as well. I did notice that the color methods in the filter affect the image differently depending on the subject matter.

I took this shot of a trailer in Cisco, Utah. I couldn't believe it had a California license plate and the last registration tag was from 1939. When I saw that plate, I instantly thought about the Infrared filter and I decided that an old-school Florida Art Deco-ish effect would be perfect. So when I got back to my computer, this was the first image I opened, and I went straight to this filter.

Step 1: Finding the color

To get to the Infrared Filter, I chose Filter ▶ Nik Software ▶ Color Efex Pro 3.0, and after the window opened, I selected Infrared Film. When I use the color methods inside the Infrared filter, I go through each method just to see what each one will add or take from the image. For this image, Color Method 3 was exactly what I wanted. Even using the default settings, the effect looked great (see Figure 3-49).

Step 2: Using the Brightness slider to adjust the color

I came across something interesting about the Brightness slider while I was using the color methods. Even though the Infrared filter does control the brightness, it has the side effect of changing the colors in your image. For example, with Color Method 3, as I decreased the brightness, it shifted the colors to the blue range, and as I increased the brightness, it went toward the yellow color range. For this image, I discovered that increasing the bright-

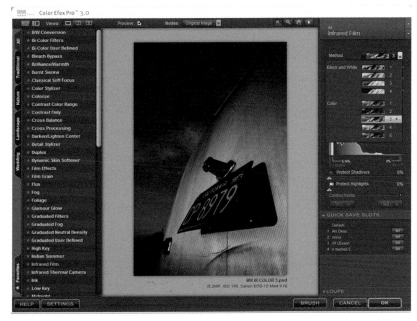

Figure 3-49

There are five color methods to chose from, all with different effects.

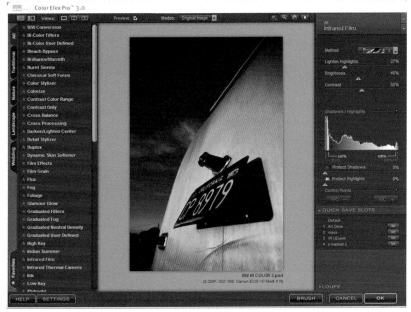

Figure 3-50

In addition to controlling brightness, the Brightness slider also affects the color ranges when using the color methods.

ness up to 45 percent gave the trailer a cool reddish yellow and the sky became a wild shade of blue (see Figure 3-50).

Step 3: Bringing on the sun with contrast

Just like when using the Brightness slider, the Contrast slider affects the color ranges as you increase or decrease the value. Using Method 3, I increased the Contrast slider to 70 percent, which made the car appear as though it were being blasted by over-saturated sunlight. Despite the fact that this was a neat effect, it was just too strong. So I took care of that in the final step.

Step 4: Using the Shadow slider to tone down an effect

The Shadow slider, when used with the Color Methods in the Infrared filter, mutes the effect. But on the whole, it did give my image an interesting effect. So by dialing up the Shadow slider to 50 percent, it took down the overall effect on the image, and finished it nicely (see Figure 3-52).

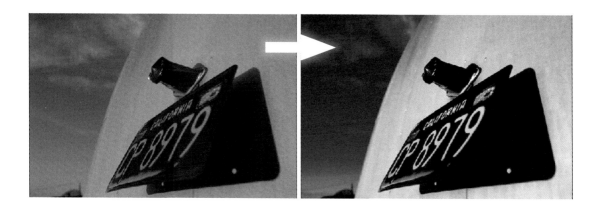

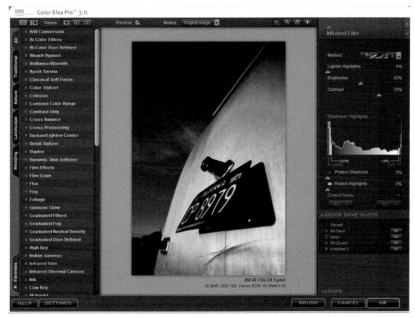

Figure 3-51

Increasing the Contrast gave the effect of the sun blaring down on the car.

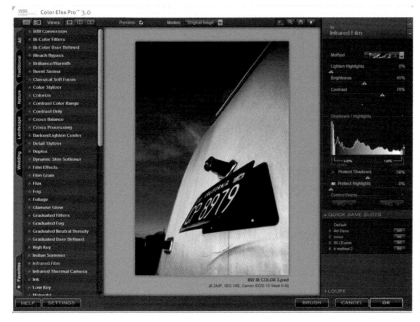

Figure 3-52

In this effect, the more I increased the Shadow slider, the more the effect is muted, which can be useful in finishing the image.

LESSON 16:
SETTING THE TONE WITH PAPER TONER

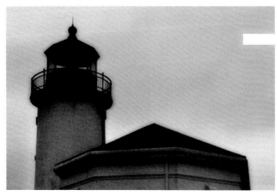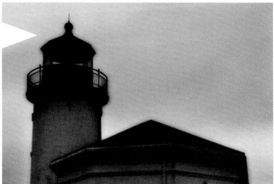

The Paper Toner filter is another great filter to use for that old-time look. Whether you want a warm sepia tone or a cooler ice tone, you can achieve it with this filter. It is a simple filter: You select the Paper Tone type and adjust the Strength slider to create the effect you want. This is a short lesson, but I think it is an important one.

This is another shot of Coquille River Lighthouse taken on an overcast day. The light was such that it made the original image seem almost black-and-white without any conversion, so I went with it.

Step 1: Choosing the tone
In the Paper Tone filter, you can choose from eight different paper tones (see Figure 3-53). For this type of faux black-and-white image, I really liked the warm paper tone preset #1. The default for the preset is 50 percent. The effect was nice but I thought it could be improved.

Step 2: Dialing up the strength
To finish this image, I dialed up the Strength slider to 75 percent. This setting gave the image an antique look and made the rust stains really pop (see Figure 3-54). And, believe it or not, that was it for this image.

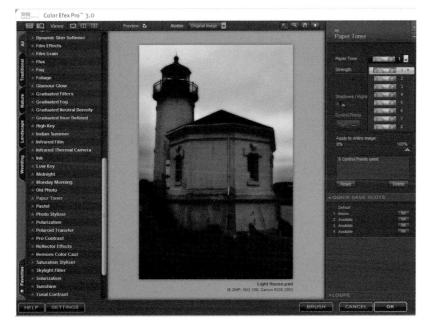

Figure 3-53

Depending on which Paper Toner preset is chosen, a warm or cool effect will be applied.

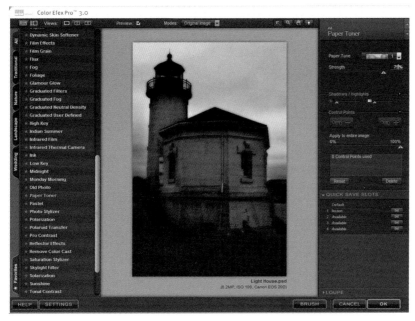

Figure 3-54

Increasing the Strength of the effect can make the image appear richer or more drab.

LESSON 17:
DRAMATIC PHOTO STYLIZER

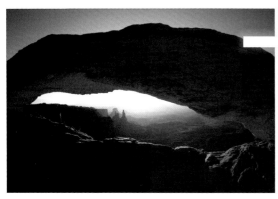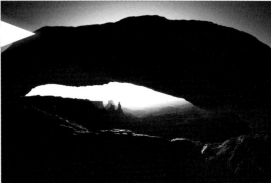

The Photo Stylizer is an interesting filter that provides some amazing results depending on the image and the final effect desired. Most of the time when I use this filter, it is because I want to finish an image with a dramatic effect. This filter actually has four filters. And the one I like to use is the Copper filter. It is great for images containing reds. It can give the sky a great copper color, especially if the shot was taken at sunrise or sunset.

The Copper filter has two sliders: a Warmth slider and the Strength slider. I use both to achieve the desired effect. I took this shot of the Mesa Arch just as the sun was rising. I'll show you how I finished this image.

Step 1: Bringing down the strength
I opened this filter by choosing Filter ▶ Nik Software ▶ Color Efex Pro 3.0 and selecting Photo Stylizer. It starts in the Varitone filter. From the pop-up menu, I chose Copper.

The default settings for the Copper filter can make the image very dark, especially if the image is underexposed to begin with. So the first thing I did was to dial down the Strength slider to 50 percent. This setting lightened the image somewhat and gave me a starting point (see Figure 3-55).

Step 2: Using the Warmth slider to make it colder
I'll bet when you first saw this image, you thought the sky looked a bit on the pink side — and you're right. So to fix this, I brought down the Warmth slider to 50 percent. This lessened the pinkish hue in the sky, but not by much (see Figure 3-56). Seeing the results, I knew I needed to bring up the Strength slider.

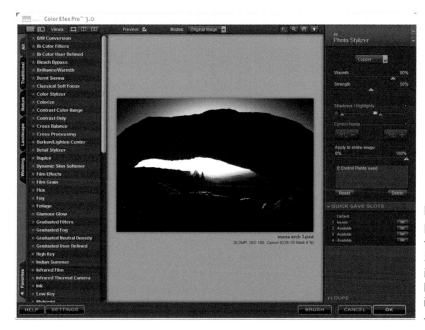

Figure 3-55
Dialing down
the Copper filter
Strength slider
in Photo Stylizer
lightened the
image.

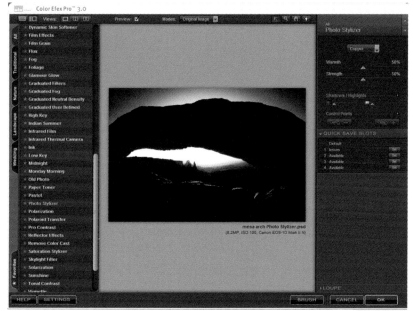

Figure 3-56
With increased
Warmth, a
pink hue can
develop in the
sky portions
of an image.
To counter-
act that hue,
I decreased the
Warmth.

Step 3: Pumping copper, the Strength slider revisited

I was close to being finished with this image but I needed bring back some of that copper coloring to give that rock and sunrise the final effect I wanted when I took the shot. So I slowly brought up the Strength slider. I eventually set the slider at 70 percent. That setting gave me the tones I wanted in the sky and in the upper edges of the rock face. The first time I manipulated the filters and finished this image, I was content with the way it looked.

But as I really looked at it later, I realized something was missing, and that was some of the detail in the arch itself. With the current filter settings, I had made the image darker. When you look at the original image, there was great character in the rocks that was lost with the application of the effect. So I decided to add one more step to bring back that character (see Figure 3-57).

Step 4: Bring light into the shadows

By now you know why I'm heading this route. But keep in mind that in the original image there were not a lot of shadows, especially on the arch itself. However, in the process of finishing this image, I created "shadows," and the Shadow slider can still affect artificial shadows just as though they were real. So to finish this image, I went to the Shadow Protection slider and increased it to 55 percent. That brought back the detail in the arch that I had lost. Now, the image was truly finished (see Figure 3-58).

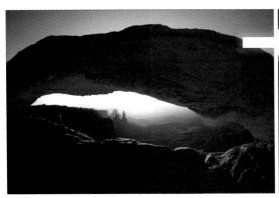
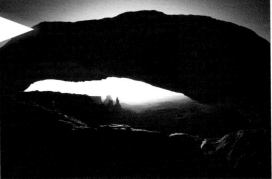

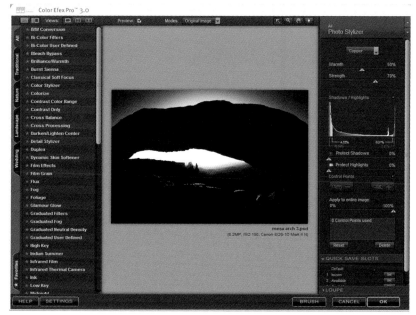

Figure 3-57

By increasing the Strength slider, I gained back the rich copper color, but the image darkened once again.

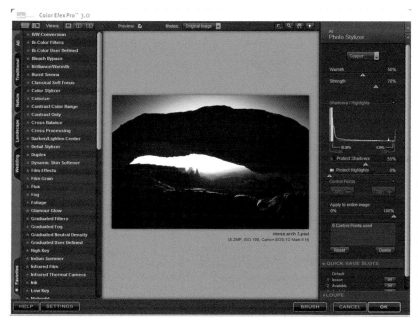

Figure 3-58

The Shadow slider can work on any area where "shadows" reside — even if they were created in the finishing process, as in this case.

LESSON 18:
REFLECTIONS WITHOUT THE LIGHT

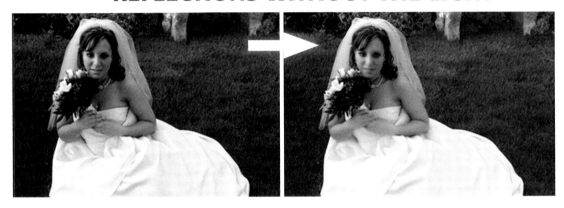

I'm always amazed at the reflectors used to bounce and shape light. And, I'm a huge fan of the amazing tools Nik Software has come up to simulate the use of reflectors. This filter comes in very handy if you find yourself, like I did recently, short a few reflectors for a photo shoot. This is another shot from the Sam and Nick's wedding to give you an idea of how the reflector filters work. I had only one reflector with me (the trials of my first wedding shoot), and I needed at least two more.

In steps the Reflector effects, and their ability to bring back an image. The overall effect can be subtle, but by bringing some warm light to the cold shadows, you can change the feel of the image. Let me show you how I used this great filter

Step 1: Using the Source Direction control for the reflector

To finish this image fast, I chose Filter ▶ Nik Software ▶ Color Efex Pro 3.0 and then chose the Reflector Effects filter. The first thing I did when I got ready to use this filter was determine whether to use it to provide fill light on the shadows, or to use it to create a more intense sun effect. For this image, I wanted to use it as fill light.

I used the default settings on the gold reflector, and slowly moved the Source Direction slider to start getting fill coming from the lower-right corner of the image (see Figure 3-59). The main reason I chose this location was because the light was coming from the top left and I wanted the bounce effect to look more natural. The effect was really strong with the default settings, so in the next steps I could focus on dialing in the effect.

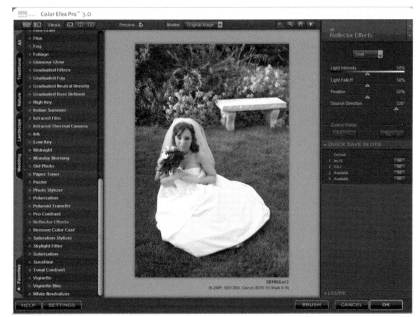

Figure 3-59

By adjusting the Source slider, I could control the angle at which the reflector bounced back at the subject.

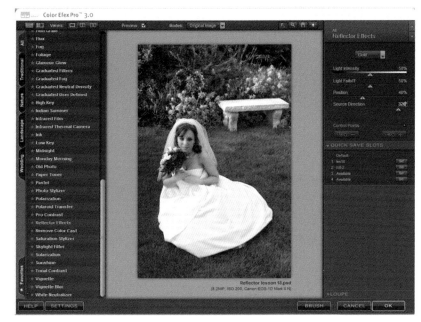

Figure 3-60

By adjusting the Position slider, I could control the amount of light hitting the subject.

Step 2: Getting in position with the Position slider

My next step was to adjust the Position slider. This slider simulates tilting the base of the reflector away from or closer to the subject and dictates how much light is spread across the image. With this image of Sam, I just wanted the light to reach her face and then start to die off, so I dialed down the Position slider to 43 percent (see Figure 3-62).

Step 3: Using the Light Falloff slider

The Light Falloff slider controls the hardness or softness of the edge of the light, a lot like when adjusting the Graduated ND filter. I adjusted the Light Falloff slider down to 40 percent. This effect was already starting to taper off by the time it gets to Sam's face (see Figure 3-61).

Step 4: Channeling the light using control points.

I had the effect almost dialed in, but I decided I wanted some more light on Sam. I took the Light Intensity slider and increased it to 70 percent. The last adjustment I want to make was to the light falling on Sam.

I really like how she looked, but not how the grass was picking up too much of the reflection, so I turned to the handy negative control points to take away the effect from the image. I dropped five negative control points around the right side of the image to remove the Reflector effect. I made sure to decrease the Size slider so that each point only covered grass and not any part of Sam — that way the effect stays on her (see Figure 3-62). And with those control points set, I was also set.

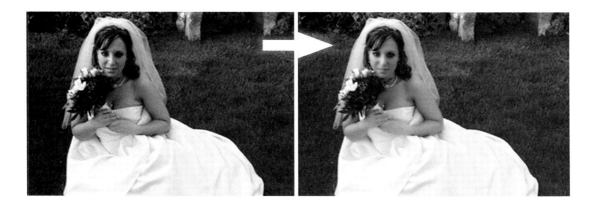

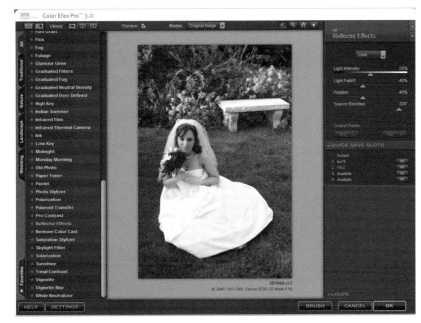

Figure 3-61

By fine-tuning the Light Falloff slider, I could get a soft or hard edge to the lighting created by the Reflector.

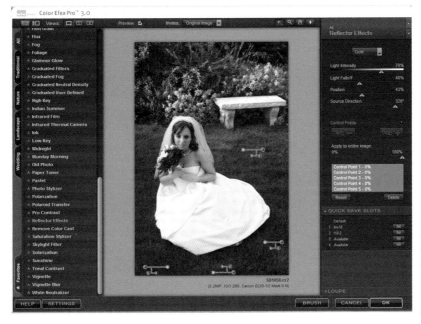

Figure 3-62

Using the control points to further shape the light in the image proved to be very useful.

LESSON 19: TONAL CONTRAST USING COLOR AND CONTRAST

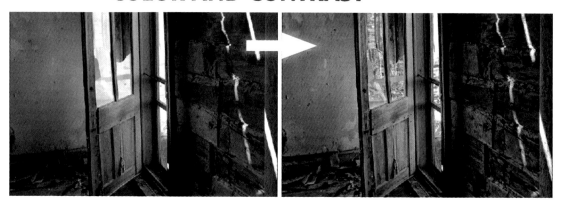

The Tonal Contrast filter provides some amazing flexibility. One thing I enjoy about using this filter is that besides being able to create more character in the image by playing with the three contrast sliders, you also can play with the saturation to provide additional interest.

I took this image of an old, abandoned house that had this great green door with a yellow wall behind it. The whole thing was built out of railroad ties and was a blast to photograph. When you look at the original image, neither the door nor the wall color really stand out. As well, there is not a lot of contrast in the image, so it is flat. I knew the Tonal Contrast filter could finish this image.

Step 1: Building from the default through saturation first
I chose Filter ▶ Nik Software ▶ Color Efex Pro 3.0 and then chose the Tonal Contrast filter to start the ball rolling. Right away, the default provided a pretty good effect on the image. The only thing off was that the Saturation slider was set to +20 percent and that didn't do justice to what I saw when I took the shot. So the first thing I did was adjust the Saturation slider all the way up to +100 percent to really get that color to come through (see Figure 3-63).

Step 2: Bringing up details with the contrast sliders
Tonal Contrast gives three sliders to play with: Highlights, Midtones, and Shadows. When I first opened the filter, the increase in contrast made the image look nice. However, I wanted a little bit more contrast in the walls and on the door. Because those areas of the image were mostly in the shadows and midtones, I focused on those attributes first. I brought up the Shadow slider to +35 percent and decreased the midtones to +10 percent. That took care of the walls and the door (see Figure 3-64).

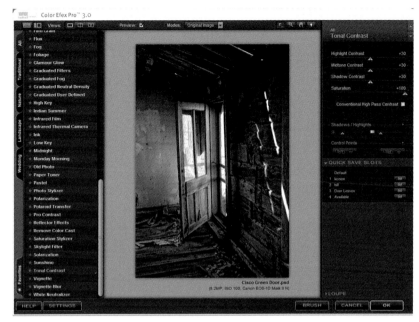

Figure 3-63

The default settings in Tonal Contrast had the Saturation slider set low, so I needed to increase the saturation to make the colors pop.

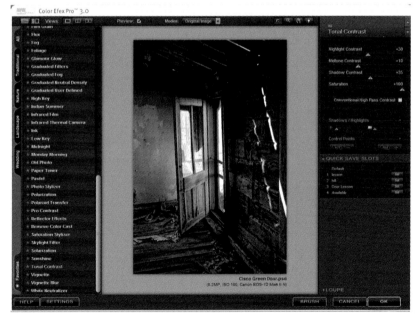

Figure 3-64

By adjusting the Midtone and Shadow sliders, I could add detail to the darker regions of an image.

Step 3: Using the Highlights slider

The Highlight slider has a very useful effect when it is cranked up to 100 percent. By increasing the contrast of the highlights, you can get some detail back. So for this image, I moved the Highlight slider up to 100 percent and recovered some of the detail in the window (see Figure 3-65). If you look at Figure 3-65 and compare it to Figure 3-66, you can see the bit of detail that was picked up by increasing the contrast.

Step 4: Protection with a twist using Highlight Protection

While playing with the Highlight Protection slider in Tonal Contrast, I discovered that when I had the Highlight Contrast slider maxed at 100 percent and began to increase the amount of protection in the Highlight Protection slider (in this case to 65 percent), I got amazing detail in areas that were almost completely gone before (see Figure 3-66).

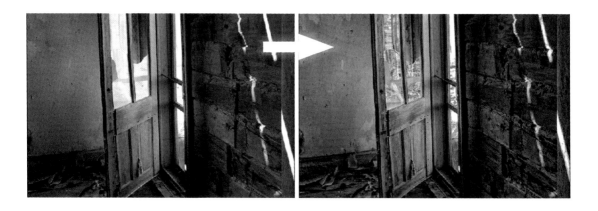

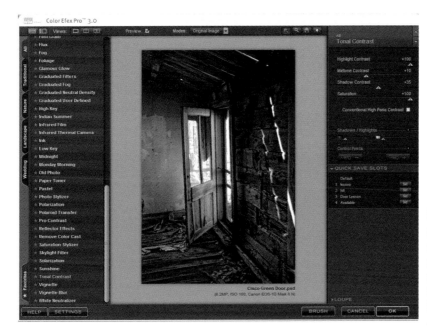

Figure 3-65
By increasing the Highlight slider, I was able to regain the details in the image.

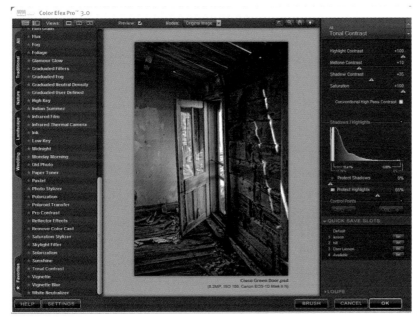

Figure 3-66
The Highlight Protection slider let me recover even more detail from the highlighted area when used with the Highlight Contrast slider.

LESSON 20: TONAL CONTRAST USING THE AIRBRUSHED LOOK

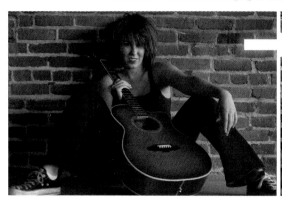 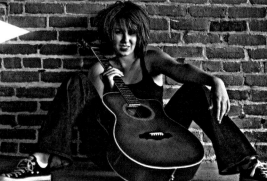

By now you've probably realize that I get a lot of inspiration from the world around me: magazines, posters, and other photographers. I'm a big fan of an airbrushed style that I have seen in various places. I wondered how I could achieve that look. My answer came in the form of the Tonal Contrast filter.

Creating an image that looks similar to an airbrushed look is pretty quick and simple, but there is no perfect recipe. Each image has its own attributes, so adjusting the various sliders in the filter is a necessary evil. Here's another shot of my friend Erica. While we were out on this shoot, I asked if I could take a shot to setup for this lesson. Luckily she agreed, because in the end this image turned out great.

Step 1: Dropping it in the basement
To kick this effect off, I chose Filter ▶ Nik Software ▶ Color Efex Pro 3.0 and then chose the Tonal Contrast filter. Right now, the image has an over-sharpened appearance. The first thing I did was to put all three Contrast sliders down to –50 percent. This gave the image a softened appearance and set a baseline from which I could begin working.

The last part of this step, and the one that was the most important, was to check the Conventional High Pass Contrast option. This option was the main key to the effect, so when you are setting up your image make sure you select this box (see Figure 3-67).

Step 2: Dialing up the contrast to achieve a painted look
Inside the Tonal Contrast filter are three contrast sliders (Highlights, Midtones, and Shadows). These are the main sliders for the effect, so I brought them up one at a time. When using the sliders, I like to start with the Shadows. I can usually see the effect begin

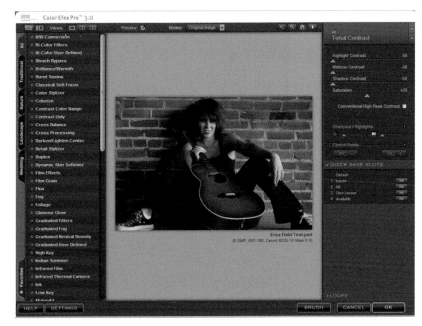

Figure 3-67
To get the effect started, I set all the Contrast sliders to –50 percent and checked the Conventional High Pass Contrast option. At this point, the imaged looked soft.

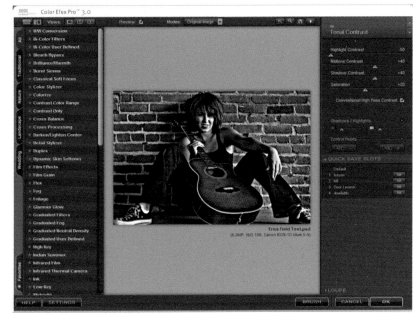

Figure 3-68
By adjusting the Shadow and Midtone sliders first, I could start to see the effect develop.

to develop quickly when I use this slider. So I took it up to +40, which started to give the image an almost painted look. After I dialed in that slider, I went to the Midtones and did the same thing. Now the look was really starting to develop (see Figure 3-68).

Step 3: Bright lights and highlights slider

I was almost finished with this image. Next I wanted to start bringing up the Highlight slider. My experience is that this slider can have a very slight effect on the image if used gingerly, so I slowly changed the values on this slider. For this image of Erica, I took it to +7 (see Figure 3-69). It has a very light effect on the white in the image, but it was worth it.

A side note: If you go for this effect and have an area of white that is "muddy" or not white, I recommend that you bring up the Highlight slider, starting at about 70 percent. It will lighten the muddy area, getting it close to white.

Step 4: Big colors and the saturation slider

You may have been wondering why I haven't talked about the Saturation slider. Well, it just happens to be the final step in the process. Depending on the image I'm working on and depending on the subject, the saturation value will change dramatically. In this case, I increased the Saturation slider to +30 percent to give a boost of color to the image. I could just as well decreased the slider to get an almost completely desaturated effect, but it wouldn't work for this image because it has so much color in it already. And with the colors punched up to my liking, this was a finished image (see Figure 3-70).

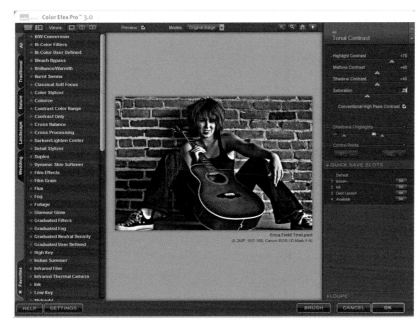

Figure 3-69

Increasing the Highlights slider gave a subtle effect on the whites in the image.

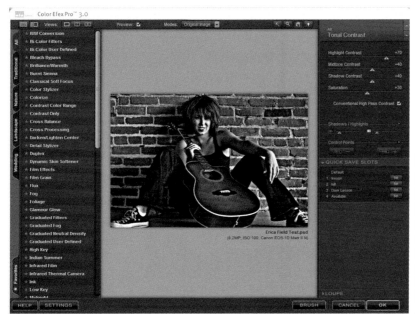

Figure 3-70

By adjusting the Saturation slider, I could punch up the color or slightly desaturate it to give it an almost faded look. I chose the former route.

PART IV

Multiple Filters, Multiple Programs

One of the things I have always enjoyed about all the Nik Software plug-ins is that they can be used with layers in Photoshop. The possibilities are almost endless when you start using layers, whether one layer or many, to combine filter effects.

Just think about it: There are 52 filters in Color Efex Pro 3.0. What would happen if you combined just one filter with the other 51 filters to create a new stacked effect in Photoshop? It starts to borderline on the exponential factor! Then toss in the fact that you can combine different plug-ins, and you might as well stick an infinity symbol on the Nik Software boxes and be done with it.

In this part, we'll tap into the potential of what happens when filters and programs get combined. I'll show you how I used stacked filters to solve problems, plus show you some tricks to help you create neat effects with your photography.

LESSON 1:
CREATING BRILLIANT LANDSCAPES

Sometimes I'll take an image that looks good but lacks definition. This can happen if you shoot in low-contrast areas where the light and shadows don't play with each other.

This scenario occurred to me recently while I was in Bryce, Utah. The hoodoos (yes, they are called hoodoos, I'm not making that up) out there are amazing and have rich colors when the sun hits them in the morning and evening. At the same time, because the sun is not bathing light over the hoodoos, their brilliant color is missing. But I can fix that.

This was shot in one of the amphitheaters in Bryce Canyon. The sun was still rising and there wasn't much detail between the hoodoos, so it looks fairly flat. I used Color Efex Pro to bring back what I knew was there. By using the Contrast Only filter, I was able to create definition and recover the image. Contrast works by increasing the contrast in the image without affecting the colors. That is what makes it a powerful filter. So let me show you how fast you can finish an image.

Step 1: Sliding to definition
Creating additional contrast to increase the definition was fairly simple. I went to the menu bar and chose Filter ▶ Nik Software ▶ Color Efex Pro 3.0, and then selected the Contrast Only filter. The Contrast Only filter has three sliders: Brightness, Contrast, and Saturation. To get this image on its way to being finished, I started with the Contrast slider. By moving the slider up (in this case to 68 percent) I got the desired effect (see Figure 4-1).

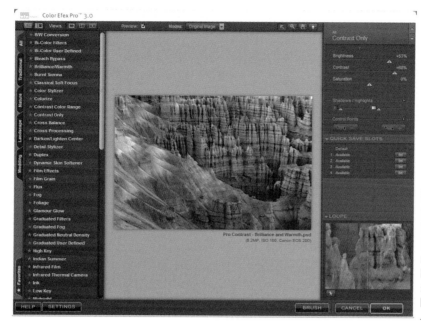

Figure 4-1

By adjust the Contrast slider, I could create more definition between the shadow and light.

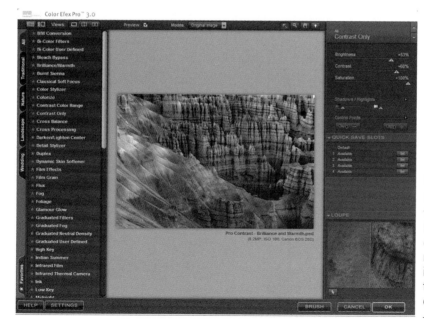

Figure 4-2

Increasing the saturation brought up the color in the rock, but there is a better way to enhance the color. ...

Step 2: Color and saturation

I could have adjusted the Saturation slider to bring up some of the reds in the rock, but there's a better way. If you take a look at Figure 4-2, you can see what the image would look like if I cranked up the Saturation to 100 percent to bring out the red rock color.

Step 3: Bring on the warmth

But like I said, there is a better way. Using the Brilliance/Warmth filter, you can enhance the image even further, making a more realistic effect. I went back into Color Efex Pro (Filter ▶ Nik Software ▶ Color Efex Pro 3.0) and then to the Brilliance/Warmth filter. I wanted to have the rocks appear with a warm radiant red, so I moved the Warmth slider up to 85 percent (see Figure 4-3).

Step 4: Using Brilliance to provide the finishing touch

From there I started playing with the Brilliance slider until I had the radiant red I wanted for the rocks. Which turned out to be setting the Brilliance slider to 85 percent. Figure 4-4 shows the effect on the image.

This combination of filters has many potential capabilities, including warming a scene and giving it that extra little pop of definition. So give it a try on your images. You might have to dial the sliders a little bit, but the effect will be a great one.

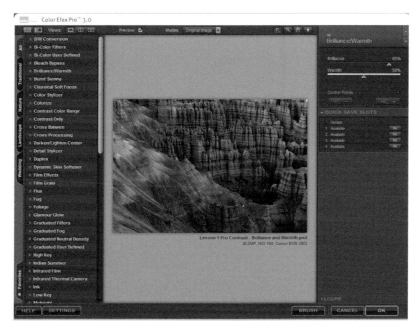

Figure 4-3

… So I introduced a more natural looking effect of warm light using the Warmth slider.

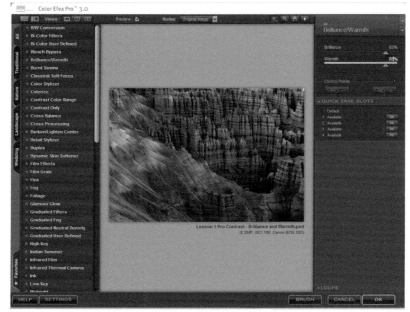

Figure 4-4

By my increasing the Brilliance slider, the image got that extra pop.

LESSON 2:
FALSE FLASH AND OLD PHOTOS

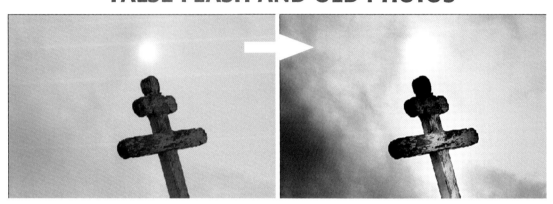

Every now and then, if you're like me, you wander into a place that while you know there is a photograph to be taken, there's just no way you can get the image you want. Like a lot of the lessons in this book, this lesson is to create and old-style effect that brings a mood to the image.

This shot was taken in Dutch Harbor, Alaska, at one of the oldest cemeteries on the island. The day I took this shot, it was really overcast, with not much detail in anything — clouds included. I didn't have a flash with me, so I knew that I would need to improvise one in postproduction. I used both Viveza and Color Efex Pro 3.0 to finish this image. Earlier in this book, I explained how to use Viveza to prep an image. Here is where that prep starts to come into play.

Step 1: Using smart objects and Viveza
Creating a "false flash" with Viveza is quick and simple. But with the effect I'm going to show you, it was even easier because I used Viveza with a smart object.

First in Photoshop, I created a copy of my background layer, by pressing ⌘+J or Ctrl+J. Then I chose Filter ▶ Convert for Smart filter. The computer processed the copy and converted it into a smart object. You can see a small smart-object icon in the lower-right corner of the layer thumbnail (see Figure 4-5). Do note that when using the smart filter, you lose the ability to use the Selective tool, so all effects will be global. The best way to control this effect is by adjusting the Size slider to suit your needs.

Figure 4-5

Creating a smart object in Photoshop provided me more flexibility with Viveza and other Nik plug-ins.

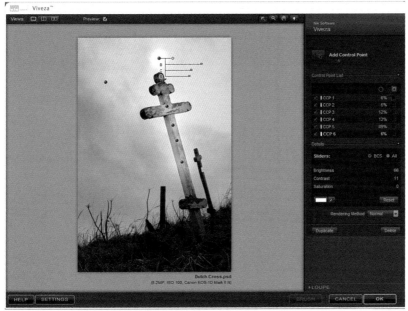

Figure 4-6

A few quick control points in Viveza created an artificial flash effect.

Step 2: And now we create false flash

So, I had my layer converted to a smart object. I then used Viveza to create an artificial flash effect to brighten the cross. I chose Filter ▶ Nik Software ▶ Viveza and, after the Viveza window opened, began creating a false flash hitting the cross. I did this by creating four points down the long access of the cross and making the size selections very small.

That took care of the flash portion for the cross, but I still needed to make a few more adjustments before I clicked OK. I dropped a point in the clouds in the upper left and moved the Contrast slider to 100 percent to bring back some of the clouds. I also dropped a point on the sun and made the Size selection slightly bigger than the outer edge. I increased the Brightness by 10 percent to give the sun a little more glow. Figure 4-6 shows how it looked before I clicked OK. I still needed to merge all the visible layers to create a new layer. So I pressed Option+Shift+⌘+E or Ctrl+Alt+Shift+E to create the new layer with all the Viveza adjustments.

Step 3: Going infrared

My next step was to use the Infrared Film filter to make a conversion to black-and-white. I went back to Color Efex Pro and chose the Infrared Film filter. For this image, I chose the black-and-white Method 1. I went this route because I didn't want the type of blur created by Method 2. Plus I knew that using Method 1 would add more contrast and make the clouds pop more. In this filter, I adjusted only the Brightness slider, which I dropped to 37 percent to add more mood lighting (see Figure 4-7).

Step 4: Setting the tone of paper

As you may have guessed by the title of this step, the final stage in finishing this image involved the Paper Toner filter. This is a great filter to use to get an aged look in an image. So I chose Filter ▶ Nik Software ▶ Color Efex Pro 3.0 and then chose the Paper Toner filter. For the effect I want to achieve, I wanted a sepia tone, so I chose Paper Tone #2 and increased the strength to 50 percent. This gave the image the appearance I wanted (see Figure 4-8).

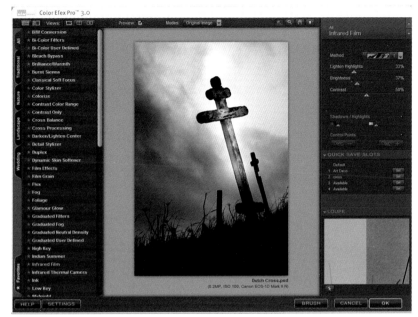

Figure 4-7
Using the Infrared Film filter provided a very cool effect that could be carried over into other effects.

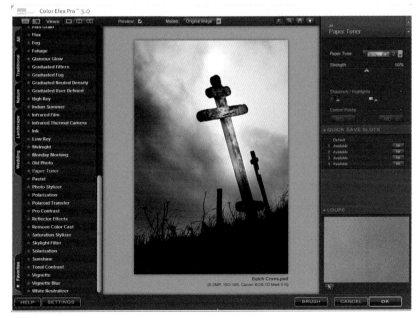

Figure 4-8
I used the Paper Toner filter for an old-style effect like sepia tone.

LESSON 3:
CREATING NEON LIGHT, OR ANY LIGHT

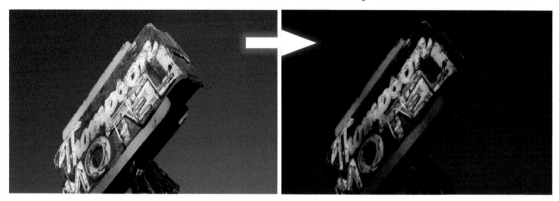

There are all kinds of tutorials on how to make neon signs glow. I have drawn my inspiration for this tutorial from my good friend Joe Sliger, who is a Photoshop genius. Creating a neon effect can be daunting, to say the least. But with a little twist on something I learned from Joe, I came up with an idea of how to make fast neon. In this image, I used a combination of Viveza and Color Efex Pro and some quick steps. So hang on tight; I think you might just like this effect.

One thing about this example is that it works best if you have an image with a neon sign or other light in it. You'll see why in a minute.

I took this shot in Utah in what was a partial ghost town, if you can call it that. The hotel was abandoned but the sign still remained. It didn't have much life in it, but I thought about it and decided to try out my idea.

Step 1: Getting ready to turn on the light: control points and sliders
In Part III, Figure 3-14 showed the image inside Viveza. To open Viveza, I chose Filter ▶ Nik Software ▶ Viveza. I then grabbed a control point and dropped it on the first letter in the sign. From there I duplicated the control point by holding down the Option or Alt key, clicked on the point, and dragged the new point to the next letter. I continued until all the letters had a control point (see Figure 4-9).

After all the letters had a control point, I held the Shift key and dragged to select all the points. Because all the letters were selected, when I changed one control point, all the others changed with it uniformly. Believe me, this technique comes in handy, so keep that little trick in the back of your mind.

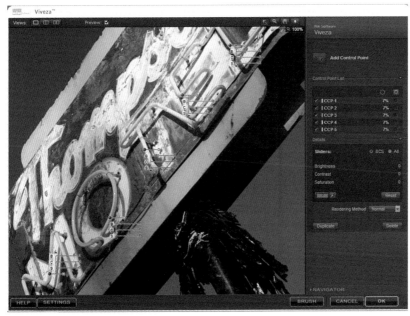

Figure 4-9

By adding multiple control points and grouping them together, I gained uniform control over all the points in the selection.

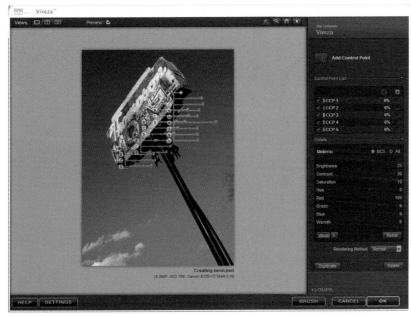

Figure 4-10

To create the neon effect, I first created the color and radiant glow using the control points.

Step 2: Creating the neon effect

From here, creating the glow was easy. I picked a control point and, because all the control points are linked together, I hit the expansion arrow so I could see all the sliders. First, I put the Red slider to 100 percent. Next, I bumped up the Brightness slider to 25 percent. I then changed the Contrast slider to 30 percent, and finally I set the Saturation slider to 10 percent. I then had the image in Figure 4-10.

Step 3: Nik selective neon

Next, I clicked the Brush button to bring up the Nik Selective tool. That sent back into Photoshop with the Nik Selective tool active. I clicked the Paint button in the Selective tool and went to town. I began by selecting a soft edge brush that was twice as large as the width of the neon. I started painting on the effect. Figure 4-11 shows how it looked. Once I was happy with the way it looks, I clicked the Apply button in the Selective tool, and that was it for the neon.

Step 4: Bringing on the evening with midnight

Well, I had neon, but neon always looks best at night. Luckily for me, the Nik folks created the Midnight filter, which is just the filter to turn day into night. In this case, I wanted to use it to make it dark outside. So I chose Filter ▶ Nik Software ▶ Color Efex Pro and then chose the Midnight filter. Once inside the Midnight filter, I dialed down the Blur to 3 percent, the Contrast to 60 percent, the Brightness to 80 percent, and the Color slider to 75 percent. A quick note on the color slider: If it is increased, it makes the neon brighter; if decreased, the neon starts to fade. Figure 4-12 shows what the final effect looked like after I clicked OK.

Note that You can also change the color of the neon by choosing the green and blue channels in Viveza or a combination of the three to make whatever color you want.

And there you have it, neon in a hurry.

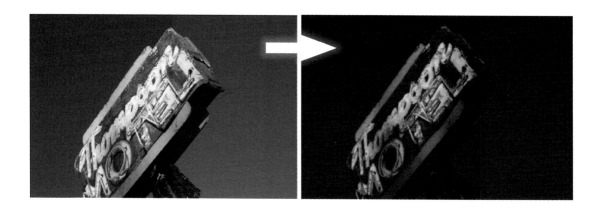

Figure 4-11

By choosing a slightly bigger brush and painting on the effect, I created the neon and the radiant glow all in one shot.

Figure 4-12

The midnight filter made the background darker and gave the neon on the sign some pop.

LESSON 4: BRING ON INDIAN SUMMER AND CONTRAST

 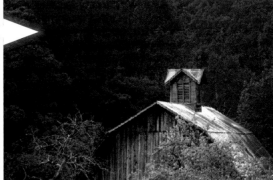

Sometimes you get to a place where they say the fall colors are shining. The reds, oranges, and yellows are supposed to be plentiful, but when you roll into town you find that you have arrived too early and everything is a lovely shade of green.

I took this shot in Bar Harbor, Maine, while with the group from the Digital Landscape Workshop Series. We discovered this great series of barns on a ranch, and there was just no way we were going to pass up these shots just because there were no fall colors.

Besides, for me, I knew I could head back to Color Efex Pro and create fall color in no time with the Indian Summer filter. However, I didn't stop with just that filter; I used two more filters to finish the image.

Step 1: Bring on the fall, Indian summer style

I fired up Color Efex Pro 3.0 by choosing Filter ▶ Nik Software ▶ Color Efex Pro 3.0 and selecting Indian Summer. Once inside the Indian Summer filter, the controls were pretty straightforward.

There are four methods to choose from. These methods offer varying shades of color in the fall color range. I chose one of my favorites, Method 2, because of its rich red color (see Figure 4-13).

When I clicked the method, the Strength slider was set to 50 percent by default, so I increased it to 65 percent to make the reds really pop.

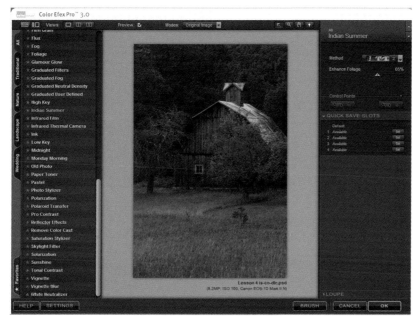

Figure 4-13

The image took on different colors of fall depending on the method used. I then dialed the Strength slider to finish.

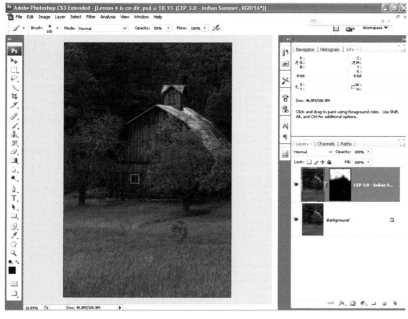

Figure 4-14

By using the Nik Selective tool and different brush tool opacities, I created varying leaf color intensities in one image without multiple layers.

Step 2: Painting on Indian Summer for effect

When I use the Indian Summer filter, I also use the Nik Selective tool to finish the effect by clicking Brush in Color Efex Pro to bring up the Nik Selective tool in Photoshop. If you are wondering why I selected the Selective tool, take a look at the grass in Figure 4-14. It was red with the overall Indian Summer effect so I wanted to take care of that excess red with the Brush tool.

In Photoshop, I clicked the Paint button in the Nik Selective tool. I made sure my foreground color was set to white by tapping the D key, then I tapped the B key to bring up the Brush tool. After setting the brush Opacity to 50 percent, I started painting on the effect. By having the Brush tool set to Opacity, I got more control while painting on the effect.

I made the first pass to build a light base of red and then I went back over the base to accent only certain areas and punch the red through. When I liked how it looked, I clicked Apply on the Nik Selective tool and finished with this portion of the image.

Step 3: Getting ready for contrast only

I had the leaves the way I wanted them, but what about the barn? It didn't have enough detail in the wood. I decided to fix that by using the Contrast Only filter. But first to get started, I needed to merge my layers in Photoshop. I pressed Option+Shift+⌘+E or Ctrl+Alt+Shift+E to get a fresh layer to work on with the Contrast filter (I named this layer "Base").

I then chose Filter ▶ Nik Software ▶ Color Efex Pro 3.0 and selected Contrast Only. I noticed that when I first opened the Contrast Only filter, my fall colors were muted because the Saturation slider was set to 0 percent (see Figure 4-15).

Step 4: Bringing color and detail with the saturation and contrast sliders

To bring back the fall colors, I increased the Saturation slider from 0 percent to 40 percent. This brought back the color I lost from using the default settings for the filter.

I then moved to the Contrast slider. I really wanted the wood in the barn to have a lot more character. It was pretty close to what I wanted using just the default settings — but not close enough — so I increased the slider to 55 percent. This gave the wood a better character (see Figure 4-16).

Step 5: Pumping up the brightness slider and heading back to Photoshop.

I did this last bit of work inside the Contrast Only filter. I bumped up the Brightness slider to 53 percent (see Figure 4-17). It was only a small adjustment, but it was necessary for the next and final step.

After I had the Brightness setting entered, I pressed OK in Color Efex Pro and headed back to Photoshop. Color Efex Pro created a new layer with the effect I had just created.

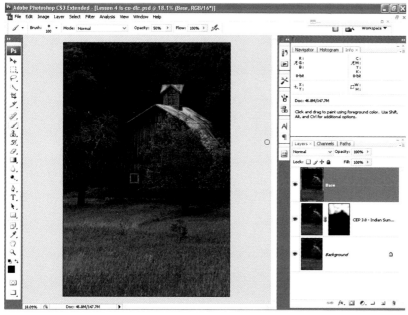

Figure 4-15

When first opened, the Contrast Only filter made the colors muted.

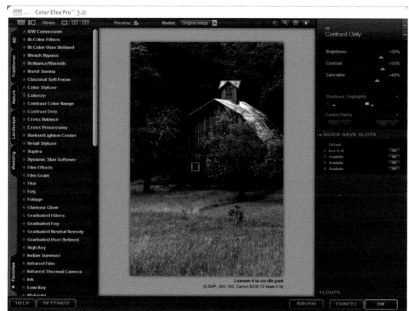

Figure 4-16

Increasing the Saturation and Contrast sliders brought back color and added detail.

(Color Efex Pro creates a new layer unless you have it set to affect the current layer, in which case it will update that current layer with your new effect.) Now that I had this new layer, I could delete the layer named "Base." I didn't need this layer anymore and it was just taking up memory.

Step 6: Bring it together with Darken/Lighten Center

The image was almost finished, but I still wanted to do just one more thing to help it along. The barn was the main focus, but I had a lot of bright green grass in the foreground, so I wanted to bring that down as much as possible.

To accomplish that, I went back into Color Efex Pro for the last time and chose the Darken/Lighten Center filter. I clicked the Place Center button and then dropped my Center Point an inch above and to the right of the window in the barn. I chose the circle shape from the pop-up menu. I then decreased the Center Size slider to 30 percent to bring down the focus of the center point, lowered the Border Luminosity to –70 percent, and changed the Center Luminosity to 60 percent to brighten the center thereby leading the eye to the center (see Figure 4-18).

Just like that, the grass's brightness had been brought down and I had drawn the viewer's eye to the barn, which was what I wanted. I clicked OK and was done.

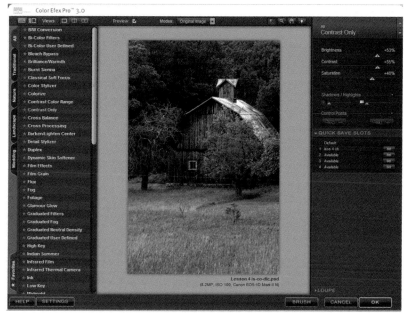

Figure 4-17
Adding just a touch of Brightness prepared the image for the final step.

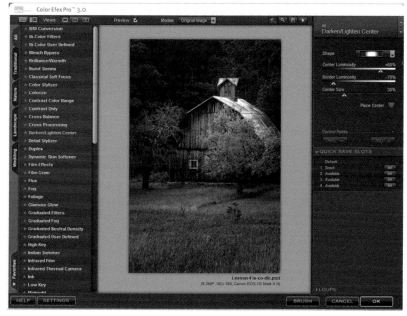

Figure 4-18
By using Darken/ Lighten Center, I darkened the grass, to help the viewer's eye focus instead on the brightened barn.

LESSON 7: SURREAL ART WITH BLEACH, DARKEN, AND VIVEZA

Finishing an image, depending on what you want the outcome to be, can take a long time to get it right — or it can take just a few minutes and a few clicks. Many times I have passed up an image because I just couldn't see it. But this shot was just waiting to be finished.

This is another angle on that old trailer in Cisco, Utah. And it's still a cool trailer. But I had to think about what I could do with this image. I put it on the image play list I keep for when I want to try new techniques and filters to see what will happen. A few days after taking this shot, I came up with the method you're about to learn.

Step 1: Polishing the sky with Viveza

You probably thought that lesson back in Part II about using Viveza to prep images was just a bunch of talk, but Viveza is a major part of my workflow. When I start out using Viveza on an image, the first thing I do is create a duplicate layer by pressing ⌘+J or Ctrl+J. Then I choose Filter ▶ Convert for Smart Filters to get a fresh, new smart filter layer before I get going in Viveza.

For this image, I did that layer duplication and then chose Filter ▶ Nik Software ▶ Viveza. After I had the Viveza window open, I went to work on the sky. I first dropped a control point in the blue portion of the sky and adjusted the Size slider to cover all the parts of the image with blue. I brought down the Brightness slider to –46 percent and bumped up the Saturation slider to 15 percent. This change made the sky a nice shade of blue (see Figure 4-19).

Step 2: Touching up clouds

While still inside Viveza, I dropped one more point on the clouds near the right edge of the image. I did this so I could recover some of the character in the clouds. Before dropping

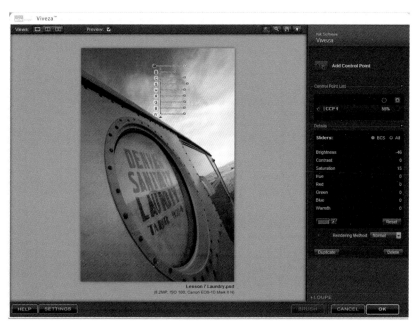

Figure 4-19
Using Viveza to create a more intense blue sky was easy using the Brightness and Saturation sliders.

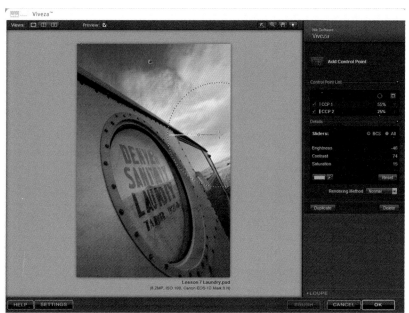

Figure 4-20
Dropping a point on blown-out clouds, lowering the brightness, and adding contrast, brought back character.

the control point, the clouds in this portion of the image were blown out, and that was not a good thing for the next step. So I brought down the Brightness slider to –45 percent, then moved up the Contrast slider to 75 percent and the Saturation slider up to 15 percent. This darkened my clouds and gave them a little more detail and color.

When selecting the area for this point, I included the reflection in the window of the trailer so that the reflection of the sky in the window would appear to be uniform (see Figure 4-20). I clicked OK and headed back into Photoshop. But, before I moved on to the next step, I pressed Option+Shift+⌘+E or Ctrl+Alt+Shift+E to merge the layers.

Step 3: Just add bleach

If by now you haven't figured out that this is one of my favorite filters, this step should drive it home. I wanted to build off of the aged effect I showed you in Part III by creating the effect with Bleach Bypass. I chose Filter ▶ Nik Software ▶ Color Efex Pro 3.0 and selected Bleach Bypass. Using Bleach Bypass on metal has this great effect that can best be described as aging with acid (odd description yes, but accurate). By moving the Brightness slider up to 80 percent, I brightened some of the darker areas. I left the Saturation slider at its default setting because the work I did with Viveza already took care of the sky (see Figure 4-21).

Step 4: Grunge metal global contrast

As always the Contrast sliders provided the character for the subject. The Local Contrast slider's default location of 50 percent was good for this effect. If I had increased the Local Contrast slider, it would have begun creating halos around the image, and that would not be a good thing. So I left it alone.

However, the Global Contrast slider was going to be my instant-age slider for this effect. I increased Global Contrast up to 50 percent to a little extra grit over the whole of the trailer, and the areas with rust and shadows became more pronounced (see Figure 4-22).

Step 5: Going off planet with Solarization

Solarizing an image is a practice that has been around for a while, and I wanted to use it on this image to make it look like it was on another planet. Solarization is a quick process that only involves two sliders. So to get started, I dove back into Color Efex Pro by choosing Filter ▶ Nik Software ▶ Color Efex Pro 3.0 and selecting Solarization.

When I first opened the filter, my image with the default Solarization settings looked nice, but I wanted to fine-tune it a bit. I kept Color Method 1 for the image because it created a great effect on the sky. Method 1 made the clouds look like they were from some nebula deep in the universe. I increased the Saturation slider to 60 percent to make the colors a bit richer, and I dropped the Exposure slider down to 45 percent to slightly lighten the image (see Figure 4-23). Now it looked like the trailer was sitting on some far-off planet. I really liked where this image was, but there was one more thing I wanted to do.

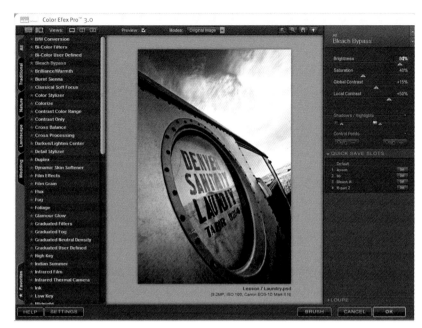

Figure 4-21
Use Bleach Bypass to start the aging process of the metal.

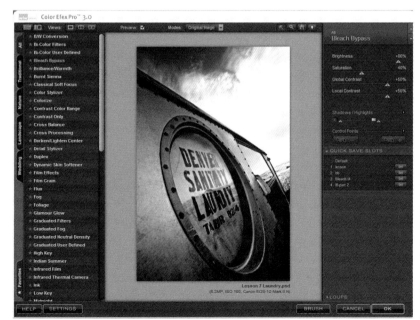

Figure 4-22
When using Bleach Bypass for the aged effect on metal, the Global Contrast slider controls most of the effect.

Step 6: Glamour glow for smoothing

If you look at Figure 4-23, you'll notice that the lettering had a harsh outline on some of the letters. To take care of this, I dove into Color Efex Pro for one last filter. I wanted to use Glamour Glow on the lettering because I also wanted to adjust the color temperature on the image.

I first took the Glow slider down to 35 percent. I did this so that I would not lose the entire gritty-metal look I had just achieved using Bleach Bypass. I didn't change the Saturation slider. But I did increase the Glamour Glow temperature to 25 percent because that little sliver of land in the background had a rich golden color, and knowing that if that color actually did exist, it would be reflected onto the trailer. So by warming the Glow temperature, I created the reflection from the ground (see Figure 4-24). And with that, my trip into the world of the surreal was finished.

Figure 4-23
I used the Solar-
ization filter to
create other-
worldly effects.

Figure 4-24
Glamour Glow
took the edge
off harsh lines
and created a
warm/cold color
over the image.

LESSON 8: FINISHING BLACK-AND-WHITE WITH GLAMOUR GLOW

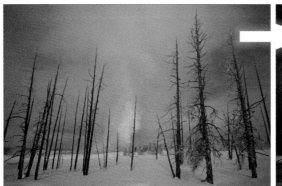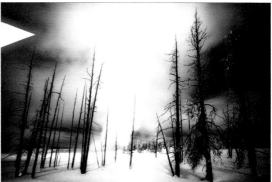

Every once in a while, I want to use a particular Nik filter on an image, but it might not give me all the control I want. You've seen this shot earlier in the book. It is one of my favorites from my last trip to Yellowstone. But one of the problems with this shot was that at the point of capture. The geyser at the very back of the shot didn't really stand out, so it was difficult to see.

I wanted to use Color Efex Pro to bring out the geyser and decided to try Infrared Film Method 2. After trying this filter, I didn't actually like the amount of glow it provided plus, I wanted to add a sense of cold to the image. So I decided to use Infrared Film Method 1 and Glamour Glow. You can see how easy it is to keep building an effect with multiple layers.

Step 1: Prepping for isolation

I gave away part of Step 1 already by talking about the fact that I knew I couldn't use Infrared Method 2 because I could not control the amount of glow. So to get this image on its way, I chose Filter ▶ Nik Software ▶ Color Efex Pro 3.0 and selected Infrared Film. From there, I chose Method 1 and prepared to isolate the geyser. Figure 4-25 shows the default in Color Efex Pro. As you can see, it was way too dark, although the geyser is isolated. To get this image where I wanted it, I needed to do some adjusting on the sliders.

Step 2: Adjusting brightness for isolation

This image was too dark, so I wanted to bring up the brightness but still keep the geyser isolated so that the viewer's eye was drawn to it. I started with the Brightness slider. I wanted to bring up the brightness just enough to take off the dark edge. In this case,

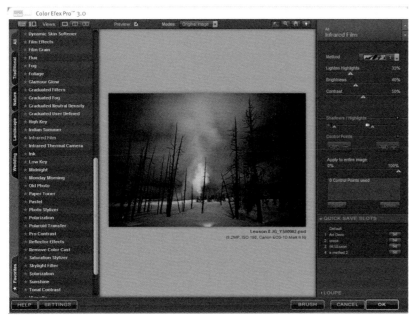

Figure 4-25

Isolating the subject in Infrared was quick and easy.

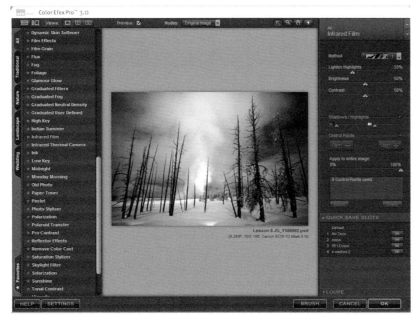

Figure 4-26

I lightened the image by increasing the Brightness slider, but I had to be careful about the amount to avoid blowing out the image.

I brought the Brightness slider up to 50 percent. This got rid of the extreme dark areas around the edge of the image and set up the next step (see Figure 4-26).

Step 3: The final isolation with Lighten Highlights and Contrast

The final push to make sure that the geyser really pop was to adjust the Lighten Highlights slider and the Contrast slider. I used the Lighten Highlights slider to do exactly what it said. Because the geyser was a giant highlight itself, by increasing the Lighten Highlight slider to 70 percent, I could make the geyser pop a touch more.

Next, I moved up the Contrast slider to 85 percent. This brought all the black areas down even further, drawing the eye to the nice steam cloud coming off the geyser (see Figure 4-27). I was finished with the conversion, so I clicked OK.

Step 4: Glowing and making it cool

Okay, this is the last step, and it was a fast one. As I worked the image, I knew I wanted to add a glow, but there were limits to how far I go. I wanted to get a bit more glow than Infrared Film could provide, so I went back to Color Efex Pro 3.0 and chose Glamour Glow. The default setting of 50 percent was just too much glow. So I backed down the Glow slider to 40 percent. That gave me just enough glow to set up for the Glow Temperature slider.

For this image, I wanted to convey a feeling of cold, so what better way to convey cold than to make the image a cooler shade? In this case, I moved down the Glow Temperature slider to –40 percent. This gave me the sense of cold I was looking for, and the image was finished (see Figure 4-28).

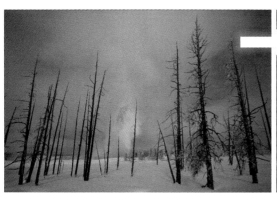
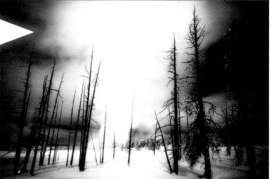

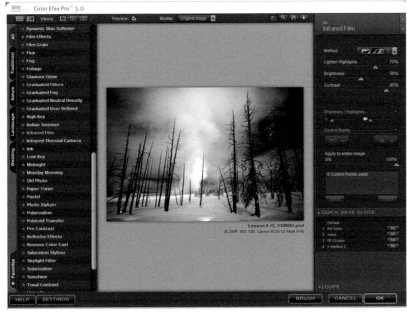

Figure 4-27
Raising the Lighten Highlights and the Contrast sliders brightened the whites and darkened the blacks.

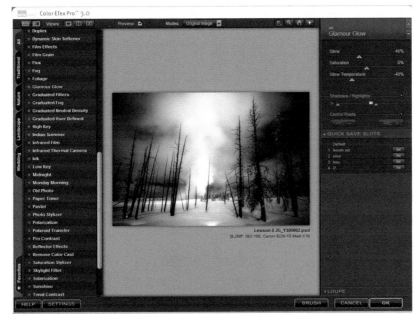

Figure 4-28
I used Glamour Glow to create a different, cooler feel for the image.

LESSON 9:
GETTING A GREAT WEDDING GLOW

Wedding photography can be a tough gig (particularly if you are shooting your first one). It's not uncommon for someone to ask you to finish an image from a wedding in Photoshop. The trick is to get a great look fast, so you're not stuck processing images for a day. I had a lot of inspiration from different filters on this lesson (to the tune of three filters).

You might recognize this shot of Sam taken at her wedding. I wanted to give it a really neat look, so I experimented for a while before I came up with this set of filters to create an effect. Now that I have it set, I tested it on a few other images. Although it takes just over a minute to finish this look, walking through it is going to take a bit longer. Once you get this down, you can crank out an image in no time flat.

Step 1: Selecting for dynamic skin
I haven't talked about this filter yet, but it is extremely useful. It works by making skin soft and smooth (at least in the photograph!). A silky-smooth skin appearance can come in handy when you're creating portraits.

To get to this filter, I chose Filter ▶ Nik Software ▶ Color Efex Pro 3.0 and selected Dynamic Skin Softener. When this filter first opened, I grabbed the eyedropper tool and selected a Midtone on the skin. I chose the bridge of Sam's nose. I used the eyedropper so I could define the tones I wanted to affect. Because each person's skin was different, setting it with the eyedropper was key to this filter's success (see Figure 4-29). Note that at this point, you won't see any real change in the image.

Figure 4-29
I used the eye-dropper tool to select the skin tone.

Figure 4-30
By adjusting the Color Reach slider, I set the range of skin tones to be affected.

Step 2: Reaching for color

The first slider in the filter control for Dynamic Skin Softener is Color Reach, which I brought up to 70 percent. This slider let me set a range of tones that would affect the image. By defining the reach, I could affect all the ranges on Sam's face in one shot instead of selecting certain areas of skin and individually adjusting them. For this image, there were various tones caused by the light falling on Sam's face. Just changing the tones on her face made it appear softer (see Figure 4-30).

Step 3: Sliding to softness

All right, the skin tone was beginning to soften, but I needed to give it a little more push to get the image ready for the next filter. I started with the Small Detail slider. For Sam's complexion, I increased the Small Detail slider to 30 percent. This gave only a small change, but I built on this change with the other sliders.

I increased the next slider, Medium Detail, to 50 percent, which took most of the skin to a softer state. The final slider was the Large Detail. This slider could have caused the overall image to become softened if I increased the slider too much, so I used this slider sparingly.

To finish the effect on Sam's skin, I changed the Large Detail slider to 25 percent. Figure 4-31 shows a zoomed in Split Preview with the effect not applied (left) and the effect applied (right). Now that I had her skin set, I clicked OK to apply the Dynamic Skin Softener filter.

Step 4: Creating a dream look

If you're a fan of dream sequences in movies and television, you know that sometimes the cinematographers make the whole scene soft to appear as a dreamscape. To achieve this dreamy appearance, I went back into Color Efex Pro and chose the Classic Soft Focus filter. This is another filter I have not mentioned before, but it fit the bill for what I wanted for the next part of this image.

When I first opened the filter, I needed to select which method to use. I wanted a diffused but slightly dark look, so I chose Method 3 (see Figure 4-32). Even with the default settings, I was getting closer to the final image.

Step 5: Using diffusion, strength, and brightness for effect

The slider options in the Classic Soft Focus filter are great and give you a lot of control. To dial in this filter, I first moved up the Diffusion slider to 70 percent. This softened the skin even further and gave a nice soft, dreamy blur to the overall image. But this alone did not achieve the look I wanted, so I increased the Strength slider and pushed it up to 80 percent. Next, I brought down the Brightness slider down to –50 percent to give the image a bit more mood by making it darker.

Figure 4-31
The Details sliders let me create the skin softness I wanted.

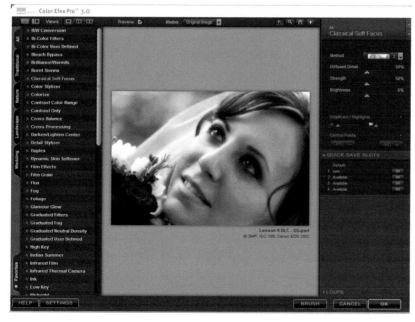

Figure 4-32
By choosing the method of classic soft focus desired, I could add subtle details.

Unfortunately, now that I'd made all these changes, Sam's eyes were soft and I didn't want that. So I grabbed a negative control point and dropped it on her right eye. I decreased the Size selection so that it just covered the eye. I then held down Option or Alt and clicked on my negative control point to duplicate the point, and then I dropped it on her left eye (see Figure 4-33). This made the eyes sharp again and led me to the final filter to finish the image.

Step 6: Drawing in the eye

The image was almost finished, but I decided there was a little something missing. The whole image was about the look on Sam's face. I wanted to find a way to isolate that further, so I decided to use Darken/Lighten Center to finish. I dove back to Color Efex Pro for the last time and headed to Darken/Lighten Center. Once the window opened, I moved down the Border Luminosity slider to –100 percent to see my edges. I clicked the Place Center button and dropped the center point of the effect on the bridge of Sam's noise. I brightened the Center Luminosity to 25 percent, and that achieved the look I wanted (see Figure 4-34).

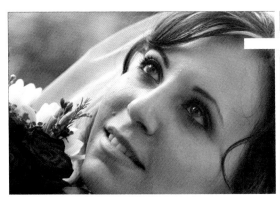

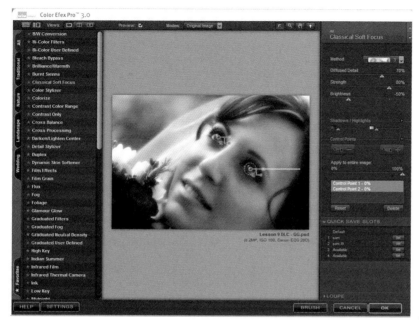

Figure 4-33

Using negative control points, I removed the softness from Sam's eye.

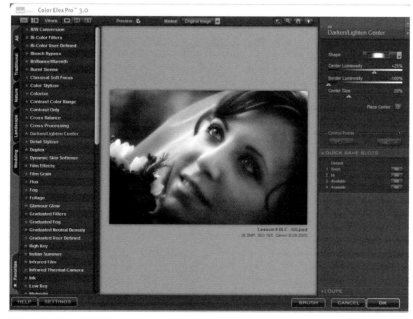

Figure 4-34

Using Darken/ Lighten Center, I isolated the expression on Sam's face to finish the image

LESSON 10:
THE ULTIMATE WEDDING FILTER STACK

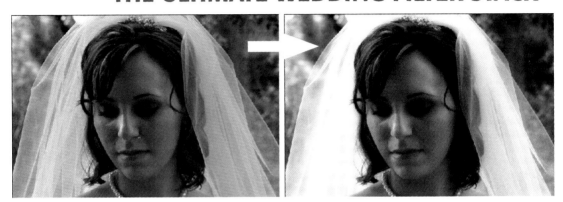

Every once in a while, at the point of capture, I make a mistake that I can't fix, because I basically came unprepared for the shoot. Such is the case with this photo from Sam's wedding. While I was trying to get some shots off, my assistant who was also shooting had most of my equipment with her, but I wanted this shot before Sam and Nick took off for their honeymoon.

Admittedly I probably should not have taken this shot given the conditions, but I knew if I finished this image with some of the plug-ins from Nik Software, I would be able to bring the image back from the brink. The reason I called this lesson the ultimate wedding filter stack is because I used three Color Efex Pro filters plus I used Viveza to fine tune the final touch.

Step 1: Starting to shed light with reflector effects

First, I needed to bring some light and warmth to this image, so I went to the Reflector Effects filter for some help. I used this filter first because it was what I call the base effect to build this image. In Photoshop, I went to Filter ▶ Nik Software ▶ Color Efex Pro 3.0 and chose the Reflector Effects filter. I found while working on this image, I had to use the filters in a particular order so that the effect looked natural. So I started off by making sure I was set to the Gold Reflector effect. I wanted the image to be warm and the gold was the best source for creating warm light. After I had the gold effect, I moved the Light Falloff slider all the way to 100 percent to carry the effect across the entire image (see Figure 4-35).

Step 2: Directing the light

Now that I had the amount of light I wanted, I needed to give it some direction so that it didn't look like Sam was being blasted from the side with light. I adjusted the Position

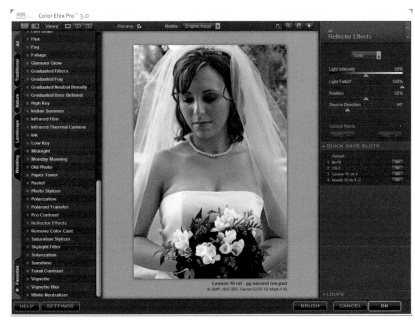

Figure 4-35

Choosing the Gold Reflector effect and increasing the Light Falloff setting together gave the image a soft, warm light.

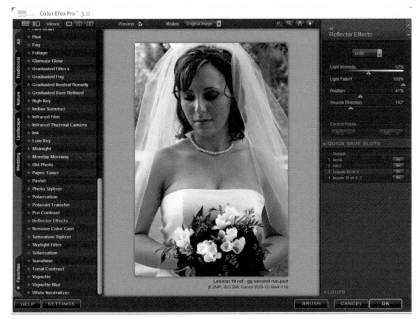

Figure 4-36

Adjusting the Position, Source, and Intensity of the light resulted in a more natural look.

slider to 41 percent to give control over how far I wanted the light to disperse across the image. In this case, I wanted it to feather off just past the right side of Sam's face giving it a more natural look. At the same time I dialed the Source slider up to 102 percent so that the light didn't seem to be coming directly from the left of the image. This adjustment gave the appearance that the light was coming from the lower-left area. As the final touch in the Reflector Effects filter, I brought up the Light Intensity to 52 percent, to give it just a bit more light (see Figure 4-36). This completed the first step in finishing this image. I clicked OK and headed back to Photoshop.

Step 3: Softening with glamour glow

Okay, I had my base set with the Reflector effects, but it was not enough to bring this image back from the brink. I decided to dive back into Color Efex Pro and go to another of my favorite filters, Glamour Glow. I picked Glamour Glow to build onto my base as the next step because I can soften the image and add a color with warmth all at the same time. To get the process started, I increased the Glow slider up to 60 percent. This slightly softened the image and gave it a little more depth by darkening some of the areas. To give it a bit more color, I bumped up the Saturation slider to 10 percent. This gave the light I created with Reflector Effects more brilliance and helped to accent the glow created (see Figure 4-37).

Step 4: Warmth and control darkness

But now I wanted to give warmth to the light I created. My quick and simple method was to increase the Glow Temperature slider. For this image, I pushed it up to 15 percent to add a nice warm glow to the light. The effect is almost complete except for the fact that as I increased the Glow slider earlier, some areas became darker. This darkness was fine for most of the image, but not Sam's left eye. Adding the glow made the eye much too dark. I took a negative control point and dropped it on her eye. I adjusted the Size slider so that it was barely bigger than the point itself and increased the Opacity slider to 50 percent to get back some of the effect but not enough to really keep the eye dark (see Figure 4-38). Having fixed the eye, I was finished with the Glamour Glow filter, so I clicked OK.

Step 5: Punching it up with contrast only

I'm almost finished with this image. This was filter number three in the set and the one that gave the image that punch. Contrast Only is a great tool to use on a muted image; it can really make it pop. When I first opened the filter, the default settings made the white in the dress blow out a bit. To counteract this, I dialed down the Brightness and Contrast sliders. I took down the Brightness slider to 42 percent and the Contrast slider to 41 percent (see Figure 4-39). This brought down my image a bit, but I could fix that in the next step.

Step 6: Bring back the light with saturation

So an unexpected side effect of dropping the Brightness and Contrast sliders was that I lost some of my created light, so I moved the Saturation slider to 20 percent. This allowed the glow and warmth to come back through and brought the color back. However, now I'd lost

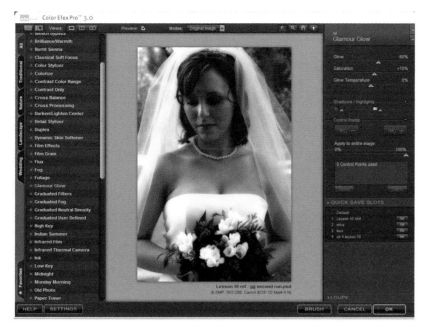

Figure 4-37
Adding Glow
and Saturation
added a soft-
ness and depth
to the image.

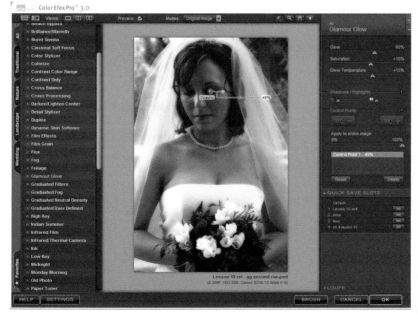

Figure 4-38
To accent
warmth in a
light, I used
Glamour Glow
and increased
the Glow Tem-
perature.

the detail in the dress again. I first moved up the Highlight protection slider to 100 per-cent. This helped but it was not enough (see Figure 4-40). I had to resort to the next step.

Step 7: Controlling highlights with negative control points

I lost the detail in the dress in the last step, but there was a way to bring it back, and that was by using negative control points to tone down the effect I had just created. I dropped one control point in the middle of the dress and set the Opacity slider to 35 percent. This let enough of the effect through so that the image lighting still looked nice and even. As well, it cut just enough and brought back the detail I lost in the dress. But now I noticed one last thing that was bothering me, and that was the highlight on Sam's nose. I wanted to do some final touching in Viveza.

Step 8: Finishing in Viveza

Wow I'm at the last step, I hope. I wanted to do some final touching on this image so I hopped into Viveza by going to Filter ▶ Nik Software ▶ Viveza. First, I wanted to take care of the highlight on Sam's nose. I dropped a point on the nose to make the Size selec-tion slightly bigger than the control point and I dropped the Brightness slider down to –35 percent. That took care of the nose and now I wanted to deal with the bright portion in the upper-left corner. I took another control point and dropped it in the corner and adjusted the Brightness slider to –50 percent, I took the Contrast slider up to 10 percent and dropped the Saturation slider down to –35 percent. That finished the image for me, and the ultimate filter stack was complete. I clicked OK and that was all she wrote on this one.

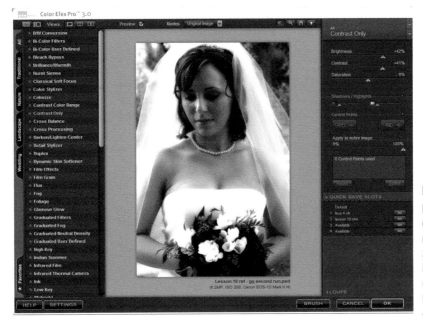

Figure 4-39

I used Contrast Only to punch up the whites and give the image a perceived sharpness.

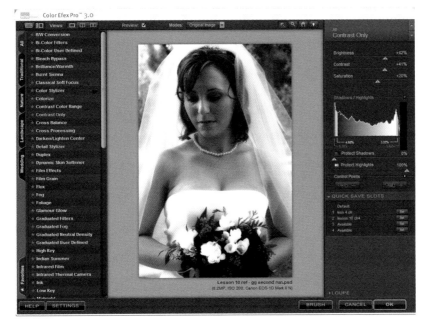

Figure 4-40

I brought back lost color by using the Saturation slider, but had to watch my highlights and shadows.

LESSON 11:
ROCK AND ROLL SPOTLIGHT

Okay coming off a long lesson, I thought I would give you a break and hit you with a short one. This is a shot of Dawn another member of the band with Erica and Roger. When I took the shot, it was just about at the end of the day and I had equipment failing on me. Luckily, I asked Dawn how she wanted her shots to look, and she said dark and moody. I thought to myself that this would make things a lot easier, and by now I had all the techniques I needed in Color Efex Pro 3.0 to complete her request.

I took the shot knowing that when I went into Color Efex Pro, I could easily make it appear as if she were in a dark alley being hit with a single beam of light and in black-and-white. You already know these techniques from Part III, but watch what happens when I combine them to finish this dark rock-and-roll image.

Step 1: Spotlighting with Darken/Lighten Center
To start off the effect, I needed to create a spotlight. I chose Filter ▶ Nik Software ▶ Color Efex Pro 3.0 and then chose Darken/Lighten Center. If you read the lesson on creating an artificial snoot, you're ahead of the game if you want to do use this effect.

I clicked my snoot action in the Quick Save slots, which set me up with the oblong-shaped light. I set Center Luminosity to 40 percent, Border Luminosity to –100 percent, and the Center size to 0 percent. Figure 4-41 shows what I had with these setting applied: an image that looked fairly dark overall and not very appealing.

Step 2: Creating a focal point with Place Center
With the main setting finished, I clicked the Place Center button and clicked a spot about an inch to the left of Dawn's head. I didn't want to set the center directly on Dawn's face

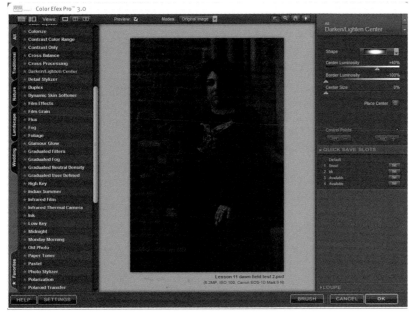

Figure 4-41
Using Darken/
Lighten Center
let me create an
artificial spot-
light.

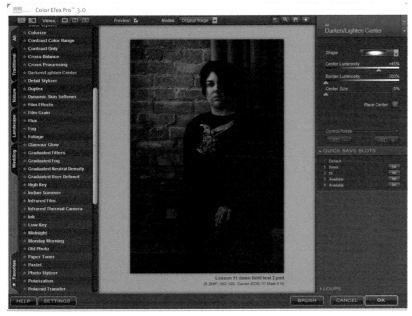

Figure 4-42
Develop a light
source out of
thin air using the
Place Center
button and some
minor slider
adjustments.

because that would be too directional for the effect I wanted. With the point off to the left, it gave the appearance that the light was coming from a source farther out to the left and was being projected on the wall and glancing Dawn.

Now that I had the light all set for the image in color, but I wanted a touch more light on the wall and on Dawn in anticipation of the ultimate black-and-white appearance I intended to create. So I took the Center Luminosity slider and brought it up to 45 percent (see Figure 4-42). I was finished with Darken/Lighten Center, so I clicked OK to apply the filter.

Step 3: Bring on the infrared

Now it was time to create that mood that Dawn requested. So I went back into Color Efex Pro (Filter ▶ Nik Software ▶ Color Efex Pro 3.0) and chose Infrared Film. That's right, Infrared Film. By default, when I opened the image it was almost jet-black. I first selected the infrared method I wanted: Method 1. This gave me the desired hard edge without any blurring. But left that way, the image would have been very dark, so I brought up the Brightness slider to 55 percent, which gave a nice black-and-white balance (see Figure 4-43).

Step 4: Controlling the light intensity

The image was almost finished, but I really wanted to make Dawn's face stand out bright in the image. So I turned to the other two sliders in the Filter Control list, Lighten Highlights and Contrast. By using the two sliders, I could make the light source seem brighter or dimmer without really affecting the overall image as compared to using the Brightness slider. I brought up the Contrast slider first and stopped at 70 percent. This created a strong highlight and drew the viewer's eye right to Dawn's face. I brought up the Lighten Highlights slider to 55 percent to give her face just a bit more light, clicked OK, and I was finished (see Figure 4-44).

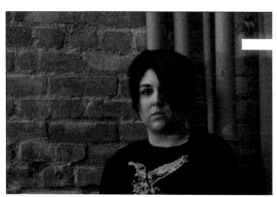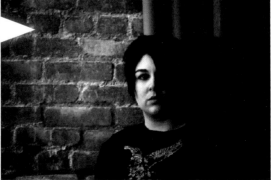

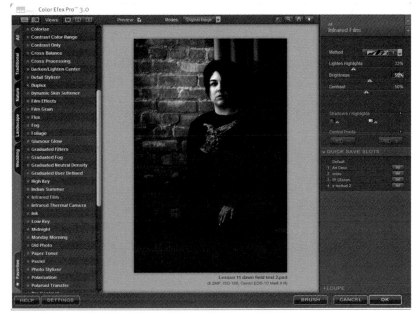

Figure 4-43

Infrared Film Method 1 let me create a great high-contrast black-and-white portrait.

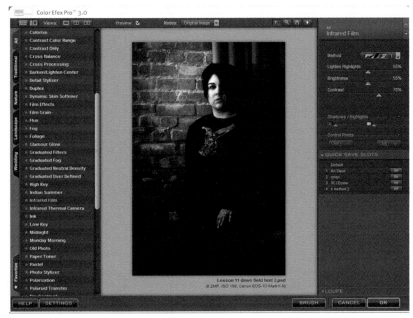

Figure 4-44

The Lighten Highlights and the Contrast sliders let me control the light intensity.

LESSON 12:
THE EVIL GRUNGE LOOK

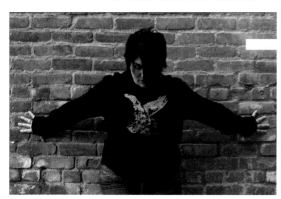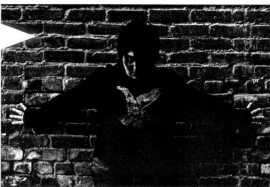

When I finished the last lesson, I showed it to Dawn, who asked if I could create another one using a different image. She wanted something that would look like a cover of an album. She wanted the image to have a real grunge feel to it, which is doable, but she also wanted it to have some color. I thought about it for a bit and came up with the following solution to her request.

I have discovered while working with Color Efex Pro that the order of the effects is very important in achieving the final look. So when I first started this project, I went through a few variations using these three filters until I got the look I wanted and the look Dawn wanted for her album-cover look.

Step 1: Creating grunge with paper toner
When I think "grunge," I think dirt, brown, aged, etc. With that in mind, my first filter was Paper Toner. I selected Paper Toner after choosing Filter ▸ Nik Software ▸ Color Efex Pro 3.0. I chose Paper Tone 2 from the pop-up menu. I like Paper Tone 2 because of its sepia look. I cranked the Strength slider up to 85 percent. This gave the image an old, dirty look. I clicked OK and my base was set (see Figure 4-45).

Step 2: Washing the grunge with bleach bypass
I now had my grunge look, so it was time to get that gritty look. What better way to do that than to use Bleach Bypass? When I first opened Bleach Bypass in Color Efex Pro, the default view looked pretty good, but not quite what I had in mind. So I moved up the Satu-ration slider to 70 percent. I dropped the Global Contrast slider to 10 percent (to lighten the image a bit from the contrast), and then pumped up the Local Contrast slider to 70 percent to get all the hard edges in the bricks and the shadows on Dawn's face to pop. I left

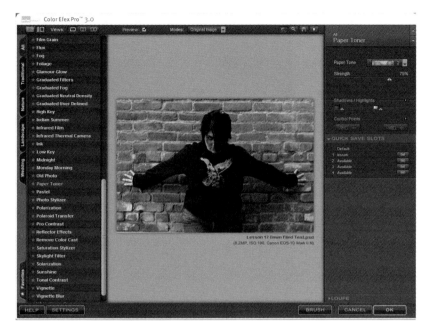

Figure 4-45
I used Paper Toner to create a base effect to help build a cool grunge effect.

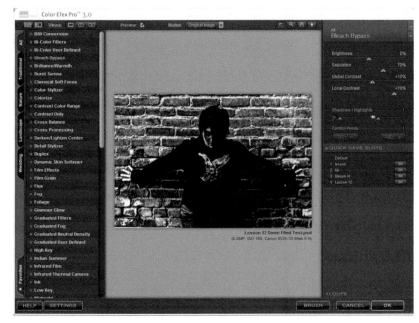

Figure 4-46
Bleach Bypass, used with Paper Toner, let me increase the grunge effect.

the Brightness slider alone because I already liked the overall level on the image. And, with that I had created my gritty grunge look (see Figure 4-46). But I wasn't done.

Step 3: Brightening with Viveza

The overall effect was looking nice, but in the process of creating the grunge look I had lost some of the brightness around Dawn's eye. So I dropped the image into Viveza by choosing Filter ▶ Nik Software ▶ Viveza to give it a quick touch-up. (Figure 4-47 shows a zoomed view of Dawn's eye.) I dropped the control point in the white of the eye and adjusted the Size slider to incorporate the visible portion of her face. I brought up the Brightness slider to 76 percent and the Contrast slider to 17 percent.

Step 4: Adding user-defined color

To finish this image, my final challenge was to find a way to add some color without losing the grunge that I created. To do so, I chose the Bi-Color User Defined filter. I wanted to keep the colors that would go with the look Dawn was talking about, so I chose a red-to-brown filter set. I adjusted the Opacity down to 40 percent to lighten the harsh colors created by the default, and I then took the Blend slider up to 65 percent to make the colors run together more evenly over the entire image. I left the Vertical and Rotation sliders at the default settings, and that finished the image (see Figure 4-48).

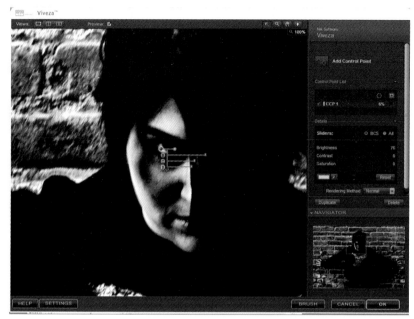

Figure 4-47
I made minor tweaks to the effect to further the finishing process using Viveza.

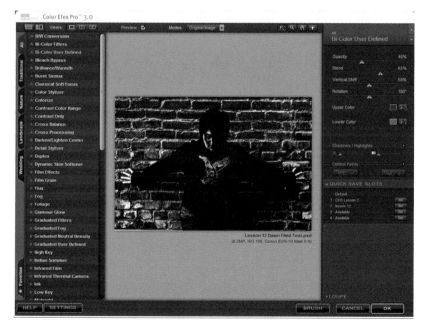

Figure 4-48
I used the Bi-Color User Defined filter to select colors that best fit the image.

LESSON 13:
CREATING AN ETHEREAL LOOK

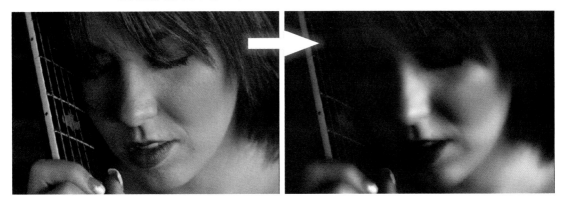

Prepare for a change. The last two lessons had rock-and-role styles, but this lesson is about creating a dream-like state. I was faced with a few challenges when I took this shot. First, the light sucked. It was a semi-overcast day, and the light was just not working for me. Second, I wanted this shot to be soft and dream-like, but there was no way to make it so at the point of capture.

It took me a while to figure out how to achieve the desired state in postproduction, but the result was an amazing finished image.

Step 1: Pick a skin tone any tone
The first thing I wanted to do to achieve that soft look was to soften Erica's skin. By softening her skin, it helped move the overall image to a softer state.

So I chose Filter ▶ Nik Software ▶ Color Efex Pro 3.0 and then chose Dynamic Skin Softener. I selected a Midtone skin tone using the eyedropper tool from the Filter Control list. I selected a color along the bridge of her nose right at the point where it was going from light to dark. This gave me a good working color.

After I had my tone selected and before moving to the next step, I made sure my Color Reach slider was set to the default of 25 percent.

Step 2: Dialing in the dynamic
With the tone selected and the Color Reach slider set, I turned my attention to softening the skin. Given that I wanted to achieve an overall smoothness to the skin, I set the Small Detail, Medium Detail, and Large Detail sliders all to 60 percent. This gave Erica's skin a

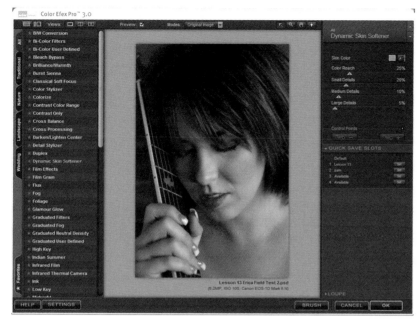

Figure 4-49
Selecting the skin tones with the filter controls gave me better skin smoothing.

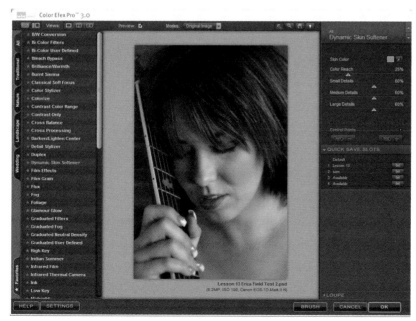

Figure 4-50
Dialing the Details sliders correctly achieved soft skin that looks natural.

great softness that I could build from later to create the final look of the image (see Figure 4-49). With that quick step, I clicked OK and I was finished with Dynamic Skin Softener.

Step 3: Soft or glamour

I had Erica's skin softened, which was a great first step, but I needed to further soften the image. I thought about using Classical Soft Focus but realized that I wanted a bit more than what it had to offer, so I chose Glamour Glow instead. One reason I selected it was to adjust the Saturation of the image, an option not available in Classical Soft Focus.

Using the default setting in Glamour Glow, I got a nice image of Erica. But I needed to make a few good tweaks to achieve the effect (see Figure 4-50).

Step 4: Creating the ethereal glow

Depending on your taste, "ethereal glow" can mean all kinds of glow but, to me it is a glow that gives you that dream-state feeling, a world of slightly blurred images.

To achieve this look with Erica's image, I had to do a few minor adjustments. First, I increased the Glow slider to 65 percent. This gave me a nice glowing softness (see Figure 4-51). However as I increased the glow, I lost the detail in Erica's hair. To remedy the situation, I dropped a negative control point in her hair and adjusted the Opacity to 35 percent. This gave the detail back in the hair, but still kept the feel of the overall effect.

To finish this portion, I dropped the Saturation slider down to –100 percent. This didn't completely desaturate the image, but did give it a nice soft coloring throughout (see Figure 4-52).

Step 5: Double the glow, double the fun

The first round of Glamour Glow gave me most of the desired effect but because of how I wanted to finish this image, one pass was not enough. I dove right back into Glamour Glow for another round of fun.

This time, I adjusted the Glow slider down to 40 percent, I brought the Saturation slider up to 0 percent, and I left the Glow Temperature at 0 percent. I also added another negative control point set to 0 percent Opacity on the hair to protect the detail (see Figure 4-53). That did it for Glamour Glow, so I clicked OK and I was back into Photoshop for a second.

Step 6: Bring down the sunshine filter

I haven't mentioned this filter yet, but basically it simulates the sun. The Sunshine filter has a huge Filter Control list, so I had to break this up into a few steps.

First when I opened the Sunshine filter, it gave the image an ultrabright red filter. So I knew I needed to dial in the filter to get the final effect I wanted on the image, which was to get a bit of sunshine on Erica. So I chose the type of light I wanted. For the effect I was

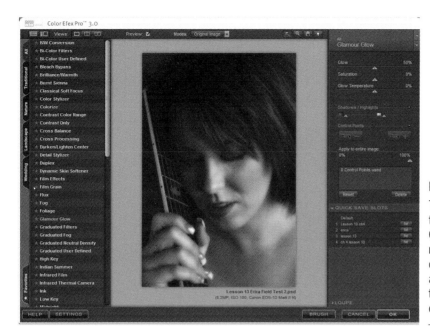

Figure 4-51

The default settings in Glamour Glow provided me a good idea of how I should affect the image to obtain the desired goal.

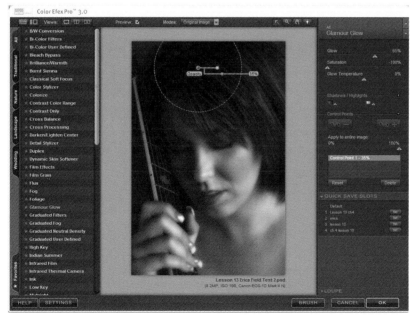

Figure 4-52

Using Glamour Glow let me create a soft image with muted colors that added to the effect.

trying to go for, #3 from the Light pop-up menu worked best. It gave a nice darkness on the image.

After I selected the type of light, I adjusted the Light Intensity Slider to 30 percent and moved up the Radius slider to 42 percent. At this point, the image was still reddish, but I knew I would fix that in the next step (see Figure 4-54).

Step 7: Putting a filter on the sun

I then set the Prefilter. For this image, I chose #4, which changed the color of Erica's lips to a deep shade of red. I adjusted the Prefilter Strength slider up to 70 percent to accent her lips.

Step 8: Dialing down the overall effect and control points

I was almost finished except the image was too dark for the vision I had. I needed to tone down the overall effect of the Sunshine filter, so I used a slider that is buried inside the control points menu. I double-clicked the Control Points bar to expand the selection to get that hidden slider: Apply to Entire Image. It is the equivalent to an Opacity slider for a layer in Photoshop. There is no way to see exactly what the slider setting is, so I eyeballed it and brought done the overall effect to 25 percent.

This brightened the image, but it also took away that great red color on Erica's lip, and her hair was still too dark. To fix her lip color, I dropped a positive control point (set to 100 percent Opacity) on her lips and adjusted the slider to just cover her lips. Then I took a negative control point (set to 25 percent Opacity) and put it in her hair to bring back some of the detail. Now the image was finished.

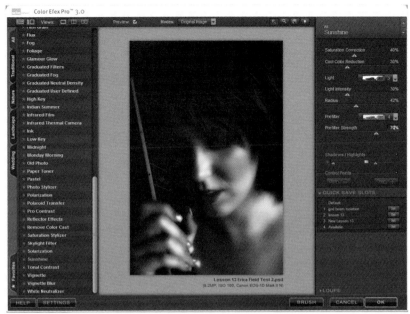

Figure 4-53
By adjust the sliders and Light types, I began to bring out the effect of the sun shining.

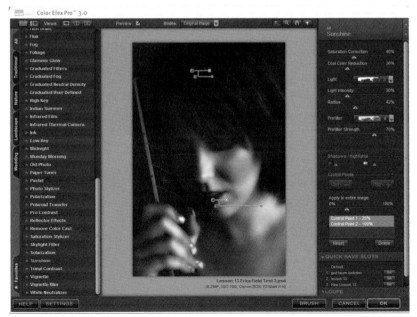

Figure 4-54
Using control points and the Apply to Entire Image slider, I had full control of the filter's effect.

LESSON 14:
CLASSIC ROCK EFFECT

This is my friend Roger, a guitar player and all-around cool guy. He was part of the band shoot with Dawn and Erica, and was a real sport because most of the shots I took of him were made to look bad so I could use them in the book. I did take some good shots of him, though, so it all balanced out.

I wanted to see what I could do with this shot. Almost everything about it is wrong (light, color, etc.) but I wanted to stress the Nik Software to see if I could take an image that was just too far gone, in my opinion, and make something of it. Believe it or not, I may have succeeded.

Step 1: Instant sunshine
In the preceding lesson, you saw the Sunshine filter and all its wonders. I wanted to use the Sunshine filter on this image to build a base. Because the light was flat and gray when I took the shot, I thought I could use the Sunshine filter to pump it up a bit. I fired up the Sunshine filter by choosing Filter ▶ Nik Software ▶ Color Efex Pro 3.0. The default settings appeared and made the image a light shade of red. All I did to build the base for the rest of the effect was increase the Prefilter Strength slider to 60 percent (see Figure 4-55), and clicked OK. A pretty quick first step.

Step 2: Sun bleach bypass
To create a hard-edged look, I used Bleach Bypass. It also gave the image an overall older look. When first opened the Bleach Bypass filter, the image was blown out. To get it back, I dropped the Brightness slider to –80 percent and moved down the Global Contrast slider to –80 percent. This brought the image down to a good brightness level and set up the image for the next step (see Figure 4-56).

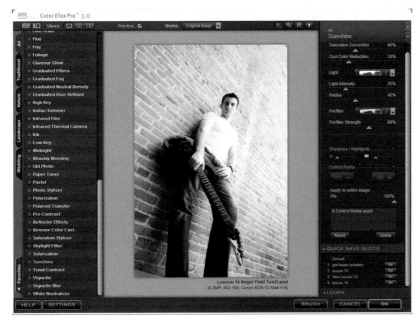

Figure 4-55
Using the Sunshine filter, I created a base to build the rest of the effect.

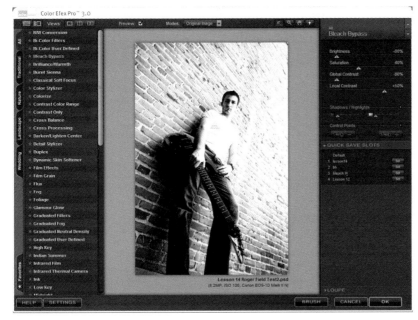

Figure 4-56
Bleach Bypass gave me a great hard edge look, but I had to control it.

Step 3: Contrast and saturation for finishing

To finish my bleaching portion of the process, I lowered the Saturation slider to 40 percent to take away some of the pink hue caused by the Sunshine filter and to give the image a subdued feel. Next, I raised the Local Contrast slider to 75 percent to put the hard edge on all the bricks, the shadows, and Roger. This gave me the effect I was looking for (see Figure 4-57). At that point, I just wanted to focus it down.

Step 4: Instant large, soft box

I had the image set but I wanted the focus to be on Roger and the guitar. To do that, I used the Darken/Lighten Center filter. I chose Filter ▶ Nik Software ▶ Color Efex Pro 3.0 and then chose Darken/Lighten Center. I used the settings I created for my snoot: a Shape of Oblong light, Center Luminosity of 40 percent, Border Luminosity of –100 percent, and Center Size of 0 percent. I clicked the Place Center button and dropped the point about two inches to the right of Roger's head to go with the flow of the natural light, and I clicked OK.

I then headed to Photoshop and applied the Darken/Lighten Center filter, I pressed ⌘+F or Ctrl+F to duplicate the filter effect, which gave me the finished image. The Darken/Lighten Center gave the image the effect of a large, soft box upward and to the left of Roger (see Figure 4-58). Just what I wanted.

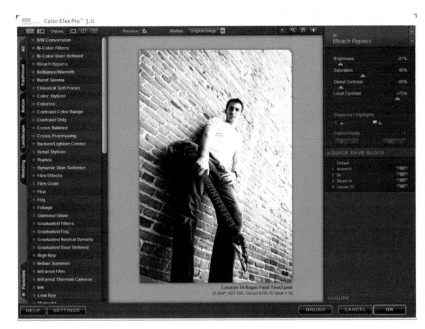

Figure 4-57

Adjusting the Saturation slider and the Local Contrast slider subdued the colors and created hard edges to give the image a chiseled look.

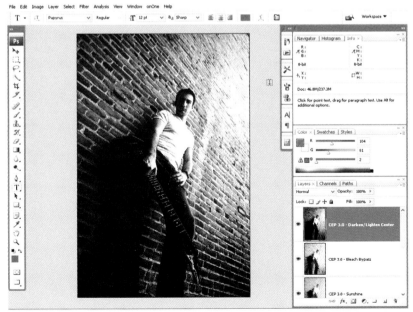

Figure 4-58

By applying the Darken/Lighten Center filter, I created the effect of a lighting system without actually using one.

LESSON 15:
GRITTY COLOR STYLIZER EFFECT

During the band shoot, Roger asked if I had seen an ad with this really neat duotone blown-out look. I said, "Yes," and kept shooting. After a while he asked if I could pull that off in Photoshop, and I thought about it for a bit and figured I probably could if I used a combination of filters in Color Efex Pro 3.0.

As the day went on, I thought about it some more and decided that a combination of two filters should get close to the look Roger was talking about. So I took one of his shots and tried to see how close I could get to the look in the advertisement.

Step 1: Going tonal for effect
The first step I took trying to solve this problem was to create a blown-out look. I did this by going into Photoshop and choosing Filter ▶ Nik Software ▶ Color Efex Pro 3.0. For this effect to work, I had to create blown-out highlights while creating a hard edges look, so I first clicked the Conventional High Pass Contrast box. I dropped the Saturation slider down to –50 (see Figure 4-59).

Step 2: Increasing the contrast
To get the highlights I needed, I started by increasing the Highlights Contrast slider to 100 percent. Then I slowly brought up the Midtone Contrast slider to 80 percent, and finally I moved the Shadow slider to 80 percent. This combination created the desired harsh blow-out effect and created the base for the image (see Figure 4-60). I clicked OK and headed to Photoshop.

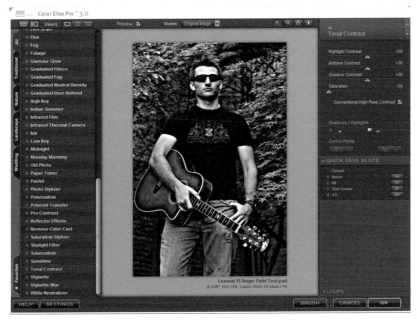

Figure 4-59
Using Tonal Contrast, I developed a base for the duotone look.

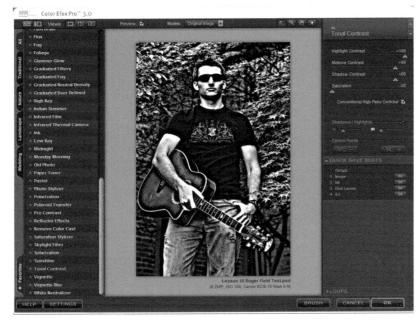

Figure 4-60
By increasing the Contrast sliders, I added the appearance of highlights.

Step 3: Setting in color

I had the blown-out highlights but still needed the duotone look. I didn't go straight for the Duplex filter on this one because I wanted a bit more control, so instead I chose the Color Stylizer filter to create the next part of the effect. I went back into Color Efex Pro 3.0 and chose the Color Stylizer. The default settings almost gave the right look, but a few adjustments were needed to make it look close to what Roger was talking about. Figure 4-61 shows the image with the Color Stylizer default settings.

Step 4: Finishing with color

To finish the image and see if I could get closer to what Roger wanted, I dropped the Contrast slider down to 20 percent. This lightened the image and made it more appealing. Next, I dropped the Saturation slider to 0 percent, so that only the color selected in the color swatch would show through on the entire image (see Figure 4-62). And with that last slider, I finished the image and got pretty darn close to the ad.

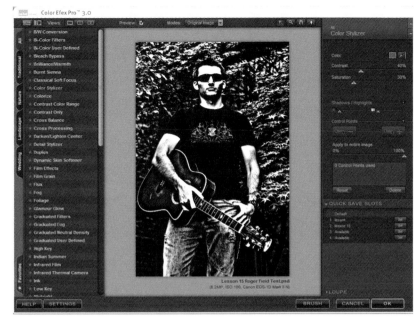

Figure 4-61
With Color Styl-
izer, I created
a good resem-
blance to a duo-
tone look.

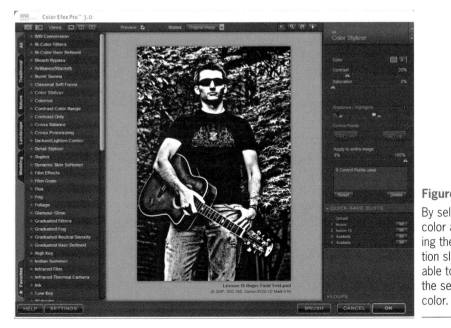

Figure 4-62
By selecting a
color and lower-
ing the Satura-
tion slider, I was
able to reveal
the selected
color.

PART V

Silver Is the New Black

So, I can honestly say that the first time I laid my eyes on this plug-in, my jaw hit the ground. Well, it felt that way, at least. A plug-in designed for the sole purpose of creating black-and-white images, I was in heaven.

Silver Efex Pro gives you an unprecedented amount of control when creating a black-and-white image. So much so that I went into overload the first couple of times I used it. The sheer number of options and creative styles that can be used are mind-boggling. Whether you are creating a traditional looking black-and-white or going way out there for solarization, you can tweak this plug-in to give you almost everything you want. You may need to do some finishing in Viveza or Color Efex Pro, but after you open Silver Efex Pro, there is a world of possibilities waiting for you.

In this chapter, I run through different styles of black-and-white images. The Nik Software guys loaded this plug-in with some incredible preset styles that you can build from. They'll also give you new ideas on how to work images. Well, enough of this intro stuff; let's have some fun with Silver Efex Pro.

LESSON 1:
CREATING A SOLARIZED EFFECT

All right, here's the first venture into the world of Silver Efex Pro. I want to mention now that, like Viveza, Silver Efex Pro can work with smart objects. You may not always use it, but it is handy to keep on the back burner.

To start off, I created a solarized effect. A solarized effect is simply an image with some or all of the image reversed in tone. Which means the blacks become white and vice versa. Overall, it is a great artistic effect, and it's fun to use. The Nik guys provided a great preset that you can use for some fun tweaking. But let me show you how I took a fairly plain photo and made it an artistic piece.

This shot is another one from Cisco, Utah, of that cool trailer. I liked this shot but wanted to try out a few conversions with Silver Efex Pro. I tried multiple effects on the door, and when I started using the solarization effect, I was hooked.

Step 1: Setting up the image

Before I dove into all the sliders of Silver Efex Pro, I set up what I call the base of the image. This included choosing the Color Filter and adjusting the Brightness, Contrast, and Structure sliders. I bypassed the Color Filter, because it wouldn't have any effect on the image, so I just made sure that the Strength slider on the Color Filter was set to 0 percent.

Then, I wanted to give the door and window a lot more character. First, I adjusted the Structure slider. Remember, this slider is like a combination of the Midtones and Shadow slider from the Tone Contrast combined into one great slider. To bring out some detail in the door, I brought up the Structure slider to 70 percent (see Figure 5-1). Just by increas-

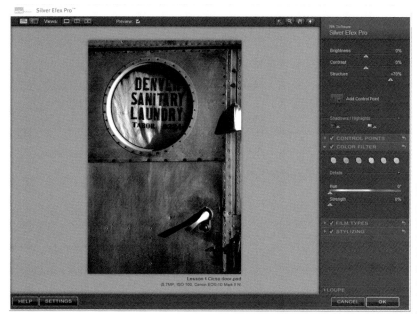

Figure 5-1

I prepped the image with the Color Filter and Filter Control sliders to build a good base for the image.

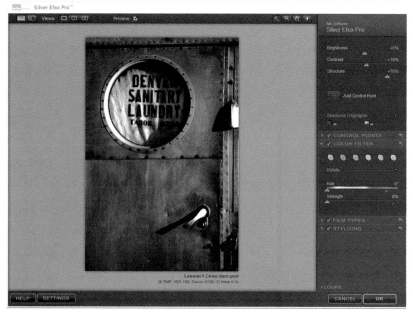

Figure 5-2

The look was right but the Contrast effect was too dark, so I adjusted the Brightness slider to lighten the Contrast slider's effect.

ing the Structure slider, you can see that I got the detail in the door that was invisible before. Getting that instant character was great.

Step 2: Making a few tweaks before the main effort

The image was coming together, but I wanted to make a few more tweaks before moving on to the solarization effect. I increased the Contrast slider to 10 percent to make the door darker and create a more aged look, but it was a touch too dark. To compensate, I brought up the Brightness slider to 5 percent to take off a bit of darkness (see Figure 5-2). I could have called this good for a black-and-white image, but I didn't stop.

Step 3: Using film types

My next step was to get the other finishing done. The Film Types Control list is packed with stuff that I can use to create great additions to the image. For the Solarization style, I used the Kodak ISO 32 Panatomic X film setting. Clicking that film preset changes the rest of the control in the Film Types pop-up menu to mimic that film.

From there I started to make the final adjustments to create the solarized effect. I clicked the Grain Title bar to expand it and reveal the Grain Per Pixel and the Soft to Hard sliders. I used these to dial in how much grain I wanted applied, and to set the space and visibility between the grain. In this case, I increased the Grain Per Pixel slider to 400 and moved the Soft to Hard slider all the way to the right. This gave the image a nice gritty look. Figure 5-3 shows a Split Preview window of how the effect looks so far (right) and the original (left).

Step 4: Tonal curve with solar power

Now down to the business of solarization. All the power for creating the solarized effect lies within the tonal curves in the Film Types pop-up menu. Figure 5-3 shows the default tonal curve for the Kodak ISO 32 Panatomic X film. I adjusted this curve to get the solarization effect (see Figure 5-4). It was a fairly quick process and based solely on personal taste, so while these were my settings, you might want to do something different. I adjusted the curve and hit OK. It was that simple, a quick process that can be used on many images.

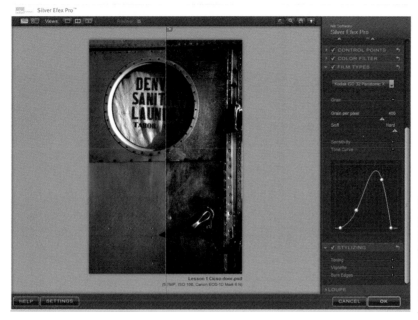

Figure 5-3
Using the Grain Per Pixel and the Soft to Hard sliders, I developed a gritty image noise.

Figure 5-4
Using the tonal curve, I achieved the appearance of a solarized image.

LESSON 2:
SOLARIZED PORTRAITS

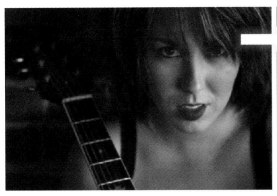

Hot on the heels of Lesson 1, I want to show you what happens when you apply solarization to a portrait. As I started going through images to get ideas for some lessons, I came across this one. This is an improvised shot of my band friend Erica taken during setup. I had just finished working on her other images in Color Efex Pro and decided to see what happens if I dropped an image into Silver Efex Pro instead.

I don't want a straight black-and-white. I want something kind of wild that has an old look, but at the same time a modern feel. When I started playing with the image, I ran through some great styles that come with Silver Efex Pro. The image has a wild High Key appearance. I like the look but it is too much, so I started from scratch to create a new solarized effect for portraits.

Step 1: Setting tones with color filters
I was working on this image in the default style of Neutral. I started my workflow like I always do by deciding whether I wanted to use a color filter. I clicked each filter to see the effect on the image of Erica. When I got to the green filter, I noticed that it made her lips go dark and brought down her complexion slightly — which looked good. So I chose the Green filter and set the Strength slider to 100 percent. Then I moved up to the Structure slider giving the image a harder-edged feeling. I moved the Structure slider up to 40 percent (see Figure 5-5). That change gave me the extra contrast I needed to steer the image in the right direction.

Step 2: Fine-tuning the base look
Just by applying the Color Filter pane and bringing up the Structure slider, the initial finishing was almost there. Knowing that when the solarization was applied it would cause a

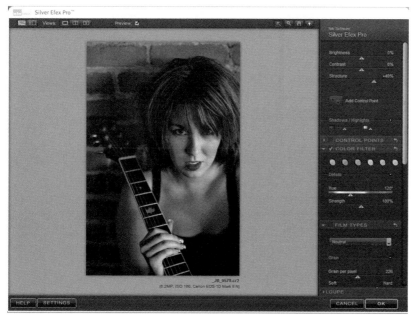

Figure 5-5
The Green filter gave the skin tones a nice appearance.

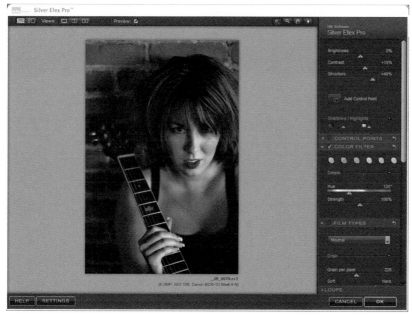

Figure 5-6
Making slight adjustment to sliders and building on them was better than making large adjustments that would have been harder to fix later.

reversal in the tones, I brought down the image a bit more by increasing the Contrast slider to 15 percent. I left the Brightness slider at 0 percent because I didn't want any bright areas that would be shifted to black during the solarization process. Figure 5-6 shows how the image looked with the extra bump in contrast. I knew at this point the effect seemed minor, but as you have seen in previous lessons, minor adjustments work better than large adjustments. I could always fine-tune later in the finishing process.

Step 3: Working with film and grain

I started the next step by selecting the Film Types pane. I wanted to add some grit to the image while I was thinking about how I wanted the final image to look. I kept the Film Type pop-up menu set to Neutral. I then placed the Grain Per Pixel slider at 226, and set the Soft to Hard slider about three quarters the way to the right. I chose 226 for the Grain Per Pixel value because it gave me the right amount of noise in the image for what I thought would transfer nicely into the final effect. The positioning of the Soft to Hard slider took just enough of the hard edge off the grains. Figure 5-7 shows a zoomed in Split Preview of the effect with the grain applied.

Step 4: Solar-powered portrait

Just like in the preceding lesson, solarization is Tone Curve's secret sauce. And, as before, getting the right look was a matter of adjusting that curve. So when I clicked the left side of the curve and added a second point, I dialed in the blacks within the curve. I did the same thing for the whites on the right side of the curve and then made a few minor tweaks to get the overall desired effect. I brought the left side of the curve almost straight up and down to bring back the blacks a bit more and complete the solarized effect (see Figure 5-8).

Because of the solarization process, I lost too much detail in Erica's face, and her hand in the foreground was distracting, so I dropped a control point on her hand and face, adjusted the Brightness down to –31 percent on her face, and –52 percent on the hand. Now the viewer's eye wouldn't be drawn away from the subject by the bright white on her hand.

Step 5: Styling with toning

I had free rein of the Stylizing pane. I wanted to add a bit of color to the image through toning. So first I chose the Preset filter. For this image, I wanted the cooler side of the Tonal range, so I used the Selenium 13. It gave a nice overall appearance. I brought the Strength slider up to 31 percent, set the Silver Hue slider to 30 degrees, and increased the Balance slider to 43 percent. My last adjustment was to the Paper Hue slider, which I set at 50 degrees to give the image a subtle, almost reddish tone that I enhanced in the next step. Figure 5-9 shows the sliders and the effect on the image.

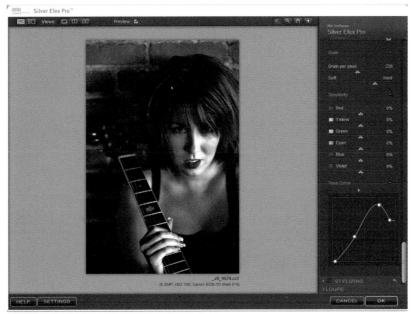

Figure 5-7

I created various levels of simulated noise by selecting the film type and then adjusting the Grain Per Pixel and Soft to Hard sliders.

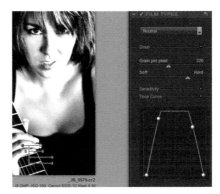

Figure 5-8

A few adjustments on the tonal curve made the image take on a new life.

When I work on an image, I always make working on the Toning pane its own step. Given all the control that I have inside the Tonal pane and its numerous possibilities, it is easier to make all these adjustments in one setting.

Step 6: Bring it down with vignette and burning

To finish the process, I used Vignette and Burn Edges. For the vignette effect, I took the Amount slider to –4 percent, set the Size slider to 67 percent, and moved the Circle/Rectangle slider all the way to the left. My final step was to click the Place Center button and drop it on Erica's face. Next I gave the borders a nice burned edge, I set the Strength slider at 100 percent, set the Size slider to 3 percent, and left the Transition slider at 0 percent. I applied these setting to each edge to create a nice uniform burn around the image (see Figure 5-10). I was happy with how everything looked, so I clicked OK and applied the settings.

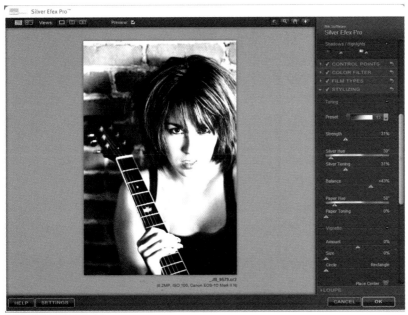

Figure 5-9
By using Toning inside the Stylizing pane, I could create a wide array of tones to finish the black-and-white.

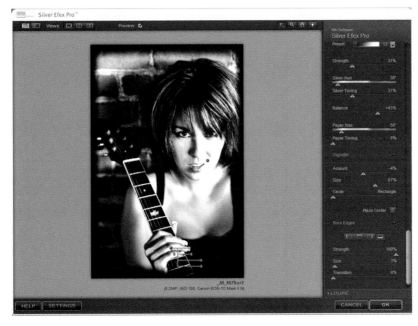

Figure 5-10
Using Vignette and Burn Edges, I created lighting and edges effects for the black-and-white image.

LESSON 3: SILVERING FOR EFFECT IN BLACK-AND-WHITE

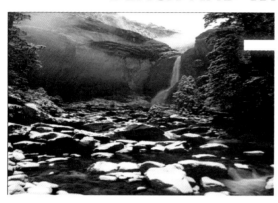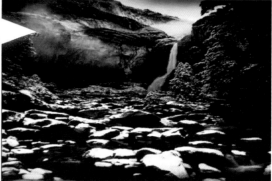

Silver Efex Pro gives you the ability to do various types of toning inside the plug-in. It provides a lot of maneuverability and can take an image to the next level. This shot of lower Yosemite Falls is great because it is already almost black-and-white. It doesn't need a lot of help, but I wanted the image to tell the story of this amazing place. Changing the tone of an image can create a different overall feel to the viewer. Adding shades of blue can give a sense of cold, while going to an orange hue can give a sense of warmth. But finding that happy medium between creating a mood and ruining an image with color can be a fine line. Let me show you how I finished this image and then used the Stylizing pane to finish my vision of the image when I took the photo.

Step 1: Building with the structure slider
I opened Silver Efex Pro by choosing Filter ▶ Nik Software ▶ Silver Efex Pro to begin the fun. I started my workflow with the Color Filter pane. Because the image was almost completely black-and-white already, there was no visible effect, so I moved on. I headed over to the Structure slider and brought it up to 80 percent. This cut some of the mist from the falls and gave a nice contrast between the rocks and snow. Beyond that, I wouldn't touch the Contrast or Brightness slider, because I liked the way it looked.

However, there was one exception to the appearance, and that was the blown-out sky in the top right. I didn't want to do a global change on the image, so I grabbed a control point and dropped it in the middle of the blown-out sky. I lowered the Size slider to just cover the sky and brought down the Brightness slider on the control point to –50 percent. This darkened the blown highlight so it was more tolerable (see Figure 5-11).

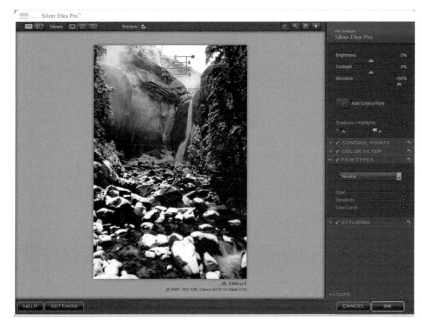

Figure 5-11
By using the Structure slider and control points, I developed a good starting point to finish the image.

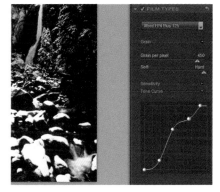

Figure 5-12
The right film type combined with the Grain and tone curve got the image closer to finished.

Step 2: Using film to strengthen the black-and-white

I always encourage playing with the plug-ins, including all their menus and options. One day while playing, I found that for some images, when I used IlfordFP4 Plus 125 and pumped up the Structure slider, I could push the black-and-white barrier to the edge. When I chose this film type from the Film Types pane, it made the division between the white and black more pronounced. So I dialed in the rest of the effect in the Film Types pane by increasing the Grain Per Pixel slider to 450 and moved the Soft to Hard slider all the way to the right. This cut down the appearance of the grain, but didn't fully take it away. Then I tweaked the tonal curve to bring up a bit more of the whites (see Figure 5-12).

Step 3: Cooling it down with toning

This whole lesson is based on the toning of the image. To start it off, I chose the Selenium 14 preset. I increased the Strength slider to 17 percent and pushed the Silver Hue slider to 253 degrees. This applied a small amount of toning and developed a cooling effect over the entire image. I set the Balance slider to –100 percent. The final touch was to make sure the Paper Hue slider was at 195 degrees and the Paper Toning slider at 3 percent. This finished the cooling effect I wanted on the image (see Figure 5-13).

Step 4: Burning down the edge

I had the ability to bring down each edge individually to accent the image. In this case, I was dealing with that blown-out area of sky. I knew that I wouldn't be able to get rid of all of it, but I brought it down a touch more so that it was not such a nuisance. I started with the top (the second button). I dialed the Strength slider to 50 percent, the Size slider to 20 percent, and the Transition slider to 20 percent. This brought the sky down to my liking. Next, I changed the left and right sides, starting with the Strength slider to 10 percent, Size slider to 20 percent, and Transition slider to 0 percent. On the bottom, I changed the Strength slider to 50 percent, Size slider to 20 percent, and Transition slider to 30 percent. By burning the edges, I knew I would draw the viewer's eye to the falls and the rocks. I clicked OK and was finished.

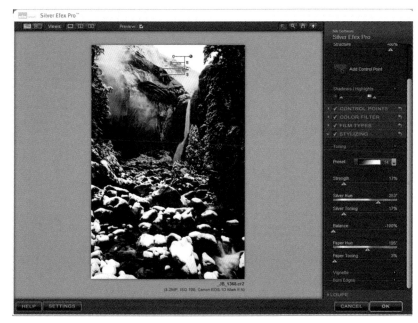

Figure 5-13
Toning the image to set the mood was quick and simple in the Stylizing pane.

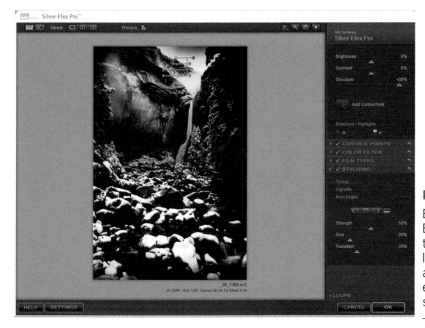

Figure 5-14
By adjusting the Burn Edges settings individually, I created mood and drew the eye toward the subject.

LESSON 4: HIGH-CONTRAST BLACK-AND-WHITE

I took this shot on a beach in Northern California. The sun had almost gone down, and there wasn't a lot going on until I stumbled across this piece a driftwood floating in a tide pool. The image doesn't have a lot of contrast because of the waning light. I thought I could make a cool infrared film shot, so I opened Silver Efex Pro to see what else I could achieve.

High Contrast B/W is a cool effect. I saw it in the Silver Efex Pro styles list and decided to try and make my own style of high contrast. Because this image lacks contrast, I decided to kick it into overdrive. But there is a caveat to doing this type of effect: Although you can create a high-contrast image, it will be really dark, and the trick is to find a happy medium. So with that said, let me show you how I took this image to the next level.

Step 1: Getting the primary contrast

I headed to Silver Efex Pro by choosing Filter ▶ Nik Software ▶ Silver Efex Pro. This was one of the few times that I did not go into the Color Filter pane for my initial tweaking. Instead, I went straight to the Structure slider and began building the high-contrast look. To really get this ball rolling in the right direction, I pushed the Structure slider up to 90 percent. This increased the contrast throughout the image, but I wasn't done with this step yet. I grabbed the Contrast slider and increased it to 50 percent. This took the image to a whole new level. At that point, it was all about the finishing for effect, because I couldn't get more contrast without killing the image (see Figure 5-15).

Step 2: And now there's the color filter

I headed to the Color Filter pane to finish the effect. The fun thing about this step was that if I had tried the Color Filter before I increased the contrast of the image with the Structure and Contrast slider, the effect would have been minimal. But now that I had more

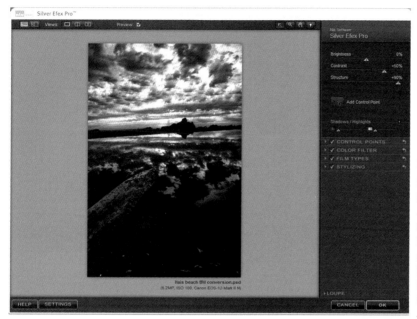

Figure 5-15
By increasing both the Structure and Contrast sliders, I could really crank up the image contrast but preserve the image.

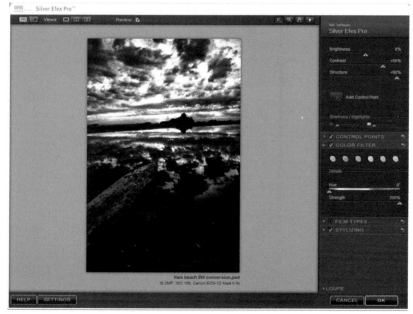

Figure 5-16
Using the Color Filter after the Contrast was applied had more of an effect on the image.

contrast, there was more to affect, so I clicked the Red filter and cranked up the Strength slider to 200 percent. With these Color Filters, I had the equivalent of two lenses but no loss in light. With the Red filter Strength slider set to 200 percent, the contrast was more accentuated in the clouds and in only some of the water (see Figure 5-16).

Step 3: Getting more contrast and setting the final tone

I went into the Film Types pane and chose Kodak ISO 32 Panatomic X to add just a bit more contrast and depth. But now the image was too dark at the bottom. I left the Grain Per Pixel, the Soft to Hard slider, and Sensitivity at their default settings. I did a quick adjustment on the tonal curve and headed to my control points to shed some light back onto my image. I took a control point and dropped it about halfway up the log. I then increased the Size slider to encompass most of the lower portion of the image so that the adjustment would affect only the lower portions of the image and blend nicely into the upper half. I then increased the Brightness slider to 38 percent (see Figure 5-17).

Step 4: Stylizing for the finish

To complete the high-contrast look, I chose the Selenium 13 preset filter and used its default settings to give a slight tint to the image. The tint was just my personal taste, but I liked having that touch of blue on the blacks and whites. To finish this image, I used Vignette. I first clicked Place Center and dropped it on top of the control point I had dropped earlier. Then I brought down the Amount slider to –42 percent, took the Size slider to 36 percent, and left the Circle/Rectangle slide all the way to the left so that the Vignette was circular. This wrapped the vignette around the top, right, and bottom, and it would pull the viewer's eye toward the log. And with that I had created a high-contrast image that I now have hanging on my wall.

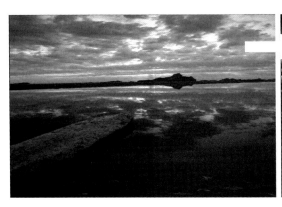
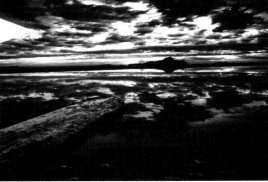

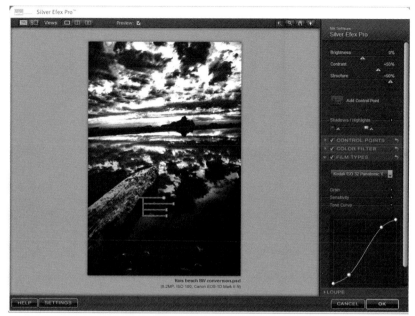

Figure 5-17
Adjusting the film type and the tonal curve allowed fine-tuning control over the contrast in the image.

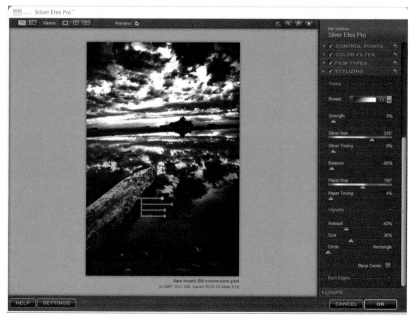

Figure 5-18
A quick Toning adjustment and some Vignette finished the image with a nice effect.

LESSON 5: CREATING A BLACK-AND-WHITE PORTRAIT WITH SEPIA

Depending on your tastes, a black-and-white portrait can look amazing or just alright. In my opinion, taking black-and-white portraits is a delicate balance of light and shadows. Use too much light and it's ruined. Don't light it enough and you haven't told the whole story. I asked my friends Erica and Roger to pose for me. The light was starting to go and with both dressed in black and the background being a lovely shade of cement, I thought I would take a chance and set up a shot. I knew I was going to make this a black-and-white, but I didn't know how I wanted it to look, and that was a big problem. I didn't know what I wanted to do with the image but I knew I could play with it later. I decided to go with Silver Efex Pro and find a system for creating a black-and-white portrait that I liked. Here's what I came up with.

Step 1: Dealing with the light

I started by choosing Filter ▶ Nik Software ▶ Silver Efex Pro. The first thing I wanted to deal with was the light. The image was unfortunately too evenly lit to create real drama, so I decided to use control points to help me start bending the light. Light creates drama in a black-and-white photograph, so that was why this step was important and needed a little extra attention. I dropped three control points on the right side of the image: one on Erica's shoulder and one on her face. I also dropped a control point on Roger's face. I moved the Brightness slider on each to –30 percent. I then dropped one more point in the top-left corner on the concrete. I adjusted that Brightness slider to –50 percent. I had the Size slider on this point expanded so that it stopped at Roger's and Erica's head. Figure 5-19 shows the layout of the point and the Size slider selection in the top-left corner. Now instead of light being everywhere, it was being funneled in from the lower left.

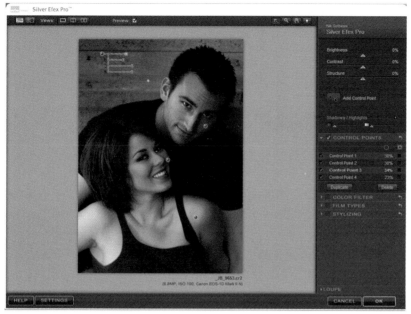

Figure 5-19

Using control points, I sculpted with light by adjusting the light/dark balance in a specific area.

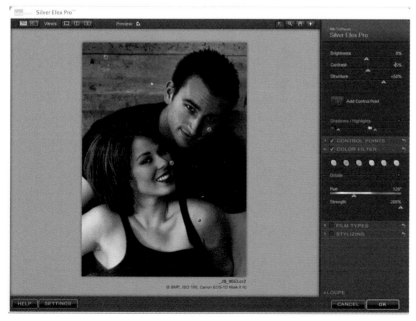

Figure 5-20

The Color Filter combined with the Structure and Contrast sliders let me enhance the skin's appearance in this portrait.

Step 2: Color filters and skin tone

I then needed to take care of the skin. In the Color Filter pane, I applied the Green filter. I liked how the Green filter made the red areas pop. I cranked the Green filter's Strength slider to 200 percent to get that look on the lips I wanted. The Green filter was also toning down the brightness on the skin, which helped move the effect forward to the Structure slider. I wanted to get an edgy feel and give the skin some character, so I took the Structure slider up to 50 percent. At the same time, I increased the Contrast slider to 5 percent to add a little more contrast and darken the image slightly (see Figure 5-20).

Step 3: Drop the film type

For this portrait I started with the Ilford Delta 400 Pro filter and then modified it to suit my needs. I increased the Grain Per Pixel to 500 and moved the Soft to Hard slider all the way to the right to give the skin an apparent smoothness. I also adjusted the Sensitivity sliders as follows: Red at 100 percent, Yellow at 50 percent, Green and Cyan at 100 percent, and Blue and Violet at 75 percent. I next headed to the tonal curve and gave the histogram a nice S-curve to bring the dark areas up a touch more and keep the whites leveled (see Figure 5-21).

Step 4: Using sepia and vignette to finish

As I worked on this image, I realized this was just not going to hold up as a true black-and-white image (you can't win them all!), so I played a hunch and tried the Toning Preset Sepia 18. The image took on a look that I really liked. At this point, though, their faces were too dark. The quick fix was to take the control point on each face and bring up the Brightness slider by 5 percent on both. The last bit to finish this black-and-white sepia was to apply a vignette to help isolate Erica and Roger, and dump some of that distracting background. I decreased the Vignette to –77 percent, the Size slider to 53 percent, and moved the Circle/Rectangle slider all the way to the right. With those set, I clicked the Place Center button and dropped it right below Roger's chin. I clicked OK and I was done (see Figure 5-22).

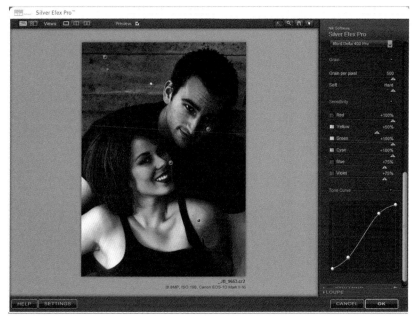

Figure 5-21

The combination Grain, Sensitivity, and the Tone Curve provided ultimate control over the image.

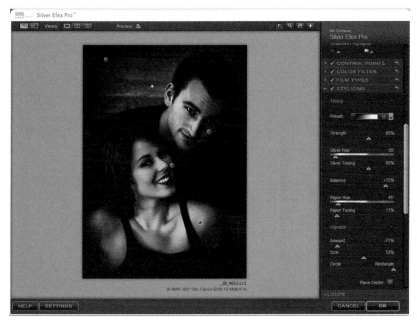

Figure 5-22

Adding a Sepia toning and a touch of Vignette added richness to the image and eliminated unwanted backgrounds.

LESSON 6:
DRAMATIC LANDSCAPE

Just like black-and-white portraits, black-and-white landscapes can be amazing. There are many tools in the digital darkroom today that you can use to compose a black-and-white image, but Silver Efex Pro takes landscape photography to a whole new level of cool. Everyone will have a different method of converting to black-and-white. You have seen a few of mine so far, but now I want to show you how I handled this image in the black-and-white process.

This shot was taken in South Dakota. It was this great old abandoned prairie house that had a really neat look. I didn't want to do with it in color, so I decided to go for black-and-white — but there was a hitch. Before going into Silver Efex Pro, I needed to go into Color Efex Pro to create a certain look so that once inside Silver Efex Pro I could quickly finish the image.

Step 1: Setting the sky with graduated ND

I opened Color Efex Pro by choosing Filter ▶ Nik Software ▶ Color Efex Pro 3.0. The first thing I needed to do was deal with the sky. I wanted to use the Graduated ND (neutral density) filter to give the sky a more even feel. I first dropped the Upper Tonality slider to –61 percent. This created a nice rich blue looking sky, which is what I wanted at that point. It also created a nice flow from the dark area in the upper-left and would lead the viewer's eye down to the house.

The last bit to get this image ready for Silver Efex Pro was to take the Vertical Shift slider up to 100 percent and the Blend slider to 100 percent as well (see Figure 5-23). The image was ready for Silver Efex Pro, so I clicked OK and headed back into Photoshop.

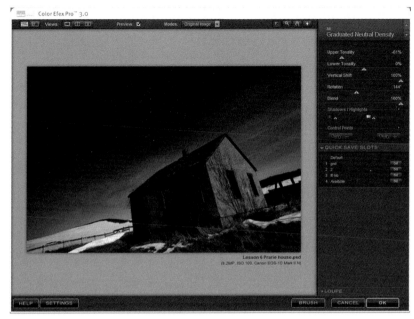

Figure 5-23

Using Color Efex Pro, I prepped the image for Silver Efex by using Graduated ND to bring down the sky.

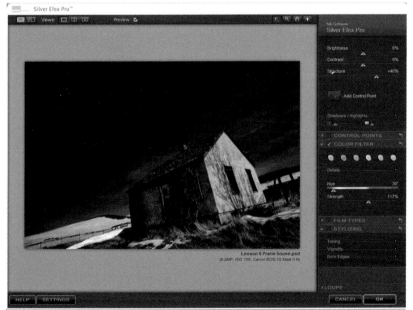

Figure 5-24

Using the Color Filter to enhance the image was easy to do, and increasing the filter's effect had an even more pronounced effect.

Step 2: Building on the blue sky

I went to Silver Efex Pro in Photoshop by choosing Filter ◗ Nik Software ◗ Silver Efex Pro. Right off the bat, my blue sky started to turn into a nice shade of black. To build off this change, I went to the Color Filter pane and chose the Orange filter. The Orange filter had a great darkening effect on the sky and also brought up the house a bit. So with the Orange filter selected, I increased the Strength slider to 117 percent. At this point, I also increased the Structure slider to 40 percent. That gave the house and surrounding vegetation a great pop against the darkened sky (see Figure 5-24).

Step 3: Working with tonal curve and film

To get some more drama into the image, I decided to choose a film type from the Film Types pane: Ilford Delta 100 Pro. Adding this film brightened the face of the house and the clouds surrounding it. To get just a bit more out of the film, I adjusted the Yellow Sensitivity slider to 100 percent. This increased the brightness of the yellow house and gave a great effect to finish. The Tone Curve control got a little treatment too. I created a gentle S-curve that would hold up, and with that small tweak I was almost finished with the image (see Figure 5-25).

Step 4: Burning the house

Admittedly, this is a short step, but the creative process can be short, too. Because the sky was pretty well gone, I didn't need to burn the sky or, for that matter, the left side of the image. However, I could do a bit of burning on the bottom and the right.

So I started with the right side Burn button. I increased the Strength slider to 35 percent, Size slider by 3 percent, and Transition slider to 100 percent. That wrapped up the right wall, so it was time to burn in the bottom. I wanted the bottom slightly darker, so for the lower burn, I set the Strength slider to 56 percent, the Size slider to 5 percent, and made sure there was no transition. And with that, I clicked OK and was out of there.

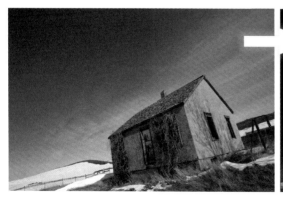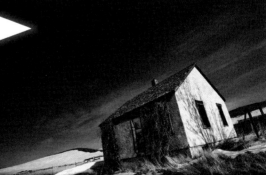

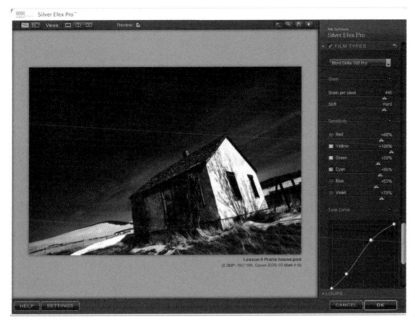

Figure 5-25
By affecting the Sensitivity slider and adjusting the Tone Curve, I created a drastic effect.

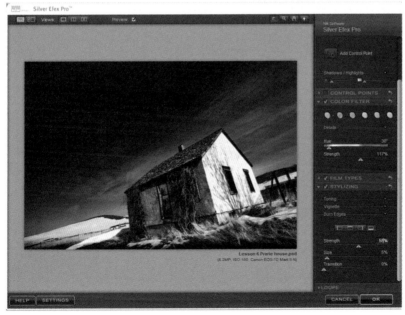

Figure 5-26
Like Vignette, Burn Edges can give great control over various ways to draw the eye to the subject, as evidenced here.

LESSON 7:
CREATING A PINHOLE

Pinhole photography has been around for a long time. It is a style all its own, and it has a big following. Creating a pinhole camera is as easy as getting a box and poking a hole in one side of it. That hole acts as your lens. The photos created with a pinhole camera are not tack sharp, but instead usually a bit soft. I can honestly say I have never used a pinhole camera, but I have always liked the look of the captured image.

When I got my hands on Silver Efex Pro, I noticed the style called Pinhole in the Styles list. I thought about the kind of image that would support a pinhole effect, and this flower image seemed perfect. I liked how the Pinhole style in Silver Efex Pro looked, but as with anything I do, I wanted to see if I could improve on it and make it my own. So to that end, I came up with my own pinhole style using the Pinhole style in Silver Efex Pro as a spring board.

Step 1: Generating the pinhole

This process started out drastically different from my usual Silver Efex Pro workflow. Instead of starting at the Color Filter pane I started where I usually finish, in the Stylizing pane. I wanted to start this image by creating a focused point where the light would "fall" on the image. It focused on the area that has been exposed to the most light. So I used the Vignette tool to get the isolation I was looking for. First, I decreased the Amount slider so that I could see the effect. In this case, I brought it down to –38 percent (this was only a temporary setting), I then moved up the Size slider to 100 percent, and left the Circle/ Rectangle slider all the way to the left. Then all I had to do was locate the center of my effect. I clicked the Place Center button and, for the moment, dropped it about an inch to the left of dead center (see Figure 5-27).

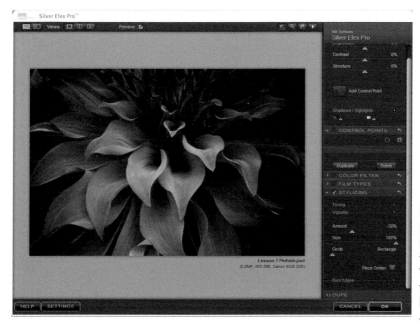

Figure 5-27

I defined the boundaries of the effect using Vignette first, then fine-tuned later.

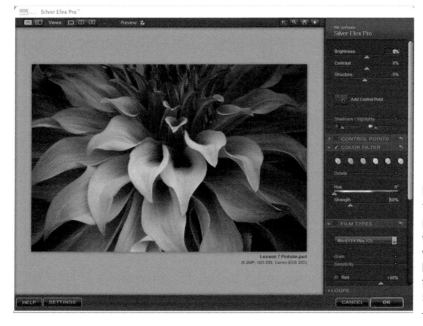

Figure 5-28

To get an image on its way, I started with the Color Filter pane and the Structure slider.

Step 2: Adjusting color for effect

I got back on track with my regular workflow, so I headed to the Color Filter pane. I knew I wanted to affect the red in the image so I chose the Red filter. I also brought down the Strength slider to 50 percent, which lessened the effect of the Red filter on the flower petals. Next, I went to the Structure slider to give the petals a little boost. I brought up the Structure slider to –5 percent (see Figure 5-28). The effect was starting to come together. At that point, it didn't look much like a pinhole image but, give it a more few steps and I knew it would.

Step 3: Amplifying the effect with contrast and brightness

I started to bring the effect into focus. I knew that increasing the Contrast slider would make the image darker overall. So I cranked up the Contrast slider to 51 percent. This amplified the effect of the Vignette and made the Color Filter's effect seem brighter with the increased contrast. To finish, I dropped the Brightness slider down to –8 percent to mute everything a touch because the next step would put the image into black-and-white overdrive (see Figure 5-29).

Step 4: Using film types to finish

Because I used my usual finishing step to start this lesson, dialing in the Film Types pane was the last step. To truly have a black-and-white image, I needed to take the image and push it into overdrive. To accomplish this push, I used the Ilford FP4 Plus 125 film type. Just the default setting made this image truly a black-and-white, but I was not happy with the default on a few sliders. So, to finish the image, I increased the Red Sensitivity slider to 48 percent and the Yellow slider to 41 percent. The adjustments were minor, but it gave the image that finished look. I liked the amount of Grain, so I left that at its default. The final tweak was to adjust the Tone Curve to bring back a sliver of the white that was lost when I increased the contrast, and with that I pronounced this image finished (see Figure 5-30). I liked the way everything looked, so I left the Vignette where I had it set originally, clicked OK, and that was all he wrote.

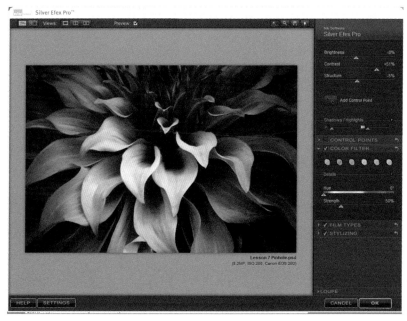

Figure 5-29
To obtain a more dramatic look of the vignette, I increased the Contrast slider and decreased the Brightness slider.

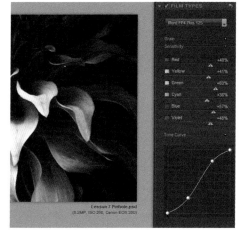

Figure 5-30
Using the Sensitivity slider and the Tone Curve, I made minor adjustments when fine-tuning.

LESSON 8: GOING FOR THE CLASSIC BLACK-AND-WHITE

So going wild and finishing images with Silver Efex is always fun, but sometimes I just want the plain old simple black-and-white. That classic look, while simple, has the ability to pull people into an image and keep them there. Finding the right balance in an image that you're converting to black-and-white can be difficult. You can go for the artistic, or you can go with what you see in the real world.

I want to show you how to achieve the look of black-and-white using Silver Efex Pro as though you took the shot in the field with all the right equipment.

Step 1: Styling in exposure

I started by heading into Silver Efex Pro by choosing Filter ▶ Nik Software ▶ Silver Efex Pro. I noticed that the exposure at the point of capture was wrong (hey, it happens). One nice thing about Silver Efex Pro is that Nik Software has incorporated a preset style that mimics dialed-in exposure compensation. So I went for the Underexpose EV –1 style, which brought the Brightness slider down to –10 percent and increased the Structure slider to 10 percent. It was amazing how much an image could change just by dropping the exposure one stop. This style was the base of the image. Figure 5-31 shows how just the use of this style had started to improve the image.

Step 2: Filtering in the field

If I had been prepared in the field, I would have had a red filter in my bag and used it for this shot, but I didn't and that was okay because of the Silver Efex Pro's Color Filter pane. I chose the Green filter and increased the Strength slider to 100 percent. This created the effect of using the filter on the shot, darkening the skies a touch. So now I had created the effect of having the camera dialed down to –1 exposure compensation with a green filter

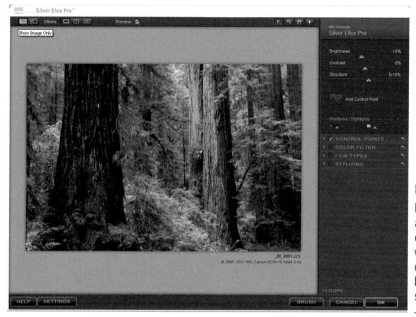

Figure 5-31
I could achieve an effect that closely mimics what could be done in the field by using a pre-set style.

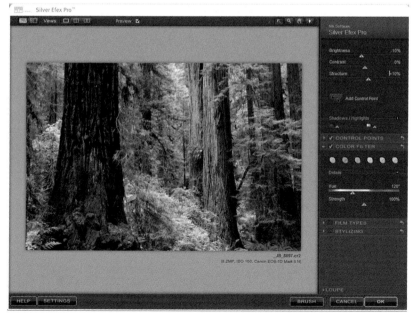

Figure 5-32
Using the Color Filter pane, I simulated a red filter on the lens.

attached to the lens. Figure 5-32 shows how Steps 1 and 2 worked together to bring the effect together.

Step 3: Film and beginning postproduction

So back in the days of film, the type of film in your camera made a world of difference in how your image turned out. For this image, I chose the Ilford Delta 100 Pro film type. It added more contrast to the image while at the same time darkened it and added a small amount of grain. I left all the default settings so that I had the feel of using the film in the field.

Adding that film effect helped make the image come together, but now I needed to shift from creating an image in the field to the realm of postproduction. To get the ball rolling, I dropped a control point on the tree trunk on the left and increased the Brightness to 15 percent, I used this point as if I were dodging the image (see Figure 5-33).

Step 4: Traditional postprocessing

The process of burning can be done in postproduction. I'm a big fan of burning the edges on black-and-white photographs because it gives me the ability to control where the eye should focus. To finish this image, I went to the Stylizing pane and headed to Burn Edges. I started on the left of the image and brought the Strength slider up to 24 percent, the Size slider up to 30 percent, and the Transition slider up to 50 percent. I used the same setting for the right side and the bottom of the image.

However, I didn't use the same settings on the top of the image. The light was falling from the top, so I wanted to accentuate that light. I did this by keeping the Strength slider at 24 percent and the Size slider at 20 percent, but I increased the Transition slider from 50 percent to 65 percent (see Figure 5-34). With that, I clicked OK and there it was: a black-and-white image made using original techniques — but all in Silver Efex Pro.

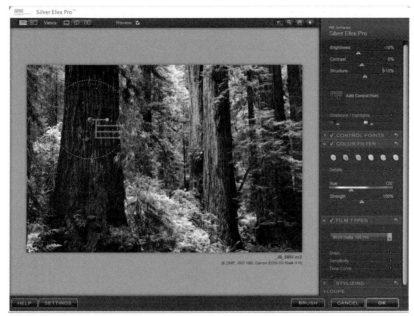

Figure 5-33

Choosing the right film can make or break the feel of an image, as seen here.

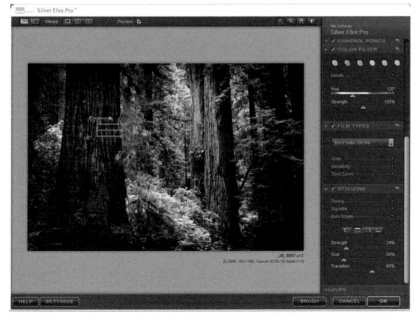

Figure 5-34

Burning edges was easy using the Stylizing pane in Silver Efex Pro.

LESSON 9:
BRINGING BACK TINTYPE

Tintype, like the pinhole camera, has been around a long time. It is a great effect for making images look really old. The tintype look was created by taking photographs using iron-coated plates. In most cases, the tintype effect has a reddish pink look, and over time fades into a great antiqued look. I had a bunch of images from the Independence Mine up in Alaska. A claim was staked in this area in 1906, and it grew from there. I took this shot of an old door that, as you can see, belonged to the engineers. It was overcast that day and there wasn't a lot of contrast on the door, so it looked flat. I knew this shot would need to be touched by both Color Efex Pro and Silver Efex Pro to produce the final image. So let me show you how I took an ordinary door and made it look like it was from an bygone time.

Step 1: Color Efex for creating a base

I started by choosing Filter ▶ Nik Software ▶ Color Efex Pro 3.0. The door needed a lot of help. The color cast plus the flat light made the door seem muddy and not that interesting to shoot, but I knew with a few adjustments in Color Efex Pro, I could bring the door to life and get it on its way to looking like a tintype. I headed for the Pro Contrast filter to remove the color cast and create some contrast on the door. In Pro Contrasts, I increased the Correct Color Cast slider to 60 percent to remove of the gray color cast on the door. Then I took the Correct Contrast slider and pushed it way up to 80 percent to really get that detail popping between the lights and darks in the image (see Figure 5-35). I clicked OK and went back into Photoshop for a second.

Step 2: Adding age quickly

In Photoshop, I chose Filter ▶ Nik Software ▶ Silver Efex Pro. I skipped my usual workflow of going to the Color Filter pane and instead hopped into the Stylizing pane to get the color look of a tintype. To get the base color of a tintype, I chose Coffee #9 for my preset tone and then brought the Strength slider up to 20 percent. It looked a little browner than red-

Figure 5-35

By using Color Efex Pro's Pro Contrast filter, I cut the color cast and increased the contrast to build a solid base to work off of in Silver Efex Pro.

Figure 5-36

By using the Toning in the Stylizer pane, I created the reddish-pink look of the tintype.

dish pink, but it would be the right color with a few slides. So after increasing the Strength slider, I brought up the Balance slider to 20 percent. I then took the Paper Hue slider and set it to 22 degrees. That gave me the right tone. Finally, to finish the color, I increased the Paper Toning slider to 30 percent. Figure 5-36 shows how the image looked with the Toning applied.

Step 3: From color to film

Going way outside my normal workflow, I headed to the Film Types and chose the Kodak 400 TMAX Pro Film type to give the door a darker look and add more character to the wood. I first decreased the Grain Per Pixel to 100, and I moved the Soft to Hard slider to the middle to get a good amount of grain on the door to obtain that aged look. Then I grabbed the Red slider from the Sensitivity pane and put it at 100 percent. This lightened the frame and parts of the door, so that they were not so dark. I grabbed the Yellow slider and brought it down to –20 percent. This took down the top of the door but made the lettering pop. To finish working on the Film Types pane, I went to the Tone Curve and brought up the blacks just a bit to lighten the bottom half of the door (see Figure 5-37).

Step 4: Control point and vignette to finish

I was almost finished, but I still needed to do two things. To make the lettering on the door stand out a bit more, I grabbed a control point and placed it on the wood right above the lettering. I brought down the Brightness slider to –40 percent and increased the Structure and Contrast sliders to 40 percent. This finished the door. I still wanted to add some Vignette. I went back to the Stylizing pane and expanded the Vignette tool. I took the Amount slider and pushed it to 100 percent to lighten the edges. I moved the Size slider to 47 percent. This brought in Vignette enough to affect the edges of the entire photo. Finally, I adjusted the Circle/Rectangle slider so that the arrow was just to the left of the "e" in circle. I clicked the Place Center and dropped it in the middle of the image to get an even effect for the Vignette (see Figure 5-38). With that I clicked OK and the image was finished.

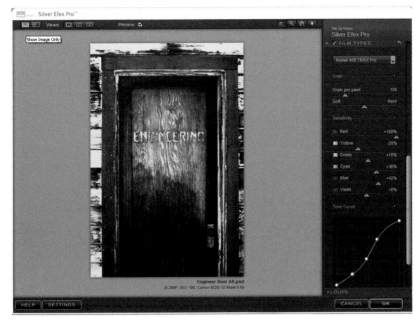

Figure 5-37

By choosing a higher ISO film, I added noise, which adds age, and at the same time adjusts the Sensitivity to color the dark and light regions.

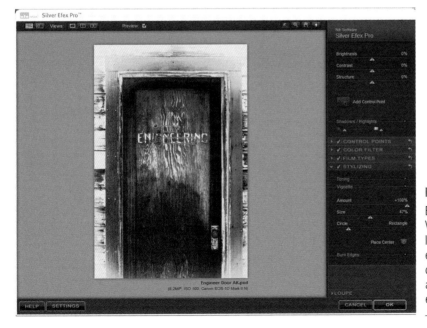

Figure 5-38

By using Vignette to lighten the edges instead of darken, I created a faded-edge effect.

LESSON 10:
SILVER FREE-FOR-ALL

It is not every day that you use every single aspect of Silver Efex to finish an image. I took this shot in Maine with the Digital Landscape Workshop Series crew. I knew at the point of capture that it would never hold up as a color image, but I knew it had potential as a great black-and-white. I also knew that it would require some work because of the highlights on the water and various nitpick things that I would have to fix to make this image a finished one. I had finished this image once before using strictly Photoshop. It took multiple layers and blending to get to the finished image. I wanted to see if I could accomplish the whole thing in Silver Efex Pro in one swoop of the plug-in.

Step 1: Fixing the highlights with control points
I started by heading into Silver Efex Pro by choosing Filter ▶ Nik Software ▶ Silver Efex Pro. I opened Silver Efex and the image went to the Neutral style as the default. The first thing I did was determine how I wanted to get rid of the large blob of grey on the water caused by the reflection from the sky. So I grabbed a control point by clicking Add Control Point. I dropped it in the middle of the biggest portion of the blown-out water. I increased the Size slider to cover all the areas that had the blown-out water, and began to bring it back down. I set the Brightness slider to –60 percent, but this made the water, for lack of a better term, "lifeless." It was just a darker blob. So to fix that, I brought up the Contrast slider to 76 percent and the Structure slider to 15 percent. Bringing those two slider up enhanced what little detail there was from the waves passing through that area (see Figure 5-39). That took care of the highlights in the water.

Step 2: Enhancing with Color Filter
I then went to the Color Filter pane to see what I could do to enhance some of the detail in the background of the image. I went for the Red filter and increased the Strength slider to

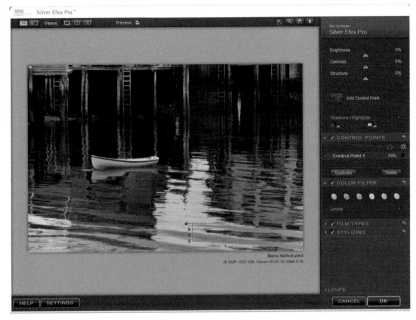

Figure 5-39

I controlled the highlights and brought back some life to an image using control points.

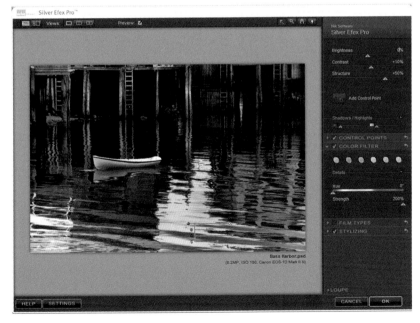

Figure 5-40

The Color Filter pane and Structure sliders brightened the darker details and increased the contrast.

200 percent. This brightened some of the details on the pylons. With the pylons enhanced, I headed to the Structure slider to enhance the midtones and shadows in the background. I took the Structure slider up to 50 percent. That punched up the contrast details and made the background sharper. To finish, I increased the Contrast slider to 10 percent and left the Brightness set at 0 percent (see Figure 5-40).

Step 3: Tweaking the film type

I was finished with the main details and now it was time to play. I headed to the Film Types pane and chose Ilford FP4 Plus 125. Just using the default gave me that true black-and-white feel. However, the default needed a bit of adjustment in the sensitivity. I increased the Yellow slider to brighten the highlights that were cast on the pylons in the background. It made a nice effect, so I stuck with it. It gave the feel of the sun hitting the pylons in the distance even though there was no sun there (see Figure 5-41).

Step 4: Stylizing for that last touch

I was at the last step in this process. I knew I wanted my image to have that almost silvery appearance, so I chose the Selenium 13 tone preset and increased the Strength slider to 19 percent. The rest of the toning sliders I left at their default settings. To finish the image, I headed to Burn Edges. In Burn Edges, I set the left edge's Strength to 10 percent, Size to 30 percent, and Transition to 90 percent. I set the bottom edge's Strength to 45 percent, Size to 0 percent, and Transition to 90 percent. Finally I set the right edge's Strength to 10 percent, Size to 30 percent, and Transition to 90 percent. I knew this would help bring the viewer's eye up to the center to focus on the boat. I didn't do anything to the top edge because I didn't want to darken it any more that it already was (see Figure 5-42).

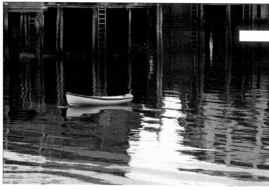

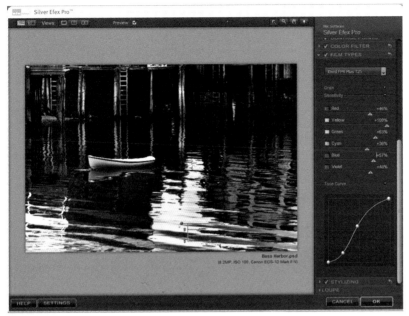

Figure 5-41
Using the Sensitivity sliders, I created a sense of light by increasing or decreasing certain channels.

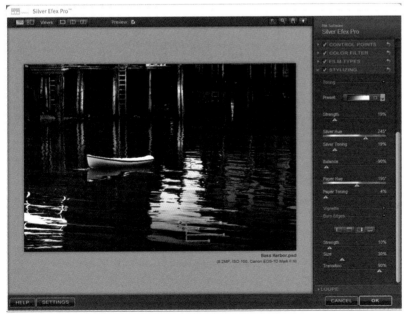

Figure 5-42
Toning and burning edges finished the image for a great effect.

PART VI

Having a Sharp Eye

The Lessons

You've worked over your image and you're ready to print it and share it with the world. Do you just click Print? The answer is no! There is one more step to give your image that extra pop, and that is sharpening. When you sharpen, you want to sharpen the content.

A golden rule in wildlife photography is that the animal's eyes must appear sharp. There are settings in your camera that let you sharpen the image, and then there's Nik Sharpener Pro. Most types of photography benefit from being critically sharp whether you're shooting weddings, capturing landscapes, or just having fun. Sharpening for content is the way to draw your eye to the subject by giving the image a little extra crispness. Sharpener Pro is not going to save a blurry image, but it will help make a good image better.

Sharpener Pro has several options you can use. You can always just set the sliders in the Basic tab and click OK. But the best way to get your image exactly the way you want is to use the options available in the Advanced tab. In the next few pages, I'll go through examples of images where I used Sharpener, and show you the benefits of using this fantastic plug-in.

LESSON 1:
RAW PRE-SHARPENING FILTER PRESET

The Pre-Sharpener filters create perceived sharpness by increasing the edge contrast throughout an image.

Step 1: Pre-sharpening set up

When I use Pre-Sharpener, I always use the Selective tool, so I chose File ▶ Automate ▶ Nik Sharpener Pro 2.0 and then selected Selective. This tool provides precise control over what is and is not sharpened. In this case, I clicked the Selective tool to bring up the Selection palette where I chose Raw Pre-Sharpener from the Filter Presets. The Sharpener window opened with my image ready to go. (If you don't use the Raw Pre-Sharpener, you should turn off any sharpening you've preset in your Raw converter. You should also turn off sharpening when you're shooting JPEGs.)

Step 2: Getting it sharp, but not too sharp

I increased the Pre-Sharpener to 75 percent to recover detail lost in the outer portions of the image (see Figure 6-1). I was happy with the image, so I clicked OK, and went back to Photoshop and the Selective tool and clicked Paint. If you're wondering why I went with the Selective tool for this, it is simple: Visually, part of my image was sharp and by adding the Pre-Sharpener, I'd overdone it. Therefore, to avoid additional sharpening, I chose the Selective tool to get the layer mask.

Using the Layer mask, I pressed the D key to reset my foreground, and then pressed the B key to select the brush and began sharpening. Figure 6-2 shows the effect of the masking. The transparent area was not affected by the sharpening process.

Figure 6-1

I used the Pre-Sharpener to get detail back.

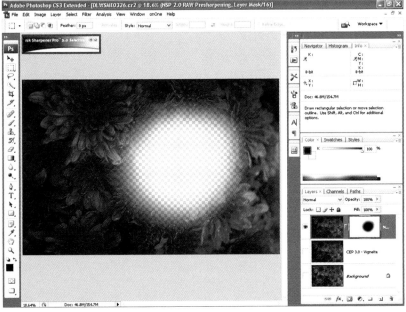

Figure 6-2

The transparent area was not affected by the sharpening process.

LESSON 2:
SHARPENING FOR EFFECT

 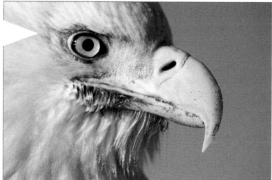

Wildlife photography takes a sharp eye. This shot was my first time taking photographs of a bald eagle, an experience I will never forget. The shot was tack sharp and looked great, but when I made a fine-art print, it looked soft. Here's a way to fix it fast.

Step 1: Figuring out my printer settings
I pulled up the image inside Sharpener Pro. I use an Epson printer, so that was my preset. The sliders were set to the dimensions that I wanted to print, which in this case was 15 by 22 inches. I had my viewing distance set to Auto, and my paper type set to Luster. And finally, I had the resolution set to my printer specifications of 2880-by-1440 dpi (see Figure 6-3). At this point, I needed to sharpen for content (in this image, the eye and feathers). I could sharpen in a single step.

Step 2: Making a piercing eye
I switched to the Advance tab and brought up my color ranges. I took the first eyedropper and selected the color range inside the eye. This image had two slightly different shades so I selected both and left the sliders set at 100 percent.

Step 3: Sharpening the feathers
I needed to fix the feathers because they were muted in the print. I grabbed an eyedropper and selected the white color range. That's all it took to sharpen the feathers. As easy as it was to sharpen the eye and feathers, I needed to prevent sharpening in the sky because sharpening would introduce noise into the image. I selected the color range in the sky with an eyedropper and moved the Color Range slider to 0 percent (see Figure 6-4). And with that, I had sharpened my fine art wildlife image and I was ready to print.

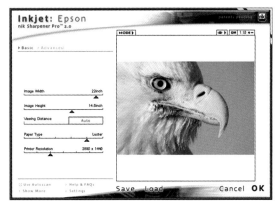

Figure 6-3
Go to the menu bar and chose: Filter ▶ Nik Sharpener Pro and choose the preset that suits your needs.

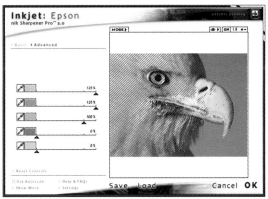

Figure 6-4
Adjusting the brightness of the yellow hues.

LESSON 3:
ISOLATING DETAILS FOR SHARPNESS

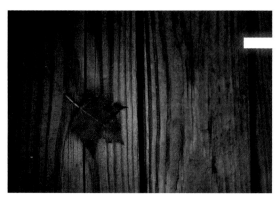

As important as sharpening the eye in wildlife photography, it's equally important to sharpen your subject in landscape photography. Whether you're sharpening something small like the red leaf in this lesson or a grand landscape, you always want the image to look its best. After all, colors are the first thing a viewer notices, sharpness is next. Sharpness makes an image successful. So take a look at this image and see what adding a little sharpness can do.

Step 1: Setting up for selective sharpening

You've seen this image earlier in the book. Before this image could go to print, the last step in my process was to get that critical sharpness in the leaf. To do this, I took a slightly different approach and from the menu bar chose File ▶ Automate ▶ Nik Sharpener Pro 2.0 and then selected Selective. This time, I chose the Selective tool because I wanted to have precise control over what was and what was not sharpened by using the layer mask created in the selective process (more on that in a bit). By clicking the Selective tool, the Selection pane opened and I chose the Filter Preset I wanted to use. Because I use an Epson printer, I chose that preset (see Figure 6-5).

Step 2: Getting sharpness under control

With the Sharpener Pro window open, I set my desired attributes and levels of sharpness (see Figure 6-6). I went straight to the Advanced tab to set the color ranges I wanted sharpened. I chose four varying colors from around the leaf and dialed down the percentage for each one until the leaf was sharpened. For my taste, going to 100 percent was too much sharpening, so I moved the first four sliders (the only ones I wanted to use) down to 82 percent. I moved the last slider down to 0 percent, but that was irrelevant because I used the Selective tool on this image. Figures 6-6 and 6-7 show the effect of sharpening turned on

Figure 6-5

The Selection tool provided precise control over what parts of the image were sharpened.

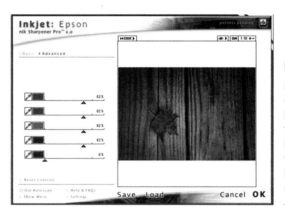

Figure 6-6

By selecting the color inside the leaf, I sharpened for content. I isolated it further when I applied a layer mask.

and off. I had everything set the way I wanted so I clicked OK, and Sharpener Pro applied the sharpening to a new layer with a layer mask.

Step 3: Isolating sharpening with a layer mask

I clicked OK again and I was back to the Photoshop window. I made sure that the Sharpener Pro layer was selected and began to work on the Layer mask to reveal the sharpened effect. In the Sharpener Selective tool, I clicked the Paint button. I use a Wacom Intuos tablet or Cintiq, and I recommend either one for precise masking.

At this point, the layer mask was black, concealing the sharpness, so I pressed the D key to reset my foreground color to white and get ready to paint. I pressed the B key to select my brush and set the Opacity to 30 percent. I did this so that I could slowly see the change in the leaf. I could go to 100 percent, but slowly brushing on the effect in multiple passes seemed to give a more natural effect. I was happy with the effect and the selection using the layer mask, so I clicked Apply in the Selective tool to finalize the mask.

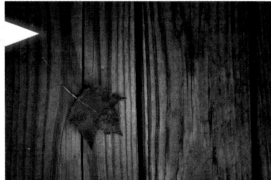

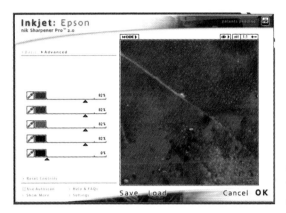

Figure 6-6
My leaf image
with sharpening
turned off …

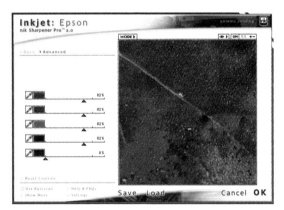

Figure 6-7
… and with
sharpening
turned on.

INDEX

CD CONTENTS

On the CD you will find the image files from the entire book provided so that you can take the original art and apply the techniques as explained in the text. Also include on the CD is 15-day trial software provided by Nik Software, Inc., so you can test out several of the Nik plug-ins on these images or on your own.

For the latest and greatest information, please refer to the ReadMe file located at the root of the CD. There you will find the system requirements, instructions on using the CD with Windows and Macintosh computers, a list of what's on the CD, and troubleshooting information.

Using the CD

To access the content from the CD, follow these steps.

1. Insert the CD into your computer's CD-ROM drive. The license agreement appears.

2. **Note to Windows users:** The interface won't launch if you have autorun disabled. In that case, click Start▶Run (For Windows Vista, Start▶All Programs▶Accessories▶Run). In the dialog box that appears, type D:\Start.exe. (Replace D with the proper letter if your CD drive uses a different letter. If you don't know the letter, see how your CD drive is listed under My Computer.) Click OK.

 Note for Mac Users: The CD icon will appear on your desktop, double-click the icon to open the CD and double-click the Start icon..

3. Read through the license agreement, and then click the Accept button if you want to use the CD.

4. The CD interface appears. The interface allows you to install the programs and run

the demos with just a click of a button (or two).

What's on the CD

The following sections provide a summary of the software and other materials you'll find on the CD.

Using the Author's Images

The image files used in the book's example and available for you to use to follow along the authour's lessons are in TIFF format, and to use them you will need Adobe Photoshop and the Nik Software plug-ins Color Efex Pro 3.0, Dfine 2.0, Nik Sharpener Pro 2.0, Silver Efex Pro, and Viveza.

Note that the images are watermarked with a copyright notice. These images are copyrighted by Joshua D. Bradley and may not be redistributed, or used in whole or in part in any materials you distribute or republish, whether commercially or not, in any medium. They may be used only to try out the lessons in this book for your personal education.

That the images' file names indicate the part and lesson they refer to. For example, 287637 fg05L07before.tif is the "before" image used in Lesson 7 (L07) or Part V (fg05).

Using the Trial Software

The trial versions of Nik plug-ins included on the CD are:

- Color Efex Pro 3.0, which offers 52 filters and more than 250 effects for retouching, color correction, and endless enhancements to your photos

- Dfine 2.0, which gives you best-in-class noise reduction

- Nik Sharpener Pro 2.0, which lets you achieve optimal sharpness in any image

- Silver Efex Pro, which provides the flexibility and precision to create dynamic black-and-white images

- Viveza, which lets you selectively control color and light without layer masks

Also included is the Adobe Reader software.

The system requirements for these plug-ins and Reader are as follows.

Windows

- Windows 2000 Professional, Windows XP Home, Windows XP Professional, or Windows Vista (Dfine 2.0 does not support 64-bit Vista)

- 1GHz Intel Pentium III or better CPU (Intel or AMD)

- 256MB RAM (512MB RAM for Silver Efex Pro)

- Adobe Photoshop 7 through CS3, Adobe Photoshop Elements 2.0 through 5.0, or an image-editing application that is compatible with Adobe Photoshop plug-ins

- CD or DVD drive

- an Internet connection

Macintosh

- Mac OS X 10.4 or later

- PowerPC G4, PowerPC G5, Intel Core Solo, Intel Core Duo, Intel Core 2 Duo, Intel Xeon, or better CPU

- 256MB RAM (512MB RAM for Silver

Efex Pro)

- Adobe Photoshop CS2 or CS3, Adobe Photoshop Elements 4.0 or 6.0, or an image-editing application that is compatible with Adobe Photoshop plug-ins; or Apple Aperture 2.1 (Silver Efex Pro and Viveza only)

- CD or DVD drive

- an Internet connection

For more information, go to the Nik Software Web site at www.niksoftware.com.

Legal Notices

Shareware programs are fully functional, trial versions of copyrighted programs. If you like particular programs, register with their authors for a nominal fee and receive licenses, enhanced versions, and technical support.

Freeware programs are copyrighted games, applications, and utilities that are free for personal use. Unlike shareware, these programs do not require a fee or provide technical support.

GNU software is governed by its own license, which is included inside the folder of the GNU product. See the GNU license for more details.

Trial, demo, or evaluation versions are usually limited either by time or functionality (such as being unable to save projects). Some trial versions are very sensitive to system date changes. If you alter your computer's date, the programs will "time out" and will no longer be functional.

Troubleshooting

If you have difficulty installing or using any of the materials on the companion CD, try the following solutions:

- **Turn off any antivirus software that you may have running.** Installers sometimes mimic virus activity and can make your computer incorrectly believe that it is being infected by a virus. (Be sure to turn the antivirus software back on later.)

- **Close all unnecessary running programs.** The more programs you're running, the less memory is available to other programs. Installers also typically update files and programs; if you keep other programs running, installation may not work properly.

- **Reference the ReadMe:** Please refer to the ReadMe file located at the root of the CD-ROM for the latest product information at the time of publication.

Customer Care

If you have trouble with the CD-ROM, please call the Wiley Product Technical Support phone number at (800) 762-2974. Outside the United States, call 1(317) 572-3994. You can also contact Wiley Product Technical Support at http://support.wiley.com. John Wiley & Sons will provide technical support only for installation and other general quality control items. For technical support on the applications themselves, consult the program's vendor or author.

To place additional orders or to request information about other Wiley products, please call (877) 762-2974.

 Software # Special Offer